Savannah College of Art and Design

SELECTED WORKS FROM THE COLLECTION

Corrigendum

The text on page 148 should read:

Claes Oldenburg
American, born Sweden, 1929

Coosje van Bruggen
American, born Netherlands, 1942

Balzac Pétanque, 2002
Fiber-reinforced plastic, cast epoxy,
and stainless steel, painted with
polyester gelcoat
102 x 300 x 444 inches
Purchase with funds from Mr. and
Mrs. J. Mack Robinson, 2002.259.1–39

High Museum of Art

SELECTED WORKS FROM THE COLLECTION

Atlanta
2005

Library of Congress Cataloging-in-Publication Data
High Museum of Art.
 High Museum of Art : selected works from the collection.
 p. cm.
 Includes bibliographical references.
 ISBN 1-932543-03-1 (hardcover : alk. paper)
 1. Art—Georgia—Atlanta—Exhibitions. 2. High Museum of
Art—Exhibitions. I. Title.
N514.A85A56 2005
708.158'231—dc22 2005010373

Front cover: Tony Smith, *Untitled* (Louisenberg) (detail).
See page 129.
Back cover: Roy Lichtenstein, *House III*. See page 146.
Page 2: George L. K. Morris, *Concretion* (detail). See page 50.
Page 14: Harry Callahan, *Untitled* (detail). See page 168.

For the High Museum of Art
Kelly Morris, Manager of Publications
Lori Cavagnaro, Editor
Christin Gray, Publications Coordinator
Melody Hanlon, Assistant Registrar
Paula Williams, Assistant to the Registrar

Designed by Jeff Wincapaw
Color separations by iocolor, Seattle
Produced by Marquand Books, Inc., Seattle
 www.marquand.com
Printed and bound by CS Graphics Pte., Ltd., Singapore

Contents

Acknowledgments

I WOULD LIKE TO TAKE THIS OPPORTUNITY to thank all of the individuals who have contributed gifts of works of art and acquisition funds. I would especially like to thank members of the Collections Gallery of Honor, which recognizes those who have made cumulative gifts of works of art to the High Museum of Art totaling more than $500,000.

Michael E. Shapiro
Nancy and Holcombe T. Green, Jr. Director

Donors who have given funds to purchase art or contributed works of art appraised at $1,000,000 or higher.

Frances and Emory Cocke
Virginia Carroll Crawford
Decorative Arts Acquisition Endowment
Fine Art Collectors
The Forward Arts Foundation
Lenore and Burton Gold
Great Painting Fund
T. Marshall Hahn, Jr.
J. J. Haverty, Miss Mary E. Haverty,
 and the Haverty Family
High Museum of Art Members Guild
Samuel H. Kress and the Samuel H.
 Kress Foundation
National Endowment for the Arts,
 a Federal Agency
Mrs. Howard R. Peevey
The Phoenix Society of Atlanta
Edith G. and Philip A. Rhodes
Fred and Rita Richman
Mr. and Mrs. J. Mack Robinson
Mark Rothko Foundation
Sara Lee Corporation
Mr. and Mrs. Simon Selig
Irene and Howard Stein

Alfred Austell Thornton Endowment in
 memory of Leila Austell Thornton
Alene Fox Uhry and Family for the
 Ralph K. Uhry Print Collection
John Wieland Homes and Neighborhoods

Donors who have given funds to purchase art or contributed works of art appraised at $500,000 or higher.

Anonymous
Barbara B. and Ronald D. Balser
Dr. and Mrs. Joel E. Berenson
Lucinda W. Bunnen
Walter and Frances Bunzl Foundation
Miriam H. and John A. Conant
Contemporary Art Society
The Joseph and Robert Cornell Foundation
The Cousins Foundation
Decorative Arts Acquisition Trust
Mr. and Mrs. Sergio Dolfi
Dr. and Mrs. Max Ellenberg
The Elson Collection for Contemporary
 Glass
Georgia-Pacific Corporation
Anne and William J. Hokin
Fay and Barrett Howell Fund
Mr. and Mrs. Scott Hudgens

Dr. and Mrs. John L. Jacobs
The Kuniansky Family
Dr. Harold and Elaine L. Levin
Life Insurance Company of Georgia
D. Lurton Massee, Jr.
Adair and Joe B. Massey
H. B. and Doris Massey Charitable Trust
Mr. and Mrs. George E. Missbach, Sr.
Julie and Arthur Montgomery
Mr. and Mrs. Carl Mullis III
Norfolk Southern Foundation
Mrs. Norman Powell Pendley
Estate of Charles Pratt
Linda and Gordon Ramsey
Mrs. Helen Regenstein
Mr. and Mrs. Louis Regenstein
Nelson A. Rockefeller
Carroll Thomas Sanders
Dr. and Mrs. Michael Schlossberg
Margaret and Terry Stent Endowment
Mrs. Jesse Isidor Straus
Albert Edward Thornton, Sr.
Turner Broadcasting System, Inc.
Sarah Miller Venable
William Hoyt Venable
Dr. Nancy W. Walls

Foreword

THE HIGH MUSEUM OF ART NOW STANDS at a significant moment in its institutional history. Just over twenty years ago, the High unveiled Richard Meier's masterpiece of architecture for Atlanta. Elegantly complementing Meier's museum, Renzo Piano has given Atlanta another architectural masterpiece. The expanded Museum facilities, designed by two acclaimed architects, move us even closer to our vision of becoming one of the nation's great museums in the twenty-first century. Hand-in-hand with the expansion of its galleries and other public spaces, the High Museum has also been collecting art for Atlanta. Thanks to the generosity of our patrons and to the impressive success of our special exhibitions, we have been able to add significant works in all areas of our collection and build on the solid foundation laid by previous directors and curators. We trust that the energy and momentum of recent efforts to build the permanent collection will only increase in the coming years.

Michael E. Shapiro
Nancy and Holcombe T. Green, Jr. Director

A History of the High Museum of Art
LINDA MERRILL

JAMES J. HAVERTY OF ATLANTA HAD WITNESSED the destruction of the city by Sherman's army, and as a furniture merchant had taken part in the restoration of its domestic and economic life. But it was as an art collector and civic leader that Haverty corrected the record in 1927, when a profile of "Vigorous Atlanta" in the *New York Times* asserted that the city lacked an art museum. There was indeed a museum in Atlanta, Haverty countered, a building donated the previous year by "a splendid and public-spirited woman," Hattie (Mrs. James M.) High. It contained a number of artworks belonging to the Atlanta Art Association, which had existed for more than twenty years, and was already showing one or two exhibitions a month. "Art is today a living, breathing thing in Atlanta," he concluded, "and its influence is becoming widespread, because our people are not content to do things in a small way."[1]

In fact, Atlanta was still struggling to establish a cultural life. The museum Haverty mentioned was not one of the Beaux-Arts palaces adorning cities throughout the nation, but a Tudor-style residence with "an easygoing sideway spread to it," as one journalist later remarked, "that made it look like a place in which one could walk in, sit down and live happily ever after. But a museum?"[2] A generous bequest from a Union Army veteran allowed some minor renovations to the house, and in October 1926 it opened as an art museum, with the third in a series of exhibitions from the Grand Central Galleries of New York proudly on display. Haverty had been instrumental in orchestrating those events, previously held at the Biltmore Hotel, which effectively whetted the artistic appetites of the very Atlantans who could lay the foundation of a museum's support.[3]

Thanks to annual pledges by the Friends of Art, another Haverty scheme to consolidate patronage, the High Museum survived the Great Depression. In the following decades it acquired neighboring houses—one to display Haverty's own collection, bequeathed by his daughter Mary in 1949, and the other to serve as a gallery for decorative arts. There were dreams of a purpose-built museum, but it was not until 1953 that the impetus came: the Kress Foundation offered a significant gift of European art, provided that a suitable facility could be constructed to house it. That building—nondescript but climate-controlled, fireproof, and secure—opened in 1955, adjoining the High mansion.[4] A few years later an antebellum home was moved from rural Georgia to the property on Peachtree Street, making the High Museum a loose agglomeration of small buildings managed mostly by volunteers in an atmosphere, an outside review committee observed in 1962, of chaos and confusion. That spring, the chastened trustees pledged to set the institution on a more professional course, although further action was postponed until after a European tour sponsored by the Art Association.[5]

That trip ended in disaster. On June 3, 1962, just after taking off from Orly Field near Paris, the chartered plane crashed, taking 132 lives.[6] More than one hundred of the

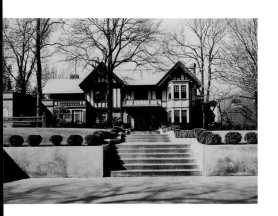

Residence of Mrs. Joseph M. High, later the High Museum of Art. High Museum of Art Archives.

The Museum's 1955 building. High Museum of Art Archives.

people who perished were supporters of the High Museum. From the city's collective grief emerged a powerful sense of unity, and for the first time the Art Association, previously regarded as elitist and aloof, was embraced as an integral part of Atlanta.[7] The Memorial Arts Center, dedicated to those who died at Orly, opened to mixed reviews in 1968.[8] To make room for the massive, colonnaded structure, Mrs. High's mansion had finally been razed, and the 1955 museum building, though left intact, had virtually disappeared: as one critic put it, "The center has swallowed it like a whale."[9] Nevertheless, the High Museum was gaining professional stature and a wider audience, largely through the efforts of the director, Gudmund Vigtel, who in 1963 had been lured to Atlanta from Washington, D.C., "strictly because," he said, "of the vision expressed at the time."[10] Vigtel remained attuned to potential. In 1974, he presented a reasoned argument for expansion, insisting that the High Museum's survival depended upon its capacity to serve the community "in terms of education and recreation," activities that would require more space than the present facility, constrained as it was by the Arts Center, could ever provide.[11]

The truth of Vigtel's words was brought home in 1976, when Atlanta lost the King Tutankhamen exhibition to New Orleans, a city with a facility large enough to accommodate not only the Egyptian spectacle, but also the unprecedented crowds it was sure to attract. The era of the blockbuster had begun, involving masses of new museumgoers, soaring expenses and revenue, extraordinary media attention, and elevated public expectations—but Atlanta had been shown unprepared to participate. Even those like Coca-Cola chief executive Robert W. Woodruff, who professed no personal interest in the arts, recognized the value of such popular events to a thriving business community.[12] In 1979, Woodruff dropped a hint that he might offer the High Museum a challenge grant, much as he had for the Arts Center years before. Vigtel immediately ordered a feasibility study, organized committees and task forces, and launched a fundraising drive.[13] In June 1980, the New York architect Richard Meier was chosen unanimously to design a new building that would more than double the Museum's exhibition space. It was to be a work of art in itself, one Arts Center official announced, that would also "put Atlanta on the circuit" for future blockbuster exhibitions.[14]

The next summer, as a brass band played and a fleet of bulldozers stood poised for action, hundreds of Atlanta children broke ground for construction with little red shovels inscribed, "I helped build a museum big enough for Atlanta."[15] That exuberant display of civic energy characterized the campaign for the High Museum, which met Woodruff's challenge a year before the deadline. The building opened right on schedule, in October 1983. John Russell declared in the *New York Times* that it was "the hottest thing of its kind in the museum world" since the opening of the Guggenheim Museum in 1959.[16] "Rare indeed is the museum . . . that is a strong and potent work of architecture in itself, yet seems completely to understand and respect the works of art within it," wrote another New York critic, Paul Goldberger. "But such a museum is exactly what Atlanta has just built." If Meier possessed the genius to envision this "triumph of museum design," the people of Atlanta had shown the courage to construct it.[17]

And then came the Olympics. In the summer of 1996, the world's eyes turned toward Atlanta, and Ned Rifkin, who succeeded Vigtel as director, recognized an opportunity to place the High Museum on an international stage. J. Carter Brown, former director of the National Gallery of Art and one of the nation's leading cultural celebrities, was invited to organize an exhibition celebrating the spirit of unity represented by

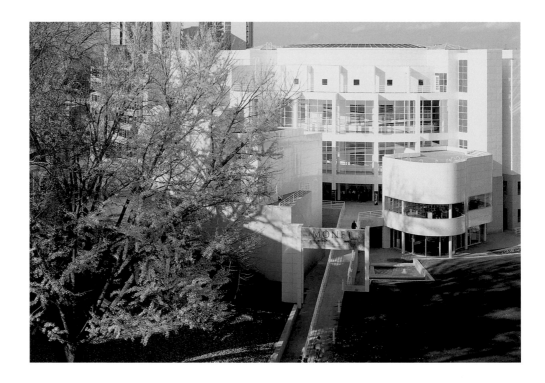

the Olympic Games. *Rings: Five Passions in World Art* filled two floors of the Museum
with awe-inspiring objects from across the globe, and Atlanta's visitors and residents
flocked to see it.[18] Besides setting a new standard for the High Museum, *Rings* dem-
onstrated the limitations of the building—the shortage of such visitor amenities as res-
taurants and restrooms, the single, small passenger elevator, the inflexible gallery spaces.
Moreover, the permanent collection had tripled in size since 1983, and with the rapid
urban growth attending the Olympics, Meier's 135,000-square-foot masterpiece sud-
denly seemed a little too small. The Museum continued to gather momentum after the
Olympics, with a series of very successful and popular exhibitions of Picasso, Matisse,
and Impressionism. The heavy attendance put more pressure on the facility.

But how could the High Museum, widely recognized as a peerless work of archi-
tecture, possibly be expanded without compromising its aesthetic integrity? "I prefer to
embrace the building," announced the architect selected to meet that challenge, Renzo
Piano, "almost to protect it, I don't even want it to touch, just to link."[19] In 1999, Piano
accepted a contract not only to design new spaces for the High, but also to develop a
master plan for the Arts Center that would harmonize the buildings with their envi-
ronment. Once a tree-lined block of a residential district, that setting had become a
bustling urban center, and Piano envisioned the Woodruff campus—with its various
structures, old and new, ranged around a public piazza—as a space invigorated by the
interaction of the arts and the enthusiasm of a crowd. The new, upper-level art galler-
ies he proposed for the High Museum expansion would be illuminated by a thousand
"light scoops" specially designed to capture and refine the brash southern sunshine.[20]

The prospect of an enlarged and enhanced High Museum of Art again galvanized
Atlanta. Led by Michael E. Shapiro, director since 2001, the Museum secured funding
for the project by November 2004, a full year before the Piano-designed buildings
were scheduled to open. The three-building, 177,000-square-foot expansion more
than doubles the size of the High Museum, substantiating Haverty's assertion, so many
years ago, that Atlanta would never be content to do things in a small way.

NOTES

1. R. L. Duffus, "Our Changing Cities: Vigorous Atlanta," *New York Times,* May 22, 1927; J. J. Haverty, Letter to the editor, "Atlanta an Art Centre," *New York Times,* June 5, 1927; "James J. Haverty of Atlanta Dies," *New York Times,* October 19, 1939.

2. John Russell, "Atlanta's New Museum Has Spaces to Fill," *New York Times,* November 13, 1983.

3. Lea Agnew and David Hughes Duke, "High Museum of Art," *Atlanta History* 38 (Spring–Summer 1994): pp. 30 and 31. The bequest of Lucius Perry Hills had come to the Art Association in 1914.

4. Ibid., pp. 32–33.

5. Ibid., p. 35.

6. Ann Uhry Abrams, *Explosion at Orly: The Disaster that Transformed Atlanta* (Atlanta: Avion Press, 2002), p. x.

7. Agnew and Duke, "High Museum of Art," pp. 35–36.

8. The Center was later renamed the Robert W. Woodruff Arts Center as a "gift of public recognition" of the principal donor. Wendell Rawls Jr., "Atlanta's Thriving Arts World Honors the Man Who Paid for It," *New York Times,* December 20, 1982.

9. Ada Louise Huxtable, "Architecture: Atlanta's Arts Center," *New York Times,* October 5, 1968.

10. Vigtel, quoted in Agnew and Duke, "High Museum of Art," p. 36.

11. Vigtel, 1974 Long Range Planning Report, quoted in High Museum of Art, *High Museum of Art: The New Building* (Atlanta: High Museum of Art, 1983), p. 11.

12. Rawls, "Atlanta's Thriving Arts World."

13. Agnew and Duke, "High Museum of Art," pp. 40–41.

14. Beauchamp Carr, then vice president of the Arts Alliance, quoted in Rawls, "Atlanta's Thriving Arts World."

15. High Museum of Art, *The New Building,* p. 17.

16. Russell, "Atlanta's New Museum."

17. Paul Goldberger, "Architecture: New Atlanta Museum," *New York Times,* October 5, 1983.

18. Roberta Smith, "Esthetic Olympics, in 5 Shades for 5 Rings," *New York Times,* July 4, 1996.

19. Piano, quoted in Catherine Fox, "Defining the Woodruff's DNA," *Atlanta Journal-Constitution,* Sunday, February 13, 2000, Arts & Books section.

20. Fox, "Defining the Woodruff's DNA."

A History of the Collections
DAVID A. BRENNEMAN

THE ATLANTA ART ASSOCIATION, later to become the High Museum of Art, began to collect individual objects soon after its founding in 1905, but it was not until 1949 that it received its first major donation—late nineteenth- and early twentieth-century American paintings by artists such as William Merritt Chase, Henry Ossawa Tanner, and John Twachtman from the collection of J. J. Haverty. This gift formed the basis of the High Museum's American art collection and shaped its growth over the years with the addition of landscapes of the Hudson River School; figure paintings by John Singer Sargent, Robert Henri, and Joseph DeCamp; and still-life paintings by John Frederick Peto and William Mason Brown. Recent acquisitions have focused on American painting and sculpture of the interwar years, 1918 to 1945, by artists such as Joseph Stella, Ben Shahn, and Theodore Roszak.

The Haverty gift of 1949 was followed in 1958 by the donation of twenty-nine Renaissance and Baroque paintings and sculptures from the Samuel H. Kress Foundation, establishing the core of the European art collection. Many of the works from this gift—Giovanni Bellini's *Madonna and Child,* Tommaso del Mazza's *Madonna and Child with Six Saints,* and Giovanni Battista Tiepolo's *Roman Matrons Making Offerings to Juno*—remain highlights of the collection to this day. In subsequent decades, the Museum has added important late nineteenth-century French paintings by such masters as Claude Monet and Camille Pissarro. In recent years, the sculpture and works-on-paper holdings have been strengthened through acquisitions of works by artists ranging from Albrecht Dürer to Henri de Toulouse-Lautrec.

With the hiring in 1979 of Donald Pierce, the Museum's first curator of decorative arts, the High embarked on an ambitious campaign that resulted in the building and unveiling in 1983 of its most outstanding collection, the Virginia Carroll Crawford Collection of American Decorative Arts, which spans the years 1825 to 1917. The High's decorative arts collection also boasts the Frances and Emory Cocke Collection of English Ceramics. Recent efforts have expanded the High's twentieth-century decorative arts holdings, including the key additions of Gerrit Rietveld's *Red/Blue Chair* and Marcel Breuer's *Lounge Chair.*

The High's modern and contemporary art holdings grew markedly during the 1970s and 1980s. During these decades, works by Romare Bearden, Philip Guston, Jacob Lawrence, Robert Morris, and Frank Stella entered the Museum. In 1999, a gift of significant works from Lenore and Burton Gold made an important contribution to the High's collection of modern and contemporary art and photography, particularly works by Christian Boltanski and Deborah Butterfield. The High has continued to strengthen its holdings by focusing on certain eminent contemporary artists and collecting their work in depth—most notably, Chuck Close, Ellsworth Kelly, Anselm Kiefer, and Gerhard Richter.

The Museum had acquired works of photography and folk art since the 1970s. In the early 1990s official departments were founded to oversee these collections. Begun in 1983, the Lucinda Bunnen Collection is the core of the High's photography collection. The Museum possesses significant collections of such masters of twentieth-century photography as Harry Callahan and Clarence John Laughlin and has obtained works by such prominent contemporary photographers as Sally Mann, Thomas Struth, and Jeff Wall.

In 1996 the folk art collection was greatly expanded and enhanced with the gift of the T. Marshall Hahn Collection. The High's folk art collection also boasts large monographic holdings of the work of Bill Traylor and Howard Finster, and more than 130 works by the Atlanta artist Nellie Mae Rowe, given by longtime Museum patron Judith Alexander in 2002 and 2003.

The High's newest curatorial department is African art. The first work of African art entered the Museum's collection in 1953. Since then, the Museum has received gifts from many individuals—most importantly, from Fred and Rita Richman. Since 1972, the Richmans have donated their entire collection, endowed a curatorial position, and founded a special initiative endowment. Recent acquisitions in African art have begun to establish a collection that will encompass the art of the entire continent.

SELECTED WORKS FROM THE COLLECTION

With the exception of African art, works are in loose chronological order in each section. Dimensions are given height before width before depth.

AFRICAN ART

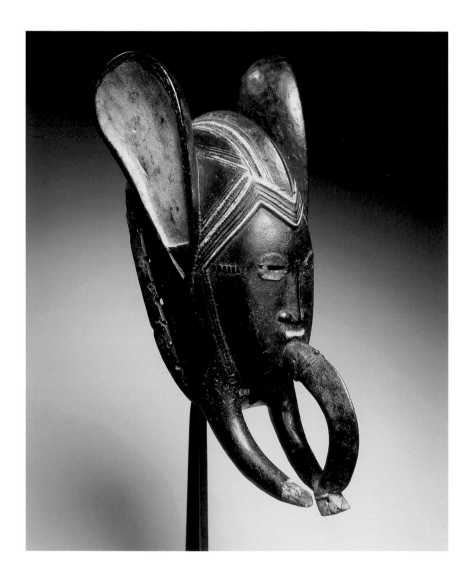

Baule Artist
Ivory Coast

Elephant Mask, ca. 1875–1950
Wood, paint, and metal, 21 × 7¾ × 6½ inches
Purchase through prior acquisitions, 2002.1

THIS DELICATELY DETAILED BAULE MASK from Ivory Coast, West Africa, combines elephant traits and elegantly refined human features in a compelling hybrid form. The bold shapes of its backswept ears counterbalanced by the graceful curves of the tusks and trunk give the mask dynamism. According to Baule aesthetics, objects made for display often feature lustrous surfaces ornamented with richly textured details. Reflective brass appliqué strips highlight this mask's narrow eye openings. Its thickly layered patina suggests it had a long performing life.

Unlike the fierce Baule helmet masks intended to be viewed by men only, this gentle elephant mask is used for village entertainment and celebrations attended by everyone—men, women, youths, elders, children, and even strangers. Known as *mblo,* they represent human and animal characters in skits and dances. Elephant masks are performed by older, more highly skilled dancers, who appear after younger dancers, still in training, have warmed up the dance space.

The carefully orchestrated performance of *mblo* masks, in which music is a vital element, is conceived as a single aesthetic entity and critiqued like an opera. While *mblo* masquerades are one of the oldest of Baule art forms, performances are reinvented every few generations.
—Carol A. Thompson

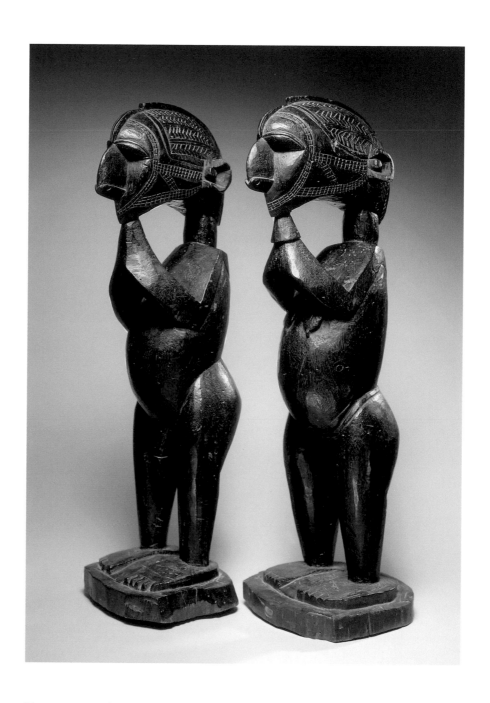

Baga Artist
Guinea

Male and Female D'mba *Figures,*
nineteenth century
Wood, 26 inches high
Fred and Rita Richman Collection,
2002.284.1–2

THESE TWO *D'MBA* FIGURES share the same profiles as the headdresses of the masquerades performed during Baga weddings and on other joyous occasions. For the Baga people living on the small tropical islands of coastal Guinea, *d'mba* is an abstract concept encompassing all that is good and beautiful in the world. This concept is embodied in both male and female figures. —Carol A. Thompson

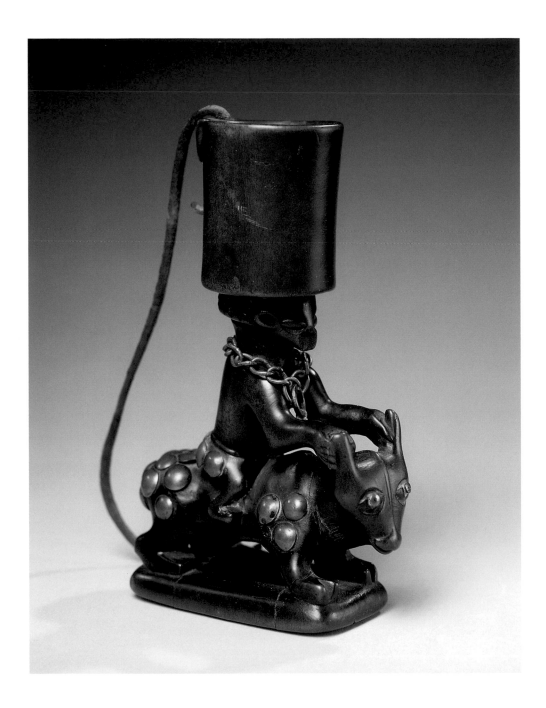

Chokwe Artist
Angola, Democratic Republic of the Congo, or Zambia

Tobacco Mortar, nineteenth century
Wood, leather, and brass tacks, 6 inches high
Fred and Rita Richman Collection, 2002.296

SHINY BRASS TACKS AUGMENT the glowing patina of this exceptionally elaborate mortar, whose support is in the form of a trader riding an ox. During the nineteenth century, brass tacks obtained through trade with Europeans were rare and valuable in Chokwe communities. Tobacco was associated with high social rank, reserved for elders, and for men and women of privileged status. Tobacco had both social and ritual importance among the Chokwe and neighboring peoples of Central, Eastern, and Southern Africa. In Chokwe ceremonies tobacco was smoked or inhaled as snuff to honor the memory of lineage ancestors. The act of smoking helped establish communication between ancestors, guardian spirits, and living generations.
—Carol A. Thompson

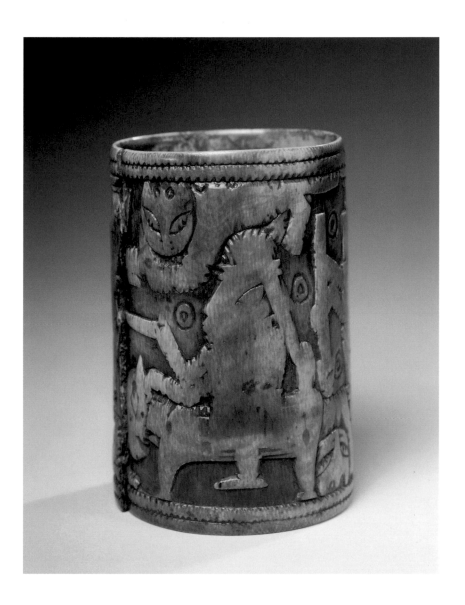

Edo Artist
Kingdom of Benin, Nigeria

Bracelet, nineteenth century
Ivory, 4¾ inches high
Fred and Rita Richman Collection, 2002.288

THIS IVORY BRACELET, from the 800-year-old Edo Kingdom of Benin, is decorated with motifs that refer to Oba Esigie, a great warrior who ruled in the sixteenth century. Motifs associated with Esigie were popular during the late nineteenth-century reign of Oba Ovonrram-wen. These motifs include a Portuguese soldier on horseback and an image of the king in the guise of a leopard, as visible on this well-worn bracelet. In Benin City today, Edo oral histories recall that Portuguese soldiers assisted Oba Esigie in his battle against the Ata of Idah. The deep burgundy color of this bracelet is the result of repeated applications of red palm oil mixed with spirits.

When the Portuguese arrived on what then became known as the "Slave Coast," by about 1472, ivory and copper were more highly valued than gold. By then, ivory carving was a well-established art in the court of the Kingdom of Benin. Eware the Great, who reigned from about 1440 to 1473, was a generous patron of the royal ivory carvers' guild. He sponsored the work of Eghoghomaghan II, a master artist who introduced ivory designs handed down over many generations and is still remembered today. —Carol A. Thompson

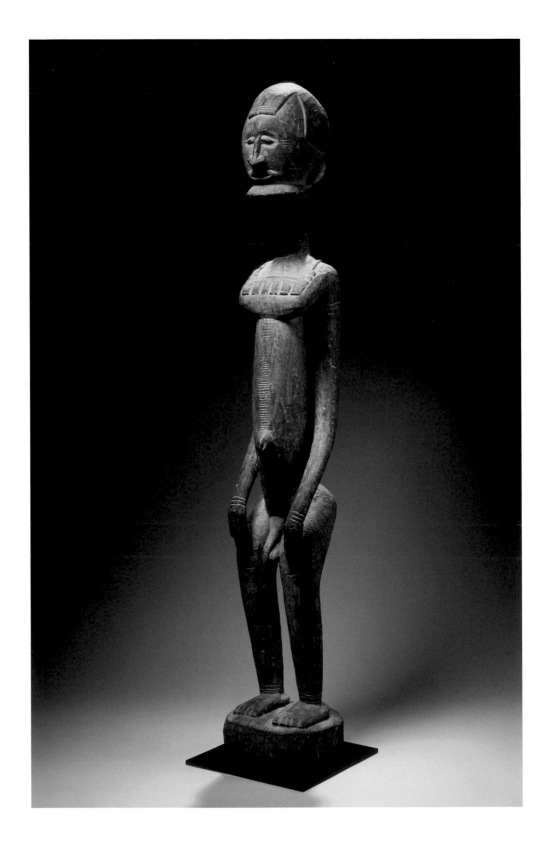

Dogon Artist
Mali

Male Figure, ca. 1875–1950
Wood, 43 inches high
Fred and Rita Richman Collection, 2004.138

In Dogon communities, male and female figurative sculptures were placed on ancestral altars to provide a point of contact between generations. This imposing figure's sharply chiseled beard indicates that he is an elder. In Dogon communities, elders are honored for their knowledge and for the depth of their life experience. Each community has a high priest, or *Hogon,* an elder male who is the supreme religious and political leader, responsible for agriculture and ensuring the earth's renewal. —Carol A. Thompson

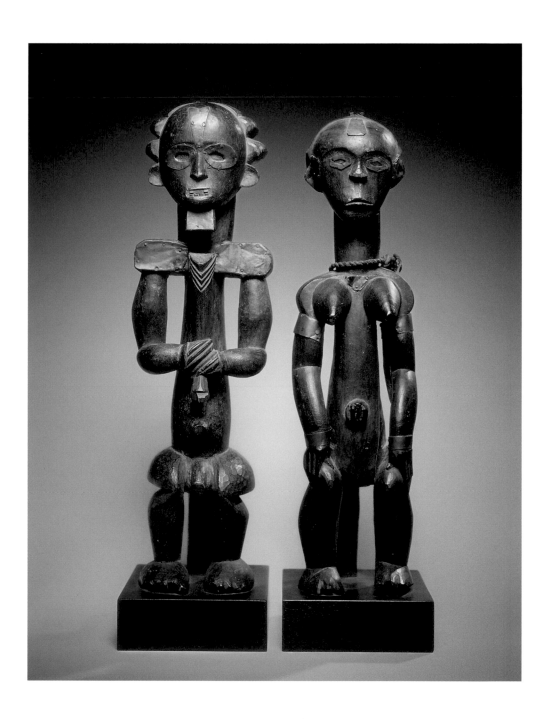

Fang Artist
Cameroon

Male and Female Reliquary Guardian Figures, nineteenth century
Wood, ancestral relics, brass, and glass,
18¼ inches high
Fred and Rita Richman Collection,
2002.291.1–2

THESE FANG SCULPTURES from the dense equatorial forest region of central Africa once sat on cylindrical bark boxes. The boxes stored a family's ancestral relics and the sculptures protected the contents. As sentinels, their posture is upright, frontal, and symmetrical; they are alert and at attention. Such sculptures were often carved in pairs, but it is unusual to find two figures still united.

Fang artists created a sense of vitality through an interplay of opposites—vertical and horizontal, solid and void, concave and convex. Fang stylistic conventions dictated that a sculpture's torso be elongated, legs compressed, and head disproportionately large to resemble both the foreheads of newborns and ancestral skulls. The harmonious contours of reliquary guardian figures convey a sense of tranquility highly valued in both art and life in Fang culture. The boldly geometric forms of such figures inspired artists of early twentieth-century Paris, including Henri Matisse, André Derain, and Constantin Brancusi. —Carol A. Thompson

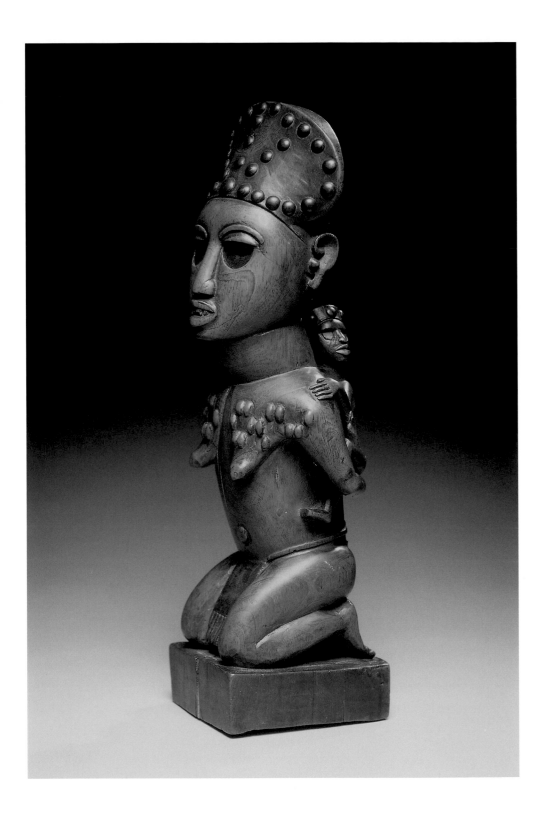

Kongo Artist
Democratic Republic of the Congo, Republic of the Congo, or Angola

Mother and Child Figure, nineteenth century
Wood, brass tacks, and glass, 12¾ inches high
Fred and Rita Richman Collection, 2002.293

THIS SCULPTURE MAY HAVE BEEN USED within the context of *Mpemba,* an organization that is concerned with fertility and the treatment of infertility, founded by a famous Kongo mid-wife. The female figure's studded cap, chiseled teeth, and scarification are indicators of aristo-cratic status. Both the brass tacks and the glass eyes are imported. The light-reflecting glass is associated with an ability to see into invisible spiritual and ancestral realms.

—Carol A. Thompson

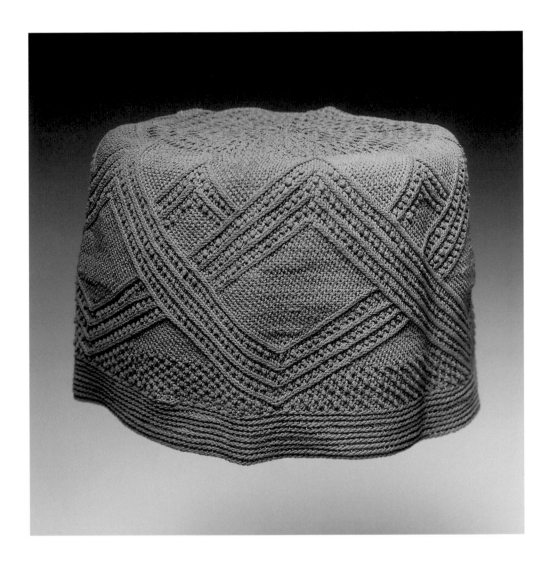

Kongo Artist

Democratic Republic of the Congo, Republic of the Congo, or Angola

Royal Hat (Mpu), nineteenth century
Woven fiber, 3⅞ × 8⅞ inches
Gift of Mrs. Pauline Lathrop Shomler,
1982.277

MADE OF KNOTTED RAFFIA or pineapple-leaf fiber, hats like this one were worn by Kongo kings, chiefs, and noblewomen throughout the coastal region of central Africa, where the Kongo Kingdom once flourished and where countless people were enslaved. Some scholars estimate that forty percent of all Africans in the Americas descend from ancestors from Kongo and neighboring regions. First encountered near the end of the 1400s by the Portuguese, the Kongo Kingdom at the height of its expansion extended across a region that is now part of Angola, Democratic Republic of the Congo, and Republic of the Congo.

The finely detailed geometric patterns of this hat are like those woven into the beautiful velvet-like raffia textiles formerly used as a form of currency throughout the Kongo kingdom. Similar patterns adorned the raffia mats used in the house construction of Kongo royalty. The geometric patterns of Kongo hats, textiles, and mats were associated with the maze-like layout of the royal palace and streets of the capital. People adorned their bodies with similar geometric patterns in the form of elaborate scarification. —Carol A. Thompson

Kota Artist
Gabon

Reliquary Guardian Figure, nineteenth century
Wood, brass, and bone, 11¾ inches high
Fred and Rita Richman Collection, 2002.292

WITH INTENSE, VIGILANT EYES and a brilliant metallic surface, this sculpture has a startling presence. The flashing brightness of the brass honors ancestors through a display of wealth. This sculpture was created to protect the relics of important ancestral leaders and once stood over a bundle of sacred remains—including skulls, bones, and ritually charged medicines—enclosed in a basket. Grouped together, figures like this one guarded all of the relics of a village. Stored in a small house accessible to only a few responsible individuals, reliquary bundles were used to teach youths about the achievements of their ancestors. —Carol A. Thompson

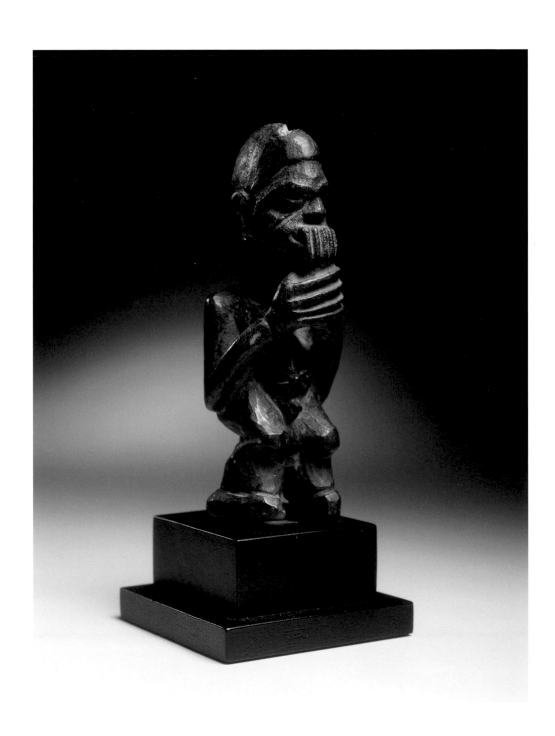

Lobi Artist
Burkina Faso or Ivory Coast

Seated Figure, nineteenth century
Wood, 6¼ inches high
Purchase with funds from Jane Fahey and
Emmet Bondurant in memory of Alan Brandt,
2003.35

A MINIATURE MASTERPIECE, THIS SCULPTURE might be seen as the Lobi version of Auguste Rodin's *The Thinker*. Its contemplative posture and the despairing gesture of its large hands give it emotional weight. Known by the Lobi people as *bateba*, sculptures like this one were carved to act as intermediaries between people and protective spirits called *thila*. The sculptures are considered animate. *Bateba* carry out the orders of *thila*, protecting individuals and communities from harm. —Carol A. Thompson

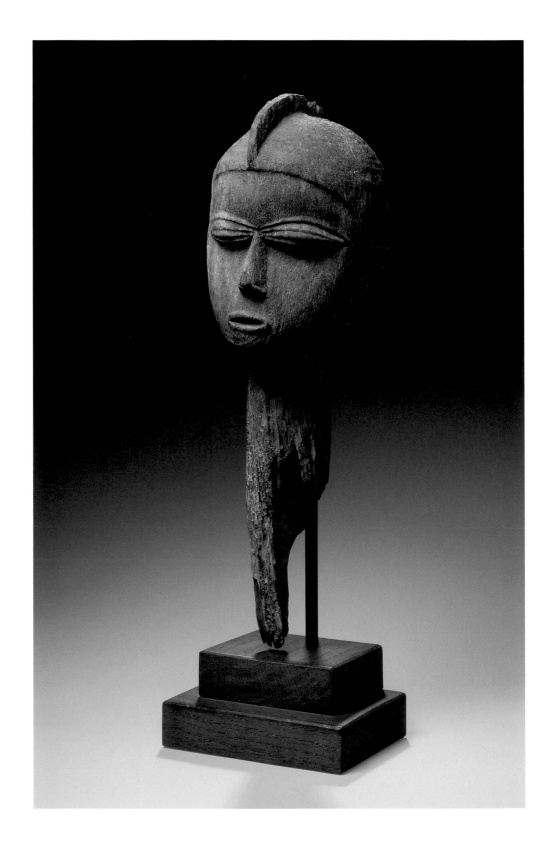

Lobi Artist
Burkina Faso or Ivory Coast

Head, nineteenth century
Wood, 16 inches high
Fred and Rita Richman Collection, 2004.139

THIS EXCEPTIONALLY BEAUTIFUL HEAD, with its elegant curvilinear forms and pure lines, is nearly life-size. The sculpture's deeply weathered surface suggests that it once lived in the open air. Carved at the suggestion of a diviner as a remedy for sickness or misfortune, the sculpture represents a protective spirit. It probably once stood on a household or market altar.
—Carol A. Thompson

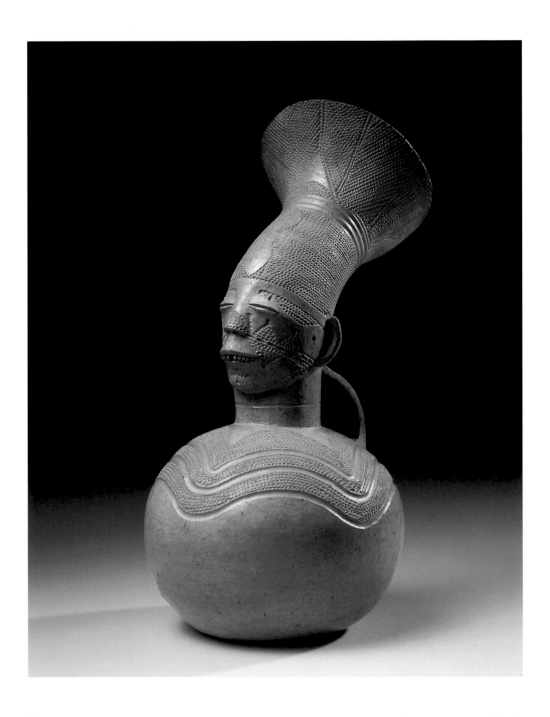

Mangbetu Artist
Democratic Republic of the Congo

Vessel, ca. 1910
Terra-cotta with white buff patina,
12½ inches high
Purchase in honor of Deborah Wagner,
President of the Members Guild, 2002–2003,
2003.36

THIS INTRICATELY DETAILED ANTHROPOMORPHIC VESSEL was made as a prestige gift. Its elegant form depicts the hairstyle worn by royal women of the Mangbetu Kingdom in central Africa at the turn of the twentieth century. The 1870 book *The Heart of Africa,* written by the German botanist Georg Schweinfurth (the first European to visit the region), sparked European fascination with Mangbetu culture.

In the 1920s Queen Elizabeth of Belgium visited central Africa and photographed a woman of the Mangbetu court, whose portrait then circulated on a Belgian postage stamp. Images of royal Mangbetu women proliferated throughout the twenties and thirties, inspiring clay and bronze sculptures by artists such as Malvina Hoffman and Victor Schreckengost, as well as Art Deco–style bookends and even car hood ornaments. The image of a royal Mangbetu woman became an important icon for such Harlem Renaissance artists as Aaron Douglas, and its influence extends to the work of contemporary artists Carrie Mae Weems and Magdalene Odundo. —Carol A. Thompson

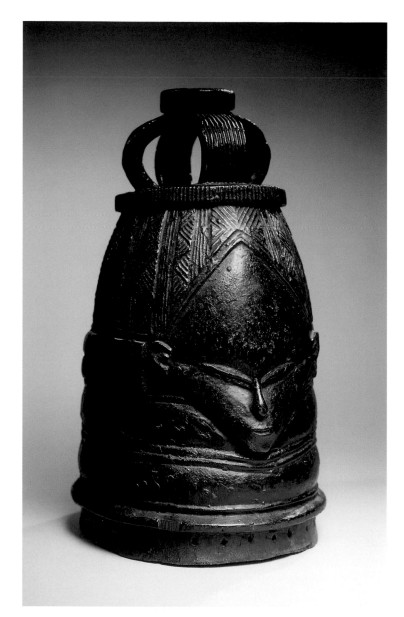
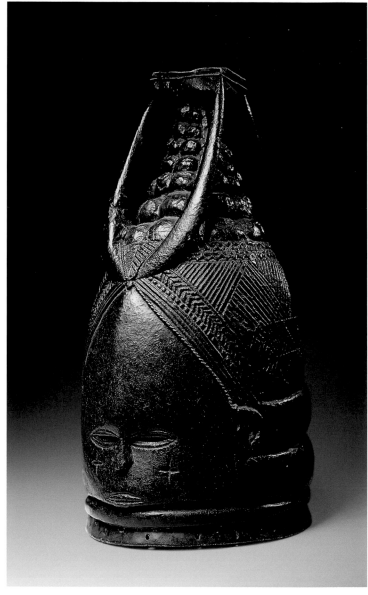

Mende Artists

Sierra Leone

Two Helmet Masks, ca. 1875–1950
Wood, 14¾ and 16¾ inches
Fred and Rita Richman Collection, 72.40.22
Gift of Dr. Milton Mazo and Billy K. Poole in
honor of Carol Thompson, Richman Family
Foundation Curator of African Art, 2002.324

IN MENDE COMMUNITIES OF SIERRA LEONE both men and women use masks. Helmet masks called *sowei* are worn by members of the exclusively female *Sande* society, a politically powerful organization, to teach young girls how to be good wives, mothers, and community members. *Sowei* masks present Mende ideals of feminine beauty, and the most appealing masks are considered irresistibly attractive and charismatic.

Both masks have richly textured, lustrous black surfaces, ringed necks, and elaborate coiffures. One wears a British-style royal crown with rows of Islamic amulets carved at its base. The other has four horns surmounted by a metal amulet.

Sowei masks each have their own distinctive individual characters and personal names. Names are chosen by spirits and revealed to people through dreams. When a mask performs, its personal name is called. During the colonial era, one mask became the leader of all other masks, nicknamed *Saji Wulei* or "Sergeant Wulei" by a European who observed her strong, assertive spirit. —Carol A. Thompson

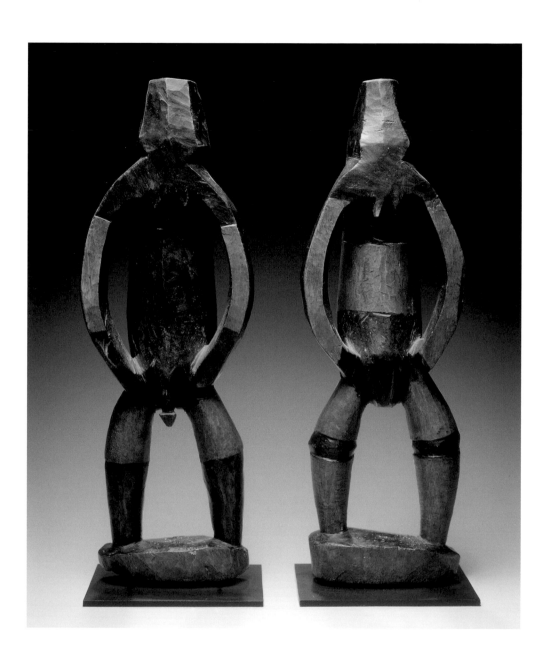

Metoko Artist
Democratic Republic of the Congo

Male and Female Figures, nineteenth century
Wood, 16 inches high
Fred and Rita Richman Collection, 2002.308.1–2

IN METOKO SOCIETIES, PAIRED MALE AND FEMALE FIGURES representing husband and wife were used in initiation rites to confer the status of *kasimbi. Kasimbi* was one of the highest ranks within the association called Bukota, whose large membership included both men and women. The paired figures served a wide variety of purposes: they provided behavioral models, encouraged healing, and promoted peace. —Carol A. Thompson

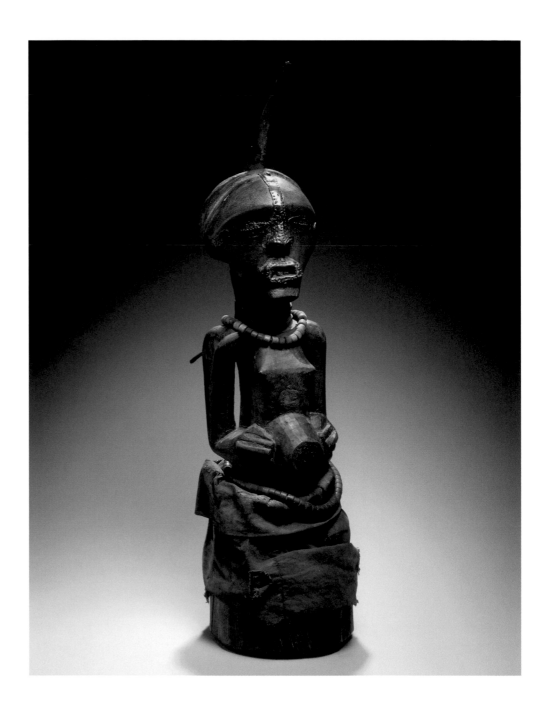

Songye Artist
Democratic Republic of the Congo

Nkishi, ca. 1875–1950
Wood, horn, metal, beads, and pigment,
29 inches high
Fred and Rita Richman Collection, 2004.164

FORMIDABLE LARGE-SCALE FIGURATIVE SCULPTURES known as *mankishi* portray the physical strength, social rank, and mystical power of Songye cultural heroes including chiefs, hunters, blacksmiths, and *banganga* (traditional priests). The sculptures, created to promote the health and well-being of entire communities, were conceived as containers for *bishimba,* secret formulae assembled by the *banganga* to achieve specific goals, drawing on the power of ancestral spirits. Without these substances, the sculptures were considered just pieces of wood without purpose. In this sculpture *bishimba* is contained within the horn inserted in the crown of the head and inside cavities capped with circles of red and blue on the torso. Each *nkishi* had its own power, identity, and individual reputation, often named after a renowned chief. Sculptures became known for their accomplishments, closely tied to the lives of the *banganga* who were their expert owners and operators. This figure wears chiefly regalia, including a full-length raffia skirt and two strings of large beads. Copper appliqué attached to the mouth, nose, eyes, and forehead protected the community against lightning. —Carol A. Thompson

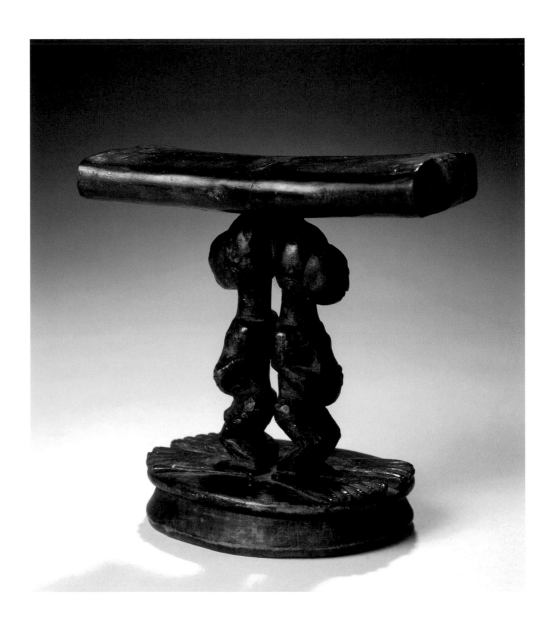

Nsapo-Beneki Artist

Southwest Songye Region, Democratic Republic of the Congo

Neckrest, nineteenth century
Wood, 7 inches high
Fred and Rita Richman Collection, 2002.309

THIS NECKREST WAS CARVED by an artist known to African art collectors as the "Master of Beneki." Though this artist's name and those of his apprentices have not been recorded, they worked among a subgroup of the Songye people during a time of great social upheaval. In 1888, the Nsapo (who had been led by a chief named Nsapo-Sap) were pushed from their homeland by Arab, European, and local political forces. They traveled in a caravan with Paul la Marinelle and settled among the neighboring Lulua people. In 1925 they moved toward the Tshibungu River.

Neckrests carved by the Master of Beneki and his apprentices reached Europe before 1900. Today neckrests made by these artists are found in museums in Italy, Belgium, and the United States. All share signature stylistic features, especially extravagantly large feet. In Songye art as well as in the art of the neighboring Luba, Kuba, and Shilele, prominent feet are a symbol of power. This remarkable motif has profound social significance: it refers to the confiscation of territory in warfare. The High's example is supported by not one, but two back-to-back figures, both with huge feet. —Carol A. Thompson

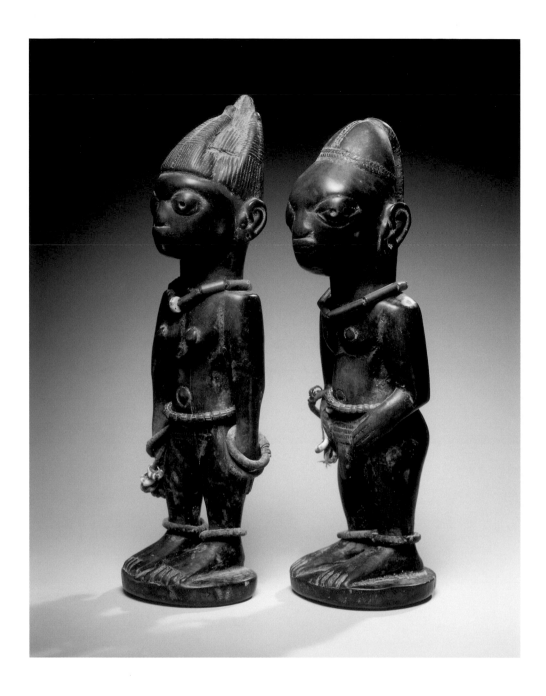

Yoruba Artist

Nigeria

Pair of Ere Ibeji, nineteenth century
Wood, pigment, beads, and cowrie shells,
14 and 15 inches high
Fred and Rita Richman Collection,
2002.287.1–2

THE SMOOTH, WORN SURFACES of these twin figures, with bodies rubbed red and heads blue, show that they have been cared for devotedly. *Ere ibeji* represent deceased twin children. The Yoruba believe twins share one soul. When a twin dies, a figure is carved to please the spirit of the deceased. If neglected, its spirit might become offended or feel abandoned and invite the twin sibling to leave the material world to join it in "the beyond."

In Yoruba communities, twins—more common than anywhere else in the world—are much admired and considered to have special attributes. The wide-open eyes, calm expressions, and upright postures of these two figures communicate spiritual alertness. The colors of the anklet, necklace, and waist beads indicate devotion to particular Yoruba deities (*orisha*).

These figures' elaborate coiffures are rubbed with a powdered dye called Rickett's bluing, used by the British during the colonial period to whiten laundry. The use of Rickett's to give color to sculptures is an example of artistic innovation in Africa, evidence of how during the colonial era Africans inverted the rules and foreign customs of Europeans to suit their own needs. —Carol A. Thompson

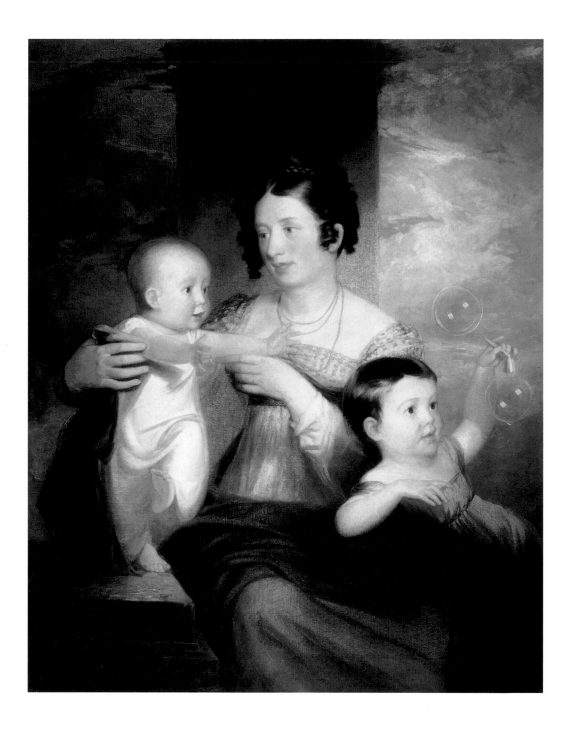

Samuel F. B. Morse
American, 1791–1872

Portrait of Mrs. Morse and Two Children,
1824
Oil on canvas, 43¼ × 34 inches
Gift of Sandra Morse Hamilton and Patricia
Morse Sawyer in memory of Bleecker,
Patricia, and Bleecker Morse, Jr., and through
prior gift of Margaret and John L. Hoffman,
2004.58

SAMUEL MORSE IS CHIEFLY REMEMBERED today as an inventor—specifically for the development of the telegraph. In the early nineteenth century, however, he was regarded as New York's leading portrait painter. This tender, elegant painting of his wife and children, descended through the family, belongs to a genre of portraits that first became popular during the mid-eighteenth century. By giving new emphasis to the maternal role in family life—an influence that increasingly challenged the father's authority at home—as well as to the positive effects of play, these portraits reveal changing ideas about childrearing promoted by such Enlightenment thinkers as Jean-Jacques Rousseau. —Sylvia Yount

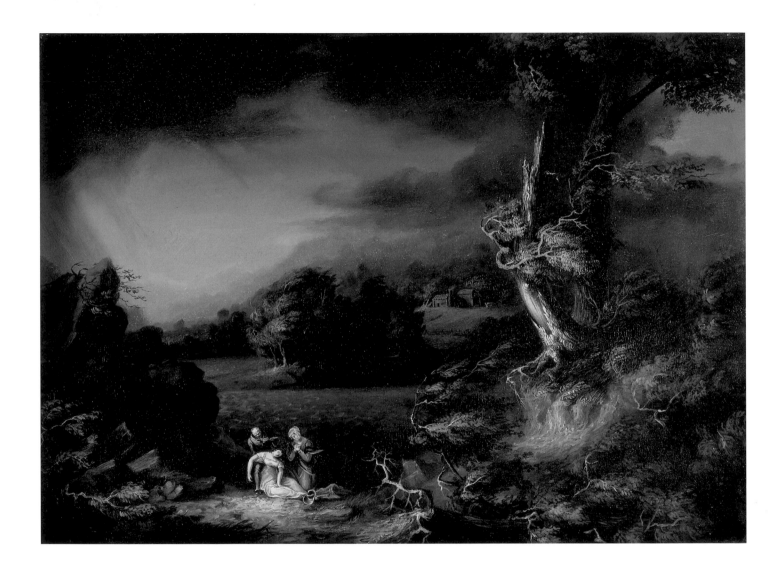

Thomas Cole

American, born England, 1801–1848

The Tempest, ca. 1826
Oil on panel, 18¾ × 26 inches
Purchase with bequest of Clarissa Hale
Poteat, 1987.100

THE STORM THAT RAGES through this early painting by Thomas Cole is the natural counterpart to the overwrought emotions displayed by the swooning woman in white. The melodramatic subject was probably inspired by a short story entitled "Emma Moreton," which Cole had written and published in the *Saturday Evening Post* in 1825. His emphasis on the "sublime and beautiful"—dimensions of nature thought to parallel human emotions—was a popular convention of Anglo-American painting.

An Englishman who immigrated to New York in the 1820s, Cole is credited with originating the romanticized realism of the Hudson River School, a group of artists whose works are characterized by precise details and panoramic vistas. He is best known for his striking depictions of the upper Hudson River Valley and the Catskill Mountains, works inspired more by nature than imagination. —Sylvia Yount

34

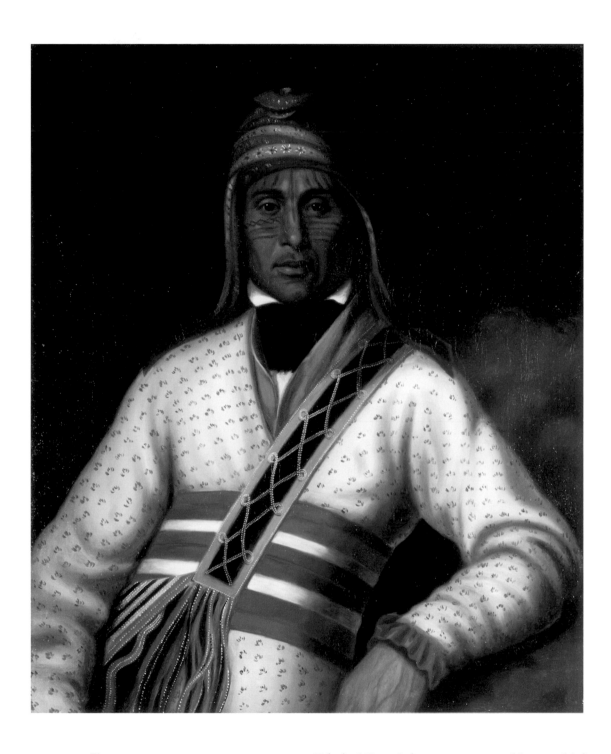

Henry Inman
American, 1801–1846

Yoholo-Micco, 1832–1833
Oil on canvas, 30⅜ × 25⁷⁄₁₆ inches
Anonymous gift, 1984.176

THIS CEREMONIAL PORTRAIT DEPICTS Yoholo-Micco (whose name means king or chief of royal blood), a Creek leader described by his contemporaries as a sincere and learned man. In 1825 Yoholo-Micco headed the Creek delegation to Washington, D.C., that challenged a fraudulent treaty with the federal government. The treaty required the Creek nation to cede most of its southeastern territory and relocate to western lands. By negotiating a more favorable treaty, Yoholo-Micco and his delegation won back the Creek territory in Alabama, but were forced to sell most of their lands in Georgia.

Inman, a leading mid-nineteenth-century portraitist, in 1831 received the commission to paint more than 100 images of Native Americans for use in the production of a print portfolio. Copied after the original oils of Charles Bird King (1785–1862)—nearly all of which were destroyed in an 1856 fire—Inman's paintings are an important visual record of early native leaders. —Sylvia Yount

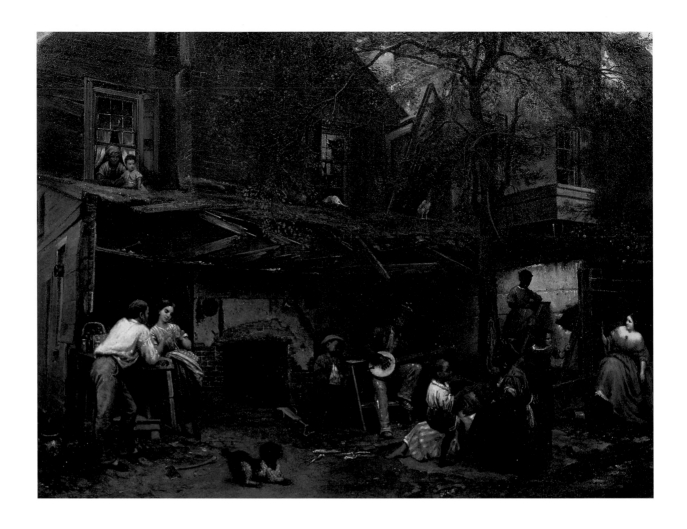

Eastman Johnson
American, 1824–1906

Negro Life at the South (Life in the South),
ca. 1870
Oil on canvas, 18¼ × 24⅛ inches
Purchase with funds from the Fine Art
Collectors with leadership gifts from
Mr. and Mrs. Henry Schwob, Mr. and
Mrs. Terry Stent, Mr. and Mrs. Austin P.
Kelley, Mr. and Mrs. John L. Huber, Dr. and
Mrs. Gerald M. Stapleton, Mr. and Mrs. Noel
Wadsworth, and the Collections Council
Acquisition Fund, and funds from the Winter
Family Foundation, and through prior
acquisitions, 1997.187

THE ORIGINAL VERSION OF THIS CLOSELY OBSERVED SCENE of urban slave life was painted on the eve of the Civil War as slave owners and abolitionists debated the issue of emancipation. Contemporary critics were divided on the interpretation of the painting. Those opposing slavery saw it as a symbol of a decaying and morally bankrupt system. Those supporting slavery believed Johnson had portrayed the black figures as contented. The early, popular association of the painting with Stephen Foster's sentimental minstrel song "My Old Kentucky Home, Good Night!" invested the work with an aura of nostalgia, evoking a myth of carefree, bygone days.

Johnson's theatrically composed scene with its layered narrative is set not on a generic Southern plantation, but in a specific place: the interior yard behind a tavern in Washington, D.C., not far from the artist's home. Although slaves were never a majority of the District of Columbia's population, their presence in the nation's "shared" capital was particularly controversial. By exposing this hidden side of the city, Johnson, whose antislavery sympathies became more pronounced after the start of the Civil War, entered the public debate surrounding slavery in America. —Sylvia Yount

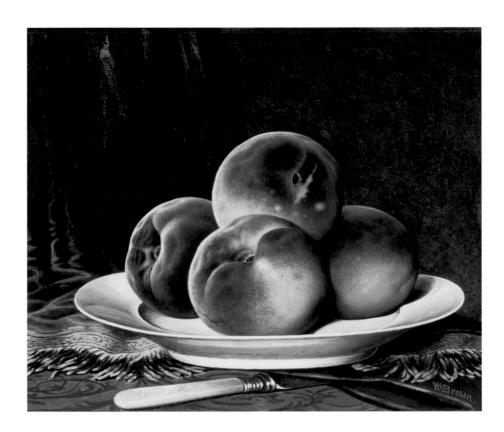

William Mason Brown
American, 1828–1898

Peaches on a White Plate, ca. 1880
Gouache, oil, and tempera on paper,
glued to ragboard, mounted to panel,
8⁹⁄₁₆ × 10⅜ inches
Purchased with funds from the Phoenix
Society, 1982.85

THE CRISP FORMS, VIVID COLORS, and carefully balanced compositions of still-life paintings like this one made William Mason Brown's works ideal candidates for reproduction. Brown was active in the new field of chromolithography, a reproductive process that generated vibrantly colored prints. These reproductions were intended for middle-class consumers who could not afford an original work of art. Currier and Ives, the leading nineteenth-century disseminator of popular American imagery, published the first chromolithograph of Brown's work in 1868, helping the artist achieve national success. —Sylvia Yount

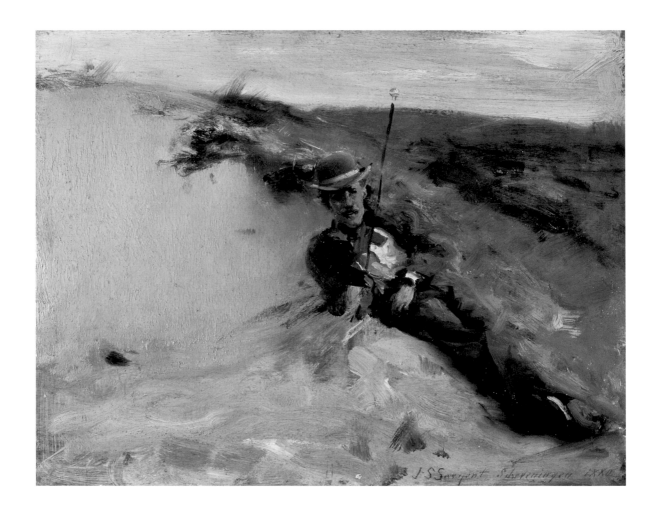

John Singer Sargent
American, 1856–1925

Portrait of Ralph Curtis on the Beach at Scheveningen, 1880
Oil on panel, 10½ × 13³⁄₁₆ inches
Gift of the Walter Clay Hill and Family Foundation, 73.3

ONE OF THE LEADING EXPATRIATE FIGURE PAINTERS of the late nineteenth century, Sargent was technically still a student when he produced this vibrant work. Grains of sand embedded in its surface suggest that the painting was executed on the spot, at the Dutch beach resort of Scheveningen. Sargent and his cousin Ralph Curtis, who was also an artist, were in Holland to study the portraits of Frans Hals, the seventeenth-century master who exercised a profound influence on Sargent's style. This small, vivid sketch of Curtis in repose—so different in spirit from the full-length, formal portraits for which Sargent is best known—represents one of the artist's favorite themes: casual portraits of friends and family painted in the open air.
—Sylvia Yount

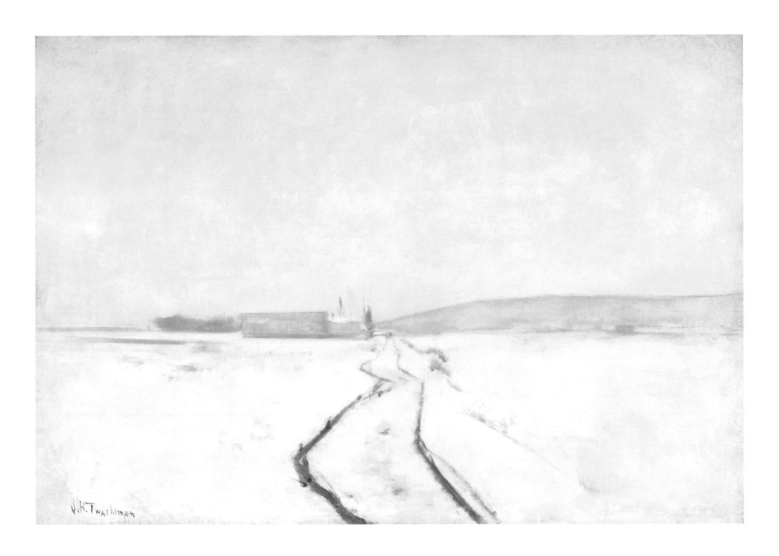

John Henry Twachtman
American, 1853–1902

Along the River, Winter, ca. 1889
Oil on canvas, 15⅛ × 21¹¹⁄₁₆ inches
J. J. Haverty Collection, 49.28

TWACHTMAN WAS A FOUNDING MEMBER of the leading group of American Impressionists working at the turn of the twentieth century. Dubbed "The Ten" by the press, the company included, besides Twachtman, Frank Benson, Joseph DeCamp, Thomas Wilmer Dewing, Childe Hassam, Willard Metcalf, Robert Reid, Edward Simmons, Edmund Tarbell, and J. Alden Weir. Though not all pure Impressionists, The Ten were united in a desire to exhibit their somewhat complementary art in intimate and selective company. Twachtman, unquestionably the most experimental of the group, is acclaimed for his shimmering marine paintings and moody winter landscapes, such as this image.

In its formal experimentation and sophisticated use of atmospheric space, *Along the River, Winter* teeters on the edge of abstraction. The scene is deliberately ambiguous. The jagged tracks in the snow may lead to an outlying building on the artist's Connecticut farm, but the lack of specificity is the point. Twachtman seems more interested in expressing the silent desolation of winter than in painting a legible landscape. —Sylvia Yount

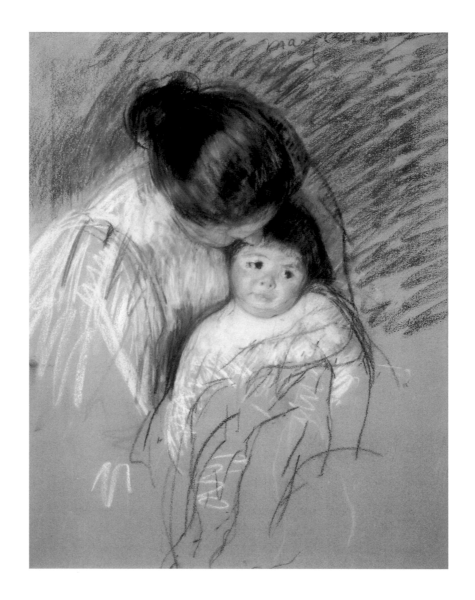

Mary Cassatt
American, 1844–1926

Sketch of a Mother Looking Down at Thomas, ca. 1893
Pastel on brown paper, 27 × 22½ inches
Promised gift of Jacqueline and Matt Friedlander, EL44.1985

A TALENTED PAINTER, PASTELLIST, AND PRINTMAKER, Cassatt occupies a unique place in the history of American art. Her early alliance with the Impressionists—she was the only American to exhibit with the group—led to her reputation in the early part of the twentieth century as one of America's major artists. The intimate engagement of mother and child is the theme most closely identified with Cassatt. She portrayed this particular pair—about whom we know very little—in six pastels, adopting her French colleagues' practice of working in a series. The sketchy quality of this work, with its staccato strokes of pastel crayon and fresh immediacy, make it the most impressionistic of the group; the others are more resolved in form and color. —Sylvia Yount

Albert Herter
American, 1871–1950

Portrait of Bessie (Miss Elizabeth Newton),
1892
Oil on canvas, 59 × 32 inches
Purchase with funds from the Margaret and
Terry Stent Endowment for the Acquisition
of American Art and High Museum of Art
Enhancement Fund, 2000.162

THIS ELEGANT PORTRAIT OF HERTER'S CHILDHOOD friend is a self-conscious homage to James McNeill Whistler, the expatriate artist whose style and art-for-art's-sake philosophy informed the work of a generation of Americans. While the sitter's pose suggests the iconic *Arrangement in Grey and Black, No. 1* (better known as Whistler's Mother), the painting's pale color scheme and suggestive props recall *Symphony in White, No. 1: The White Girl*. Such creative composites of Whistler's imagery were popular among American artists at the turn of the century.

Best known for his portraits of upper-class New Yorkers, Herter began as a painter and illustrator but later moved into decorative arts. The founder of Herter Looms, a firm specializing in elegant textiles and tapestries based on his designs, he was also heir to the leading cabinet-making and interior-decorating firm of the Aesthetic Age, Herter Brothers. —Sylvia Yount

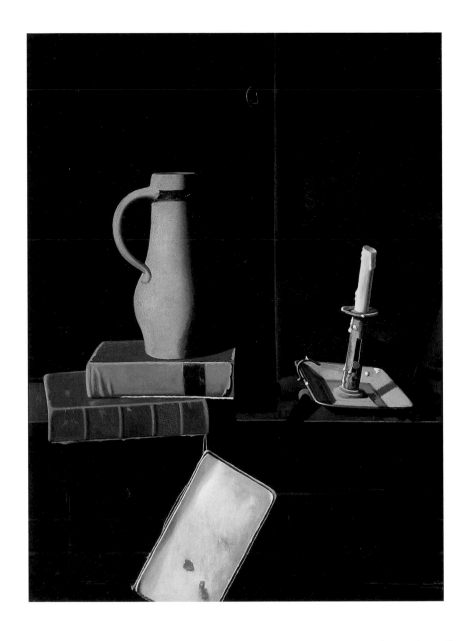

John Frederick Peto
American, 1854–1907

Jug, Books, and Candle on a Cupboard Shelf, ca. 1890
Oil on canvas, 30¼ × 22⅛ inches
Gift of Julie and Arthur Montgomery, 1980.60

THIS TABLETOP COMPOSITION of a simple earthenware jug, a burned candle, and a few tattered books evokes the retrospective mood that pervaded American culture at the end of the nineteenth century. The objects were all favorite motifs of Peto, a close friend and colleague of William Michael Harnett, whose work is also represented in the High's collection. Peto always considered Harnett's art "the standard of perfection in still life" and modeled his own trompe l'oeil (fool-the-eye) paintings on the older artist's illusionism. In fact, until the mid-twentieth century, works by the two artists were often confused. Some unscrupulous dealers even signed Peto's pictures with Harnett's name, passing them off as works by the better-known artist. Today, the hallmarks of Peto's style—painterly treatment of humble objects set in a spare but dramatically lit space—are widely recognized, and all are evident in this painting. —Sylvia Yount

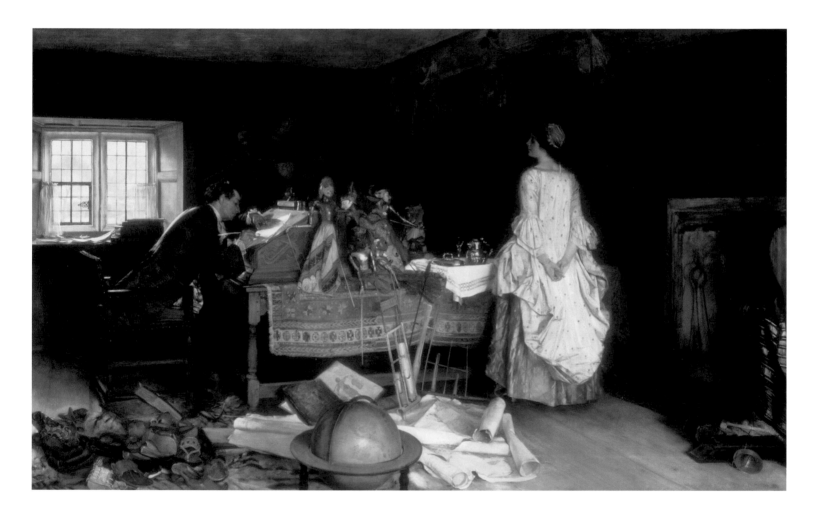

Francis Davis Millet
American, 1846–1912

The Expansionist (The Traveled Man), 1899
Oil on canvas laid on board, 42 × 68 inches
Purchase with funds from the Margaret and
Terry Stent Endowment for the Acquisition of
American Art, with funds from Alfred Austell
Thornton in memory of Leila Austell Thornton
and Albert Edward Thornton, Sr., and Sarah
Miller Venable and William Hoyt Venable,
general funds, and through prior acquisitions
from Mr. and Mrs. George E. Missbach, Sr.,
2000.199

THE EXPANSIONIST, ALSO KNOWN AS *The Traveled Man,* was painted soon after Millet returned from extensive travel in East Asia and the Philippines, where he had served as a newspaper correspondent during the Spanish-American War. Set in the Elizabethan parlor of his English home, the painting epitomizes the interest in "bygone days" that characterized much art of this time. The underlying association of the spoils of travel (many of which can be seen in this tableau) with the spoils of war gave the image topicality at the turn of the twentieth century, when the United States was grappling with its new international power and imperialist ambitions. Regarded as the masterpiece of Millet's mature career, *The Expansionist* was critically acclaimed at several international exhibitions. —Sylvia Yount

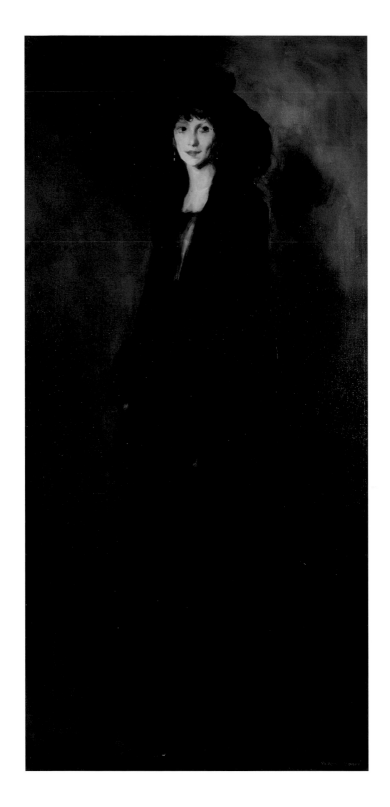

Robert Henri
American, 1865–1929

Lady in Black Velvet (Portrait of Eulabee Dix Becker), 1911
Oil on canvas, 77½ × 36¹⁵⁄₁₆ inches
Gift in memory of Dr. Thomas P. Hinman
through exchange and general funds, 73.55

HENRI WAS THE DE FACTO LEADER of the so-called Ashcan artists—a group of urban realists that included William Glackens, George Luks, Everett Shinn, and John Sloan—and an influential teacher who championed freedom and experimentation.

This portrait of the artist Eulabee Dix is one of several that Henri painted of women dressed entirely in black or white. Limiting his palette and pictorial strategies, the artist portrayed a confident New Woman in a modern manner, using vigorous brushwork to convey his sitter's vibrant personality. The harmony of subject and style makes this one of Henri's strongest portraits. —Sylvia Yount

44

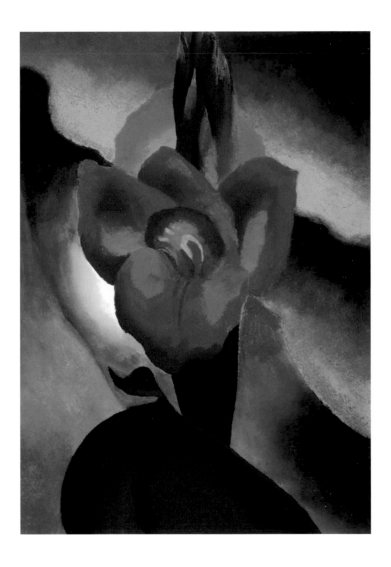

Georgia O'Keeffe
American, 1887–1986

Red Canna, 1919
Oil on board, 13 × 9½ inches
Purchase with funds from the Fine Arts
Collectors and the 20th Century Art
Acquisition Fund and gift of the Pollitzer
Family in honor of Anita Pollitzer, to whom
the artist originally gave this work, 1996.18

ONE OF THE MOST STYLISTICALLY INDEPENDENT of the American modernists, O'Keeffe became a member of the New York avant-garde almost inadvertently. In 1916 her friend Anita Pollitzer—the original owner of this painting—showed a group of O'Keeffe's experimental drawings to the photographer and tastemaker Alfred Stieglitz. Without O'Keeffe's knowledge, he exhibited them at his 291 gallery. The future wife and husband first met when O'Keeffe traveled to New York to ask Stieglitz to remove her work from public view. Unsurprisingly, the iron-willed dealer prevailed and one year later he gave O'Keeffe her first solo show at the gallery. By the mid-1920s, she had established herself as a distinctive leader in New York's progressive art circles.

O'Keeffe's personally expressive imagery was fundamentally rooted in nature, and flowers remained a favorite subject throughout her career. Soon after her romantic relationship with Stieglitz began in 1918, O'Keeffe accompanied him on trips to his parents' summer home on Lake George, New York. On her first visit, she was attracted to the profusion of canna lilies that bloomed in late summer. The sensuous curves and vibrant colors of the flower inspired the artist to begin a series of paintings that included this work. Such images were viewed by Stieglitz and other contemporary critics as revealing a new "gloriously female" language—an interpretation that defined O'Keeffe's art throughout her life, but one which she never fully embraced. —Sylvia Yount

Joseph Rodefer DeCamp
American, 1858–1923

The Blue Mandarin Coat (The Blue Kimono), 1922
Oil on canvas, 43 × 37¼ inches
Purchase with bequest of William Gordy, funds from Alfred Austell Thornton in memory of Leila Austell Thornton and Albert Edward Thornton, Sr., and Sarah Miller Venable and William Hoyt Venable, the Fine Art Collectors with leadership gifts from Mr. and Mrs. Terry Stent, Mrs. Austin P. Kelley, and Mr. and Mrs. Allen P. McDaniel, Fay and Barrett Howell Fund, and through prior acquisitions, 2000.1

DeCAMP WAS A MEMBER of the so-called Boston School, a group of artists who at the turn of the twentieth century developed a genteel variant of Impressionism inspired by the culture of their city. While DeCamp produced the occasional light-filled, freely brushed landscape, he made his reputation as a portraitist of Boston's upper class. *The Blue Mandarin Coat,* DeCamp's last work, marks a distinct departure in his art. The dramatically lit model with her theatrical pose and costume appears lost in thought, creating a tension between public performance and private introspection. The melancholic tone of the image may suggest DeCamp's own retrospective mood toward the end of his life. —Sylvia Yount

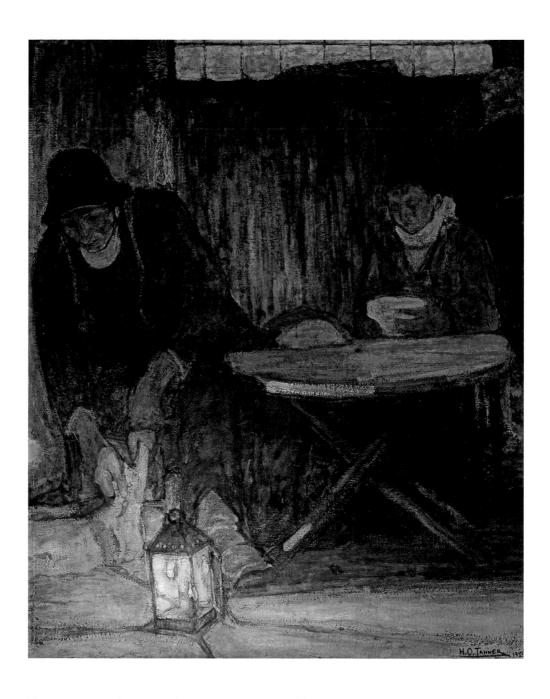

Henry Ossawa Tanner
American, 1859–1937

Etaples Fisher Folk, 1923
Tempera and oil on canvas,
47⁵⁄₁₆ × 38⁵⁄₁₆ inches
J. J. Haverty Collection, 36.16

THE LEADING AFRICAN AMERICAN ARTIST of his day, Tanner declared in 1891 that he could "not fight prejudice and paint at the same time" and moved to France. (Two years earlier, he had opened a photography gallery and "art room" in Atlanta, but the venture did not succeed.) *Etaples Fisher Folk* was drawn from daily life in the French village where Tanner eventually made his home.

The association of European peasants with a simpler, more spiritual existence was a long-standing artistic theme. Tanner turned to the subject at a difficult time in his life—he was unwell and depressed after his wife's death and his son's mental collapse—suggesting a personal, redemptive meaning for this work. The lantern may function not only as the light source in the painting, but also as a sign of hope in a time of private despair. —Sylvia Yount

Joseph Stella
American, born Italy, 1877–1946

Purissima, 1927
Oil on canvas, 76 × 57 inches
Purchase with funds from Harriet and
Elliott Goldstein and High Museum of
Art Enhancement Fund, 2000.206

THE ITALIAN-BORN STELLA immigrated to America in his teens and trained in various New York art schools. Through his association with the modernist tastemaker Alfred Stieglitz, he quickly established a reputation as one of the most innovative of the "new generation" of artists, exploring dynamic urban culture as well as the quieter symbolism of nature.

Stella's Madonna paintings, with their stylized flora and fauna, were executed during the twenties, a decade of extensive European travel for the artist. Returning to his native land in 1922, Stella found inspiration in the revival of traditional Italian subjects and forms. It was during a later two-year sojourn in Italy that the artist produced *Purissima,* the largest of his Madonna pictures. Color was Stella's primary interest in such imagery, embodying his sensual impressions of the spiritual aspects of nature. These Madonnas—as much fertility symbols as Christian icons—reveal the artist's fascination with a pagan pantheism common to southern Italy, as well as with the mysticism of Catholic devotion. —Sylvia Yount

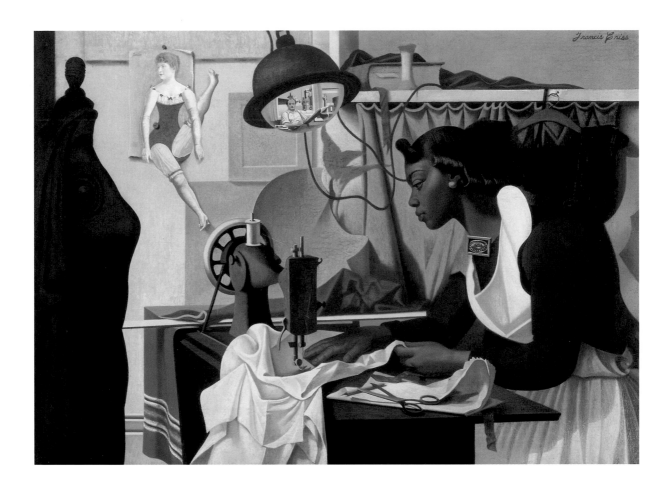

Francis Criss
American, born England, 1901–1973

Alma Sewing, ca. 1935
Oil on canvas, 33 × 45 inches
Purchase with funds from the Fine Arts
Collectors, Mr. and Mrs. Henry Schwob, the
Director's Circle, Mr. and Mrs. John L. Huber,
High Museum of Art Enhancement Fund,
Stephen and Linda Sessler, the J. J. Haverty
Fund, and through prior acquisitions,
2002.70

WIDELY ACCLAIMED DURING THE 1930S for his mix of Precisionism and Social Surrealism, Criss is less well known today. Born in London and raised in Philadelphia, he trained at the Pennsylvania Academy of the Fine Arts, the Barnes Foundation, and, after his permanent move to New York, the Art Students League.

Alma Sewing is Criss's most ambitious and striking work. The painting may be interpreted as both a quintessential 1930s image—in its celebration of the artist as worker—as well as a personal manifesto. Produced during Criss's employment with the New York City mural division of the Works Progress Administration, *Alma Sewing* refers to his artistic practice through a self-portrait cleverly positioned in the lower half of the seamstress's work lamp. While "Alma," the African American woman, with her beautifully delineated features and powerful presence, may be seen as the artist's model, Criss presents her as a skilled professional, surrounded by her own models—the mannequin and paper doll—and other tools of her trade. As a deeply felt presentation of quiet labor, the painting expresses Criss's philosophical view of himself as a "poet-artist who restructures reality." —Sylvia Yount

George L. K. Morris
American, 1905–1975

Concretion, 1936
Oil on canvas, 54 × 72 inches
Purchase in honor of Mrs. Rufus Chambers,
President of the Members Guild, 1971–1972,
72.15

BORN TO A WEALTHY NEW YORK FAMILY, Morris attended Yale University, where he studied art and literature. Upon graduation, he chose to pursue painting and entered the Art Students League of New York. Morris later sought training in Paris, working with the Cubist painter Fernand Léger. On his return to New York and through his art criticism and painting, Morris became one of the most active promoters of international modernism in America.

Concretion, which means a solidified mass, is exemplary of Morris's approach to Cubism, characterized by an elaborate manipulation of space and geometric forms. In 1936, the year he painted this work, Morris co-founded American Abstract Artists, an association that challenged the prominence of American scene painting—its realistic and native subject matter—and the related cultural nationalism of the period. —Sylvia Yount

Arshile Gorky

American, born Armenia, 1905–1948

Garden in Sochi, 1940–1941
Gouache on board, 21 × 27¾ inches
Purchase with bequest of C. Donald Belcher,
1977.50

BORN VOSDANIK ADOIAN IN ARMENIA, Gorky and his family fled their home following the 1916 invasion by the Turks. After living as a refugee for nearly four years, he immigrated to the United States and changed his name. In 1925 the artist moved to New York, where he began to experiment with a range of modernist painting styles.

Garden in Sochi is part of a breakthrough series of abstractions, informed by Cubism and Surrealism, which recall Gorky's father's garden in the Armenian village of Khorkom. Although Gorky left the village to attend school when he was only six years old, his romanticized memories of Khorkom inspired the colorful biomorphic shapes in this painting. Many of these abstracted forms recall objects from Gorky's childhood, such as the pointed slippers worn by his father and, in the center of the painting, the butterchurn used by his mother. Other forms represent elements of the landscape—on the left a magic blue rock revered by the villagers, at upper right a sacred poplar tree to which strips of clothing have been attached (an old Armenian custom). Fearing American ignorance of Armenian culture, Gorky often fabricated Russian origins for his work, in this case deliberately using Sochi, a popular resort town in Russia, in place of the little-known Khorkom. —Akela Reason

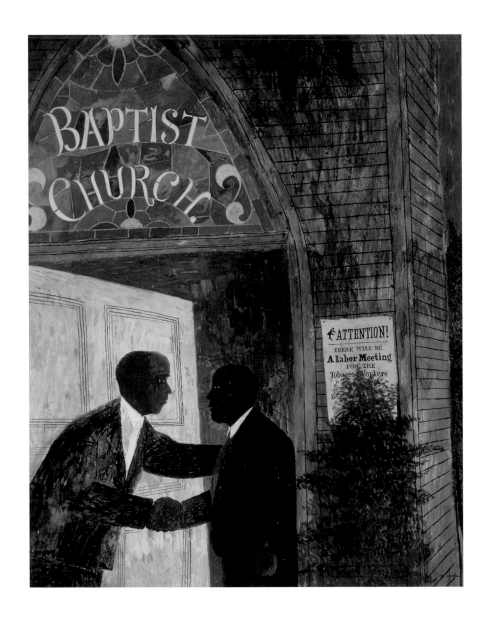

Ben Shahn

American, born Lithuania, 1898–1969

The Church is the Union Hall, 1946
Tempera on board, 20 × 16 inches
Purchase with funds from Sherri and Jess
Crawford, High Museum of Art Enhance-
ment Fund, the American Art Collectors,
Mr. and Mrs. Henry Schwob, and Mr. and
Mrs. John L. Huber, 2003.63

IN 1946, THE LEADING SOCIAL REALIST Ben Shahn received a commission from *Fortune* magazine to illustrate an article on organized labor in the South. As was the artist's practice, Shahn synthesized many visual sources for the project—from his 1930s photographic work to contemporary sketches executed as part of his on-site research. *The Church is the Union Hall,* which resonates with such lifelong concerns of the artist as class, race, and religion, appeared as a full-page color reproduction in the article. The painting marked a critical juncture for Shahn in its focus on workers' lives, suggesting his shift from what he called "social realism into a sort of personal realism."

Despite Shahn's "otherness"—he was a Jewish Russian émigré and northeastern liberal—his images of the American South reveal a keen understanding of its distinctive culture and values. *The Church is the Union Hall* represents black churchgoers in the tobacco-growing region of eastern North Carolina. While the artist often featured African Americans in his graphic work, a fully realized painting of the subject is rare, as are his temperas of Southern life. Shahn's vignette and title emphasize the role of the black church as a force for social change, while underlining the promise of fellowship and community offered by an organization of workers.
—Sylvia Yount

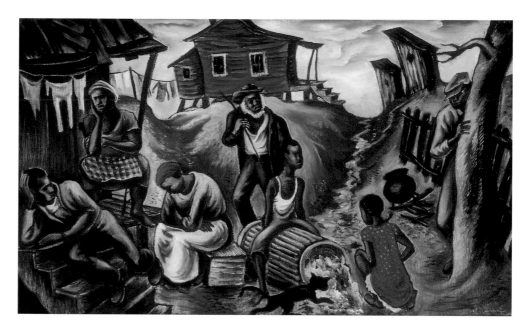

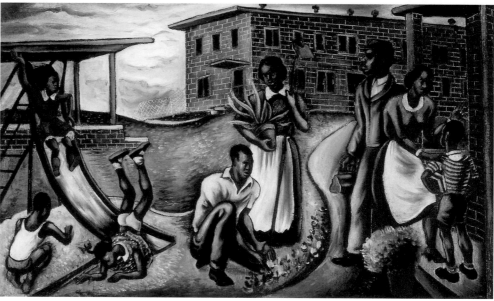

Hale Woodruff
American, 1900–1980

Results of Poor Housing and
Results of Good Housing, ca. 1941–1943
Oil on board, each 14⅞ × 24⅞ inches
Gift of Mrs. Burma Therrell in memory of
James H. Therrell, 1984.86 and 1984.87

A LEADING AFRICAN AMERICAN ARTIST AND TEACHER, Woodruff served on the faculty of Atlanta University from 1931 to 1945. In 1936 he traveled to Mexico City to study mural painting with Diego Rivera. Deeply influenced by Rivera's Social Realism, which celebrated the lives and struggles of everyday people, Woodruff returned to America a committed muralist. He was one of the few black painters to be employed by the Federal Arts Project of the Works Progress Administration (WPA), under whose jurisdiction he completed a project for the library of Talladega College in Alabama. His best-known mural cycle, *Art of the Negro,* was commissioned for the Trevor Arnett Library of Atlanta University, where it can be seen today.

These presentation studies for two murals suggest—with characteristic New Deal rhetoric —the general effects of positive and negative living environments. They were gifts from Woodruff to James H. Therrell, director of the Atlanta Housing Authority, a federally sponsored agency that in 1936 had opened University Homes, America's first public housing project. This project may have served as the inspiration for *Results of Good Housing.* When Woodruff received the commission to paint these murals for Atlanta's Herndon Homes in 1942, he had been living in Atlanta for more than a decade and was keenly aware of the poverty faced by many, particularly African Americans. —Sylvia Yount

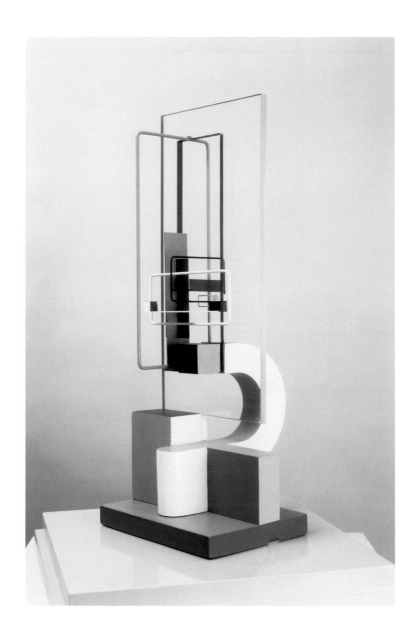

Theodore Roszak

American, born Poland, 1907–1981

Rectilinear Space Construction, 1941–1943
Painted wood, wire, and plastic,
15¾ inches high
Purchase with funds from the American Art
Collectors and the Jean and Glenn Verrill
Foundation, and through prior acquisitions
with funds from Friends of Art, Margaret and
John L. Hoffman, the Goldthwaite Estate,
William B. and Mary Mobely Fambrough,
Mr. and Mrs. Thomas K. Glenn, bequest of
Mrs. Francis Pickens Bacon, Athos Rudolfo
Menaboni, Mr. and Mrs. Francis Abreu,
Beverly Dubose, Sr., Mrs. Charles T. Hopkins,
and in memory of Byron P. Harris, 2004.202

FOLLOWING STUDY IN CHICAGO AND NEW YORK, Roszak embarked on a career as a painter and printmaker. A European travel fellowship in 1929 offered him an opportunity to train abroad, where he quickly steeped himself in European modernism. Upon his return to the United States, Roszak began using industrial tools to craft Constructivist-influenced sculptures. *Rectilinear Space Construction* reveals the use of such tools while also suggesting the personal touch of the artist, who handpainted his distinctive forms with irregular brushstrokes. In this intimate sculpture, Roszak built his composition upon a simple crescent shape, a form that has associations with the moon and the natural world but could also suggest the mechanical. The crescent form represented a pivotal motif throughout Roszak's work of the 1940s, as he moved toward a more pronounced organic abstraction. —Akela Reason

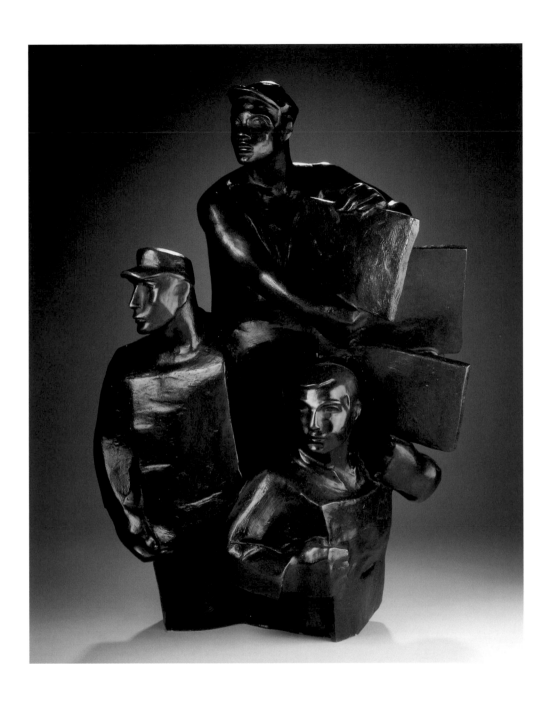

Berta Margoulies
American, born Poland, 1907–1996

Strike, 1948
Bronze, 23¾ × 16 × 12¼ inches
Purchase with funds from Sherri and
Jess Crawford, 2004.176

EMIGRATING FROM THEIR NATIVE POLAND before World War I, Margoulies and her family settled in New York in 1921. After graduating from Hunter College, she trained at the Art Students League with Edward McCartan, then traveled to Paris and entered the Académie Julian. Returning to New York during the Depression, Margoulies supported herself briefly as a social worker and an instructor at the Art Students League, where she developed a close friendship with the sculptor William Zorach and his wife Marguerite. Along with Zorach, Margoulies became a charter member of the Sculptors Guild, an organization established to support the work of progressive artists intent on producing art "for the people." Numerous federal commissions administered through the New Deal art programs further established her reputation.

Strike is one of Margoulies's best-known sculptures that deal specifically with labor issues. A powerful statement of united purpose in both form and content, the work evokes themes of class, race, and social struggle. —Sylvia Yount

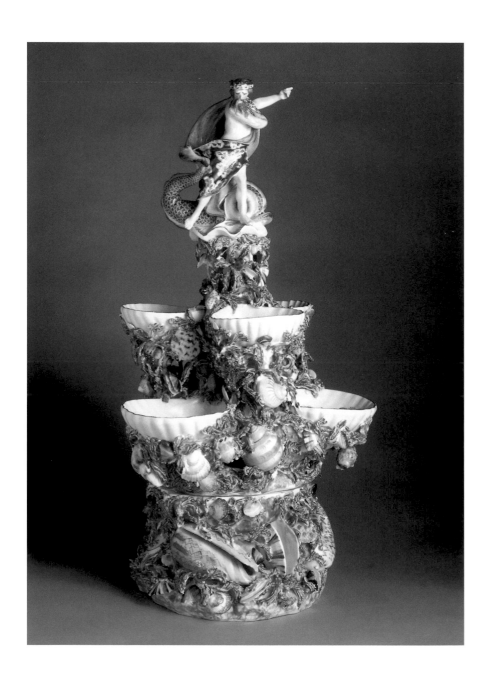

Made by
Derby Porcelain Works
Derbyshire, England, 1750–1848

Sweetmeat Stand, ca. 1760
Porcelain, 19¼ inches high
Frances and Emory Cocke Collection,
1985.162 a–b

THE MYTHICAL CHARACTERS and accurate rendition of shells in the design of this center-piece make it a triumph of mid-eighteenth-century Rococo ornament. The towering height and the heavy encrustation of sea motifs was a specialty of the Derby factory. Created as a centerpiece for dessert, the open shells would have held dried fruits and nuts in an abundant display. —Stephen Harrison

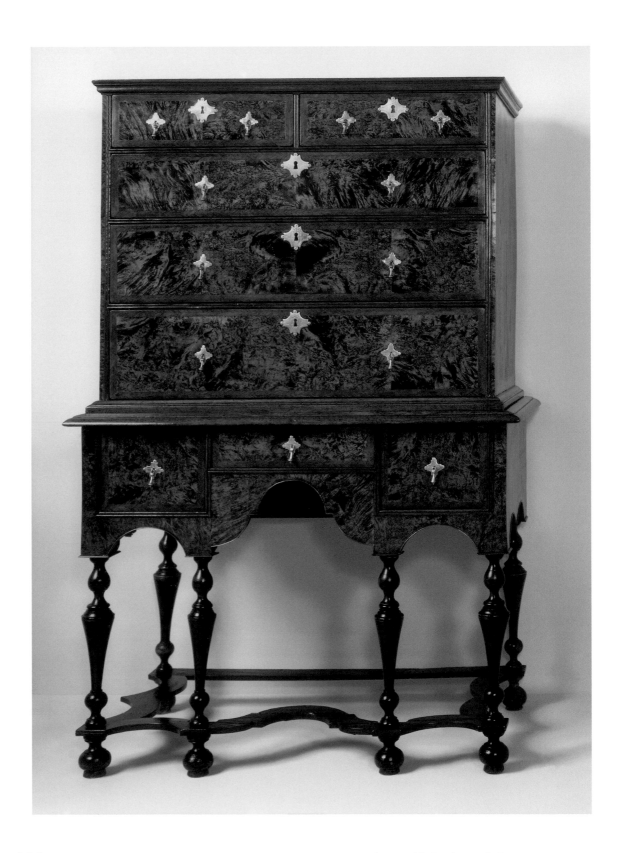

Unknown American Maker
Boston, Massachusetts

High Chest of Drawers, ca. 1700–1725
Walnut and maple, 63½ × 41 × 22½ inches
Purchase with funds from the Decorative Arts
Endowment, 1983.45

THE HEIGHT OF THIS CHEST OF DRAWERS was made possible by dovetailed construction, an interlocking joinery technique that began to be widely used in the American colonies early in the eighteenth century. Because of its strength, the dovetail joint enabled cabinetmakers to use thinner panels of wood to construct taller, more elegant forms. On this chest, the expensive veneer of burled oak was applied only to the front face, emphasizing the most important view; the sides and back were left unadorned. —Stephen Harrison

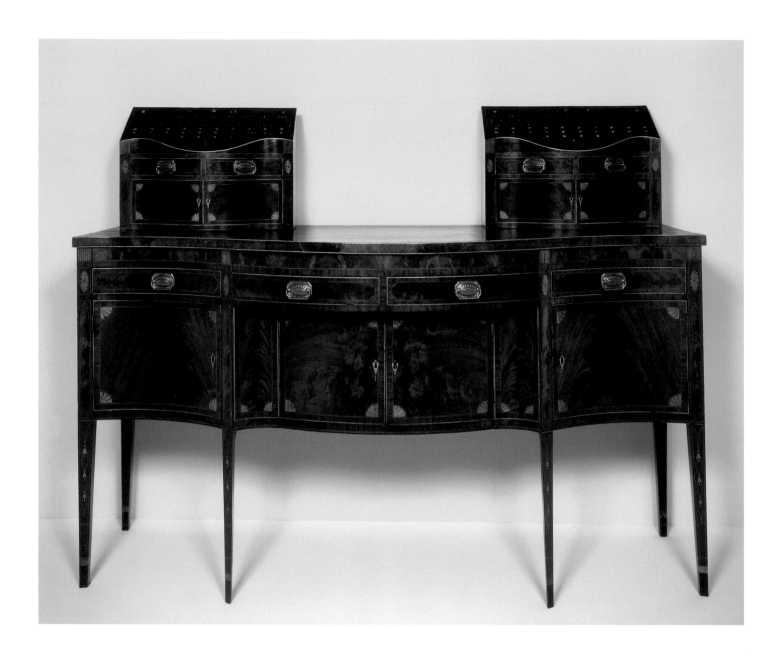

Made by
William Whitehead
American, 1790–1810

Sideboard and Knifeboxes, ca. 1794–1799
Mahogany, poplar, and inlay, 40⅛ × 72¼ ×
29 inches
Purchase with funds from a supporter of
the Museum, 76.1000.5 a–c

LATE EIGHTEENTH-CENTURY SIDEBOARDS, such as this example from New York, were designed to hold every accessory needed for a meal, even a chamber pot for guests to use during long dinners. When dinner was not being served, matching boxes held silverware and knives. Such specialized furnishings were made for prosperous merchants, who began to require rooms with a single purpose. The dining room was the first space to be devoted to a particular use at the end of the eighteenth century. —Stephen Harrison

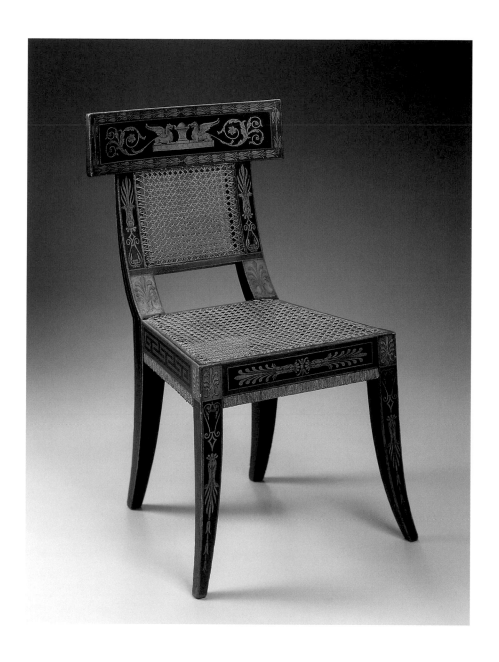

Designed by
Benjamin Henry Latrobe
American, 1764–1820

Made by
Thomas Wetherill
American, died 1824

Chair, ca. 1808
Painted and gilded yellow poplar, oak,
maple, white pine, and cane, 34⅜ × 17½ ×
16½ inches
Purchase with funds from the Decorative
Arts Endowment, 1984.47

THE GRACEFUL SHAPE OF THIS CHAIR—designed and made in Philadephia—mimics depictions of classical seating on Greco-Roman pots. The clean lines and elegant profiles of ancient Greek and Egyptian furniture appealed to many affluent American consumers, especially when the surfaces were adorned with paint and gilded stenciling to enrich the color of their parlors. The designer of this chair, Benjamin Henry Latrobe, was also the first architect of the United States Capitol and the White House, for which he designed a similar suite of furniture.
—Stephen Harrison

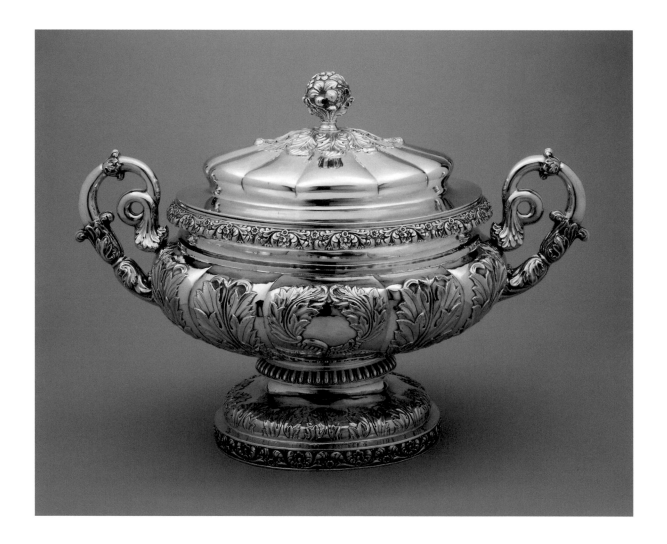

Made by
Frederick Marquand
American, 1799–1882

Covered Tureen, ca. 1820–1830
Silver, 13 × 18½ × 11 inches
Purchase with funds from the Decorative Arts
Acquisition Trust and the Decorative Arts
Endowment, 1991.19 a–b

MOTIFS ADAPTED FROM CLASSICAL ANTIQUITY, seen on this tureen from Savannah, were popular choices for the decoration of silver made in the first half of the nineteenth century. Vessels made in classical shapes and decorated with bold acanthus leaves, grapes, and grape leaves were associated with the grandeur of the ancient world. Many of these designs remained in fashion well into the 1850s, even when architects and design critics favored more elaborate floral decoration. —Stephen Harrison

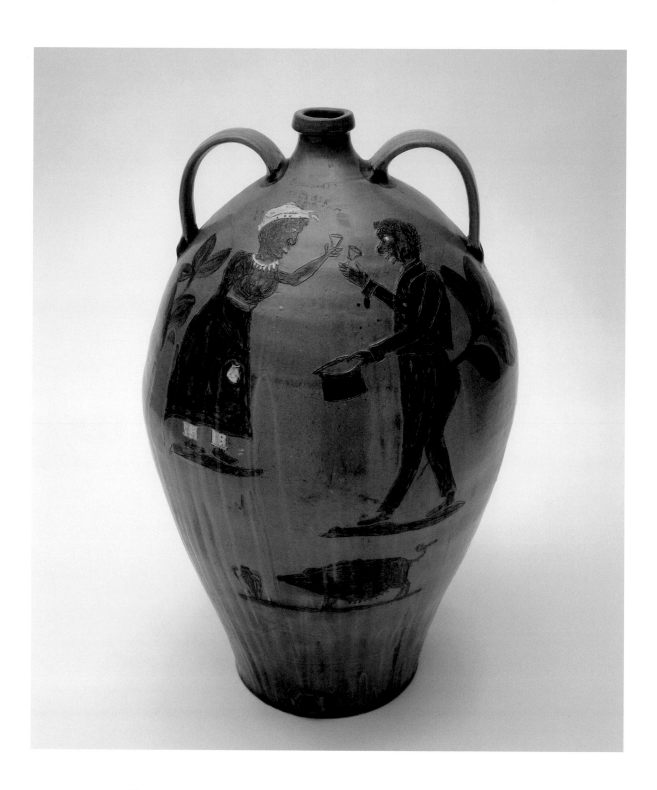

Made by
Phoenix Factory
Edgefield district, South Carolina, 1840–1846

Jug, ca. 1840
Stoneware with alkaline glaze and slip
decoration, 31¼ inches high
Purchase in honor of Audrey Shilt, President
of the Members Guild, 1996–1997, with
funds from the Decorative Arts Endowment
and Decorative Arts Acquisition Trust,
1996.132

THE FIGURAL IMAGERY OF THIS LARGE WATER JUG suggests that it was probably a vessel made to commemorate the wedding of two slaves on a Georgia plantation. Documentation records the master as ordering a hog to be butchered for the wedding of his two favorite house slaves, a scene depicted on the jug. Large stoneware jugs were often commissioned for celebrations but rarely survive with such vivid imagery and documentation, making this jug one of the most important pieces of Edgefield pottery known. —Stephen Harrison

Made by
Zalmon Bostwick
American, active 1846–1852

Pitcher and Goblet, ca. 1850
Silver, 11 × 8½ × 5½ inches;
8 × 3⅝ × 3⅞ inches
Virginia Carroll Crawford Collection,
1984.142.1–2

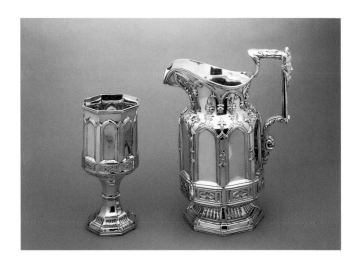

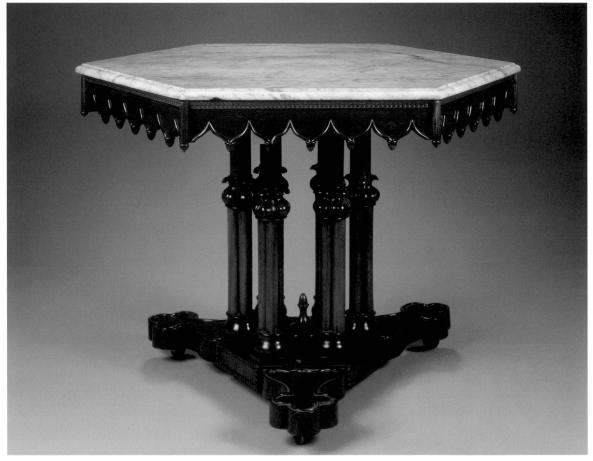

Attributed to
Alexander Jackson Davis
American, 1803–1892

Center Table, ca. 1850
Rosewood, cherry, and white marble,
30 × 37 × 43 inches
Virginia Carroll Crawford Collection, 1983.190

THE GOTHIC REVIVAL STYLE, famously applied to the Houses of Parliament in London, developed in England during the 1830s as a reaction to Neoclassicism, when critics argued that classical design was not as sacred as Gothic design. Although never as popular in this country as it was in Europe, the Gothic Revival was sometimes promoted for the design of picturesque cottages in the American countryside. On the interior, the style was seen as most appropriate in hallways and parlors.

These pieces were designed and made in New York. The center table was an important part of a nineteenth-century parlor, symbolizing family unity and serving as a gathering place for reading and conversation. The pitcher and goblet are rare examples of domestic silver made in the Gothic Revival style. —Stephen Harrison

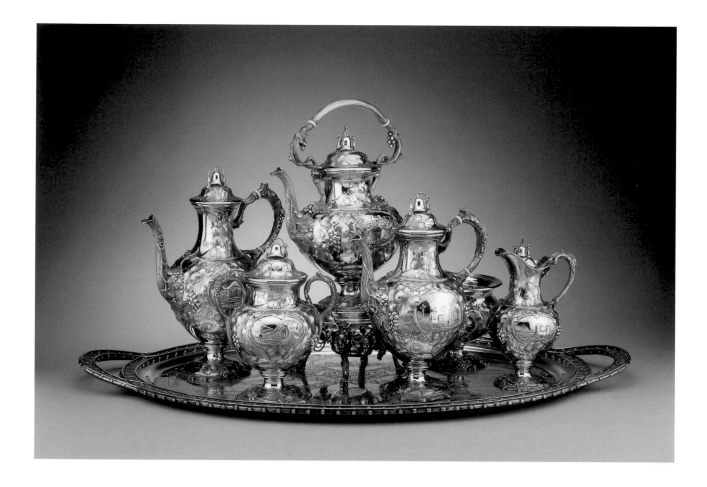

Designed by
Edward C. Moore
American, 1827–1891

Made by
John C. Moore and Son
New York, 1848–1868

Retailed by
Tiffany & Co.
New York, established 1837

Tea and Coffee Service, 1854
Silver, 15 × 33 × 20 inches
Virginia Carroll Crawford Collection,
1985.314.1–7

THIS ELABORATE SILVER TEA AND COFFEE SERVICE celebrates the romantic vision of America that prevailed in the decades immediately preceding the Civil War. As the railroads promoted western expansion, Americans became increasingly interested in images of the natural landscape and of contemporary industrial progress. In this design, engravings of trains adorn each piece and silver railroad tracks encircle the tray as a way of honoring the railroad tycoon to whom the service was presented. —Stephen Harrison

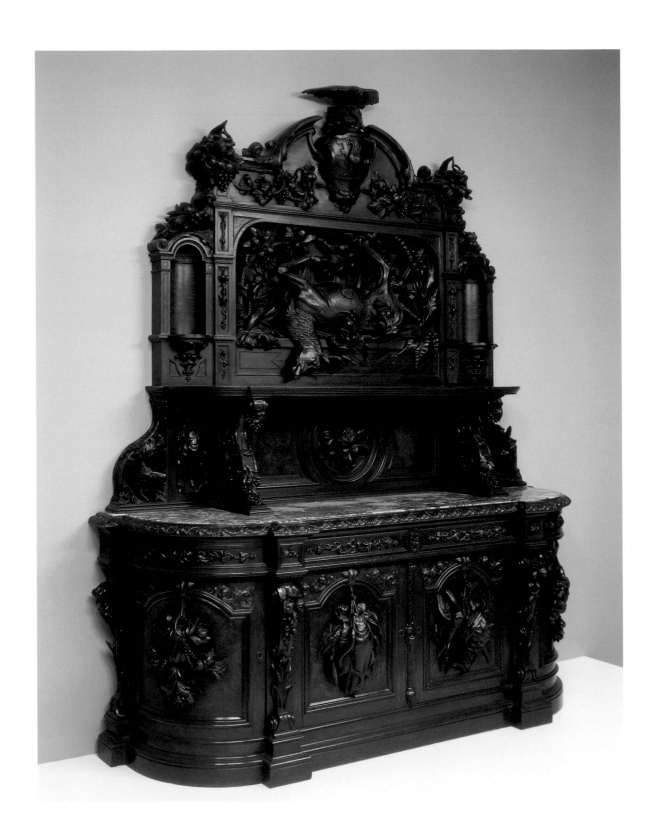

Unknown American Maker
Probably Philadelphia

Sideboard, ca. 1855–1865
Black walnut, marble, and poplar, 108 × 90 ×
30 inches
Virginia Carroll Crawford Collection, 1990.80

DESIGNED TO LOOK AS IF IT BELONGED in a baronial hunting lodge in Germany or France, this enormous sideboard signified the wealth and prosperity of its owner to guests at his table. The carved displays of freshly hunted animals mirrored in wood the large feasts that generally accompanied a country house hunt and represented the hospitality of the house. While the source for the design of this sideboard is likely French, it was probably made in Philadelphia, where there was a large concentration of German carvers producing furniture with baronial hunting motifs. —Stephen Harrison

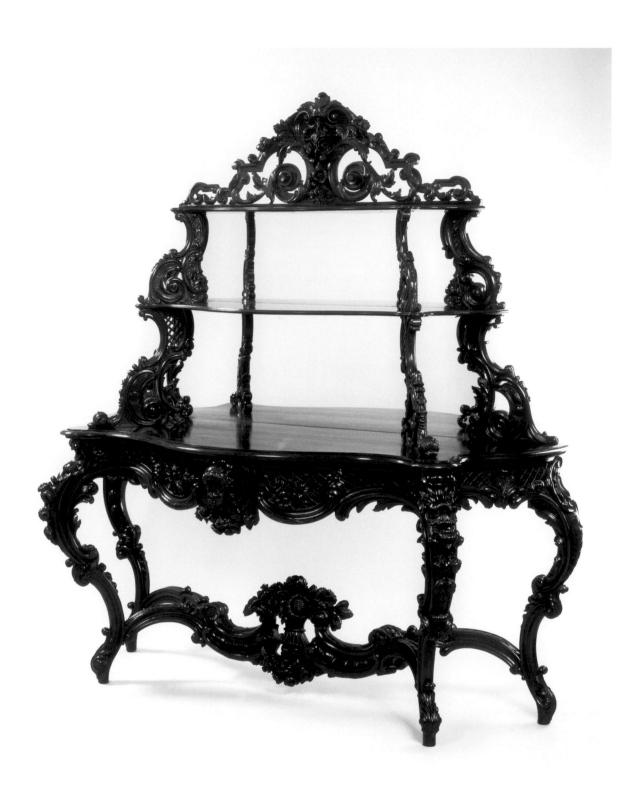

Made by
Alexander Roux
American, born France, 1813–1886

Étagère, ca. 1850–1857
Rosewood, mahogany, ash, poplar, and
mirrored glass, 86½ × 79½ × 29½ inches
Virginia Carroll Crawford Collection,
1981.1000.66

WEALTHY OWNERS USED CONSOLES like this New York étagère purely for decoration, to hold collections of porcelain, silver, or the ultimate in frivolity—a "whatnot." The curved supports, elaborate floral displays, and cherubic figures that had decorated furniture a hundred years earlier were fashionable again by the 1850s—bolder and more lush in revival. The major sources for this style came from France in this period, skillfully promoted by French cabinetmakers working in America as well as publications such as *Godey's Lady's Book,* which proclaimed it was intended for "ladies living at a distance," presumably from the style center of Paris. —Stephen Harrison

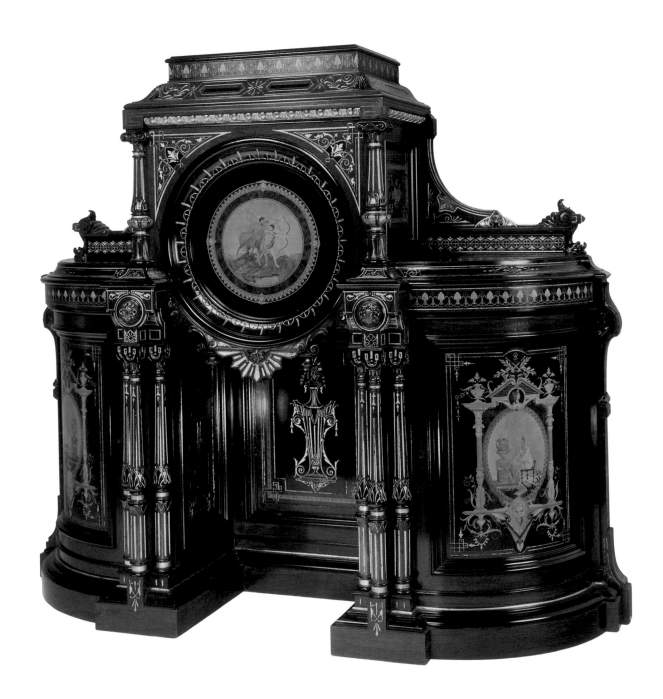

Made by
Kimbel and Cabus
New York, active 1863–1882

Cabinet, ca. 1875
Rosewood with painted, ebonized, incised gilt, and inlaid decoration, 62 × 71 × 22 inches
Virginia Carroll Crawford Collection, 1985.317

This elaborately decorated console was meant for display in a parlor or music room, where it might have held sheet music or served as a stand for small sculpture. It is typical of the decoration found in the homes of America's rising upper class, eager to associate themselves with the rarified world of the fine arts. Classical forms and decoration remained popular throughout the nineteenth century. After the Civil War, mythical figures derived from classical antiquity were frequently depicted in the form of medallions or bands of frieze work. The sideboard's marquetry panels were probably imported from France in keeping with the prevailing taste for French design. —Stephen Harrison

66

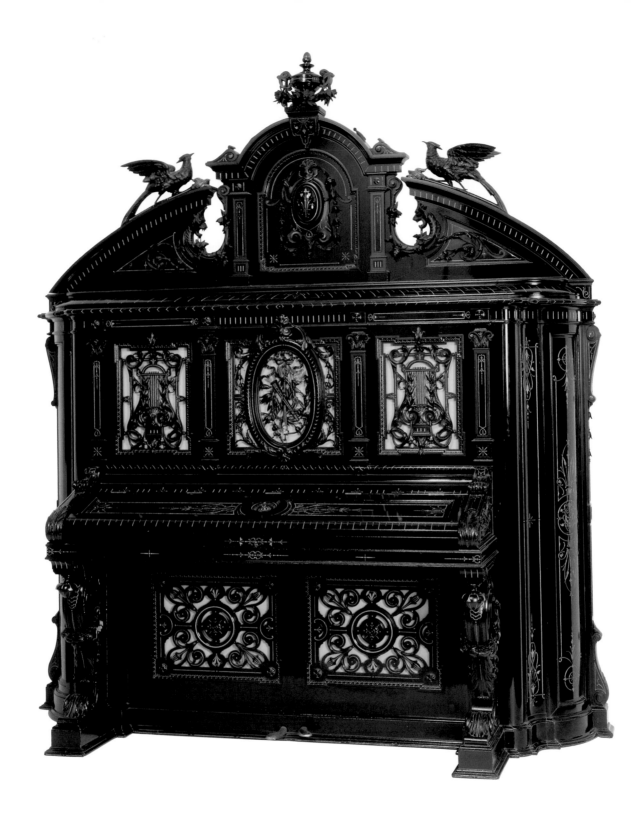

Made by
Hallet, Davis and Company
Boston, working 1850–1957

Piano, 1876
Ebonized cherry, spruce, ash, bird's-eye
maple, ivory, ebony, and various metals,
95 × 82½ × 31¾ inches
Virginia Carroll Crawford Collection, 1983.197

CREATED FOR THE 1876 CENTENNIAL EXHIBITION in Philadelphia, this piano is an example of how American companies worked to impress the critics at this important international event. Apparently, the Boston maker of this piano succeeded, since one critic at the Centennial described it as "the most elaborately constructed instrument of its kind in the exhibition." In this era, pianos were not just musical instruments but also major pieces of parlor furniture, acquired as expressions of wealth and symbols of sophisticated artistic taste as much as for their tonal quality. —Stephen Harrison

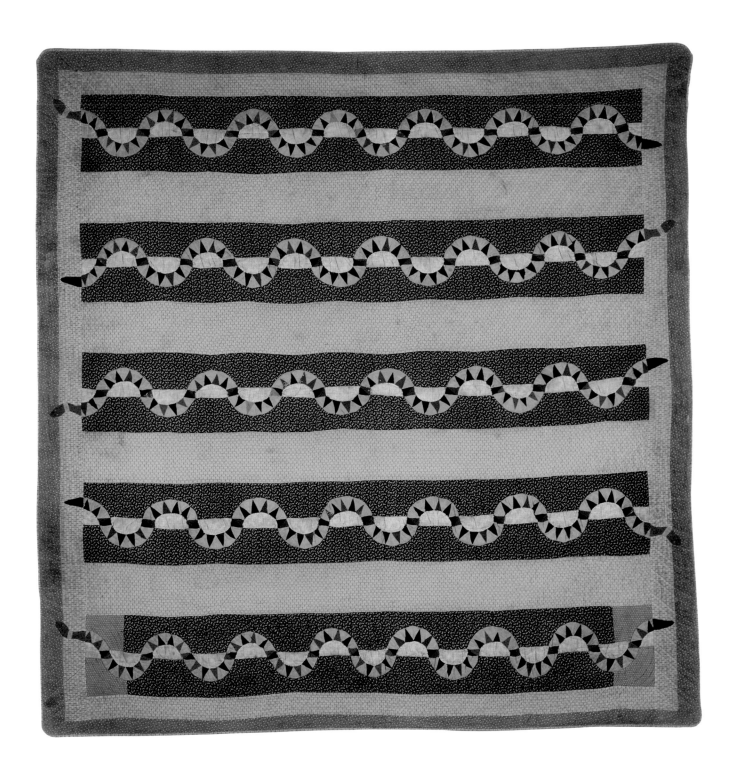

Unknown African American Maker

Probably Eastern North Carolina

Quilt, ca. 1875–1900
Pieced printed cotton and linen stuffed with cotton, 74½ × 72 inches
Purchase with funds from Ann and Tom Cousins and the Decorative Arts Endowment, 1997.203

FILLED WITH VIVID COLOR and undulating energy, this quilt is a remarkable example of the creative spirit of its unidentified maker. The imagery of snakes and alternating triangles of black and brilliant colors evoke both African and Haitian roots and was often found in Southern quilts made by former slaves. Quilted during a time when African American heritage was actively suppressed, such a personal expression of ancestral links remains a powerful symbol of pride today. —Stephen Harrison

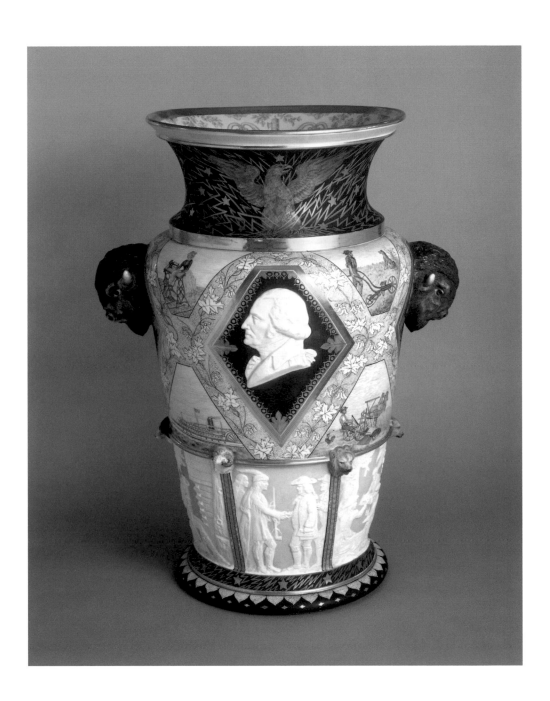

Designed by
Karl L. Müller
American, born Germany, 1820–1887

Manufactured by
Union Porcelain Works
Greenpoint, New York, ca. 1860–ca. 1921

The Century Vase, 1876
Porcelain with paint and gilt decoration,
22½ × 12 × 12 inches
Virginia Carroll Crawford Collection, 1986.163

THE CENTURY VASE WAS MADE especially for display at the 1876 Centennial Exhibition in Philadelphia in the booth of Union Porcelain Works of New York. In one monumental creation, the makers captured the nostalgia for the past, pride in the progress of industry, and optimism for the future that marked the country's one-hundredth birthday celebration. This vase is one of only two Century Vases known to exist from the fair, though the form was reproduced in smaller versions for several years after the exhibition. —Stephen Harrison

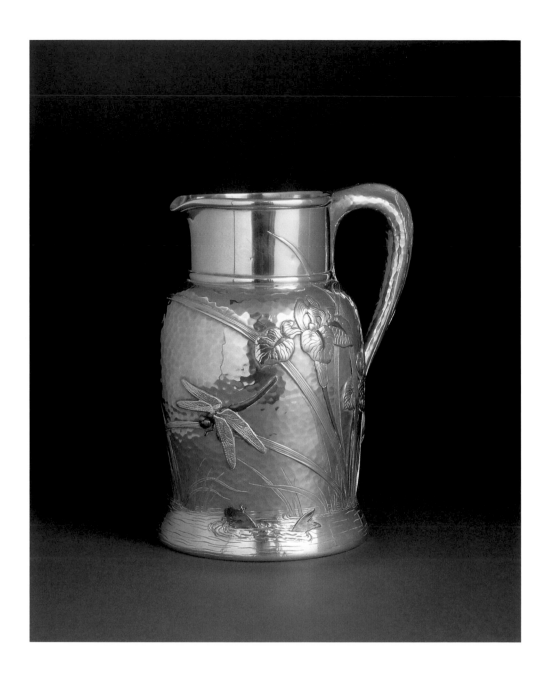

Designed by
Edward C. Moore
American, 1827–1891

Made by
Tiffany & Co.
New York, established 1837

Pitcher, ca. 1878
Silver, copper, brass, and gold,
8⅞ × 7½ × 7½ inches
Virginia Carroll Crawford Collection, 1987.175

AT THE 1878 WORLD'S FAIR IN PARIS, Tiffany & Co. gained international attention for its mixed-metal silverwares in the Japanese style. Edward C. Moore, Tiffany's chief designer, was responsible for the design of this pitcher, which was presented at the Fair. The combination of asymmetrically placed applied metal ornament with the serenity of the pond scene suggested Japanese design to Western eyes. —Stephen Harrison

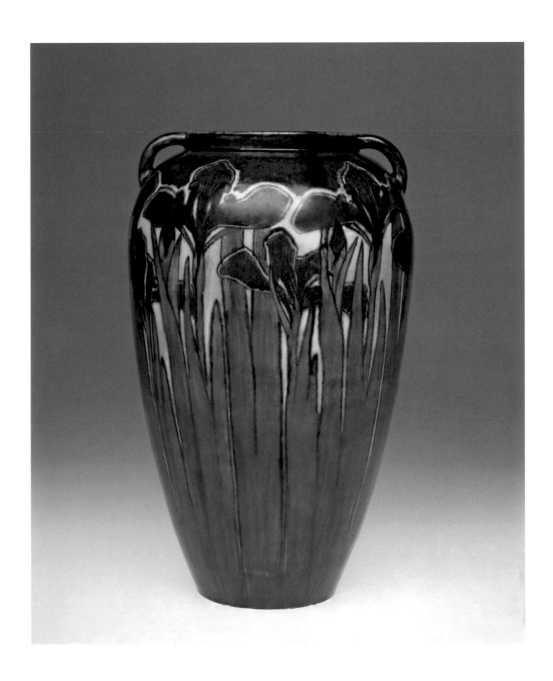

Modelled by
Joseph Fortune Meyer
American, 1848–1931

Decorated by
Anna Frances Simpson
American, 1880–1930

Made by
Newcomb Pottery
New Orleans, 1894–1940

Vase, ca. 1910
Earthenware, 12¼ × 7¼ × 7¼ inches
Virginia Carroll Crawford Collection,
1981.1000.56

A SIGNIFICANT CONTRIBUTION to the Arts and Crafts movement at the turn of the century was made by women—working independently, in colonies of artisans, or at schools and universities such as Newcomb College in New Orleans. Though the pots produced at Newcomb were thrown and fired by a man (Joseph Meyer), the distinctive naturalistic decoration that won praise from the critics was always painted by the female students. —Stephen Harrison

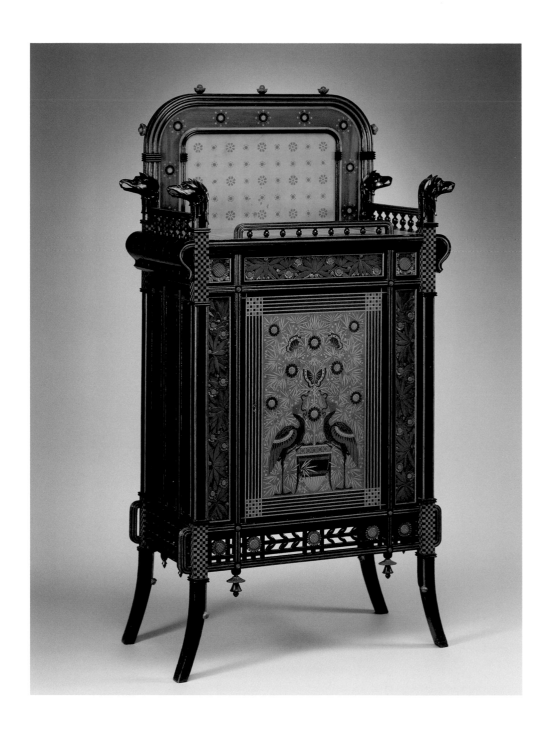

Designed by
Gustave Herter
American, born Germany, 1830–1898

Christian Herter
American, born Germany, 1835–1883

Manufactured by
Herter Brothers
New York, 1864–1907

Cabinet, ca. 1875
Ebonized cherry with marquetry of various
woods, 60 × 33 × 16¼ inches
Virginia Carroll Crawford Collection,
1981.1000.51

THE INFLUENCE OF JAPANESE DECORATION can be seen in the elaborate marquetry panels of this parlor cabinet by Gustave and Christian Herter. The Herter Brothers were part of a wave of German cabinetmakers who immigrated to the United States and settled in New York just before the Civil War. They became known for the superb quality and craftsmanship of their furniture and quickly rose to prominence in American design circles. The Herter Brothers also offered their clients complete interior design services, which earned them the patronage of affluent Americans from New York to San Francisco. —Stephen Harrison

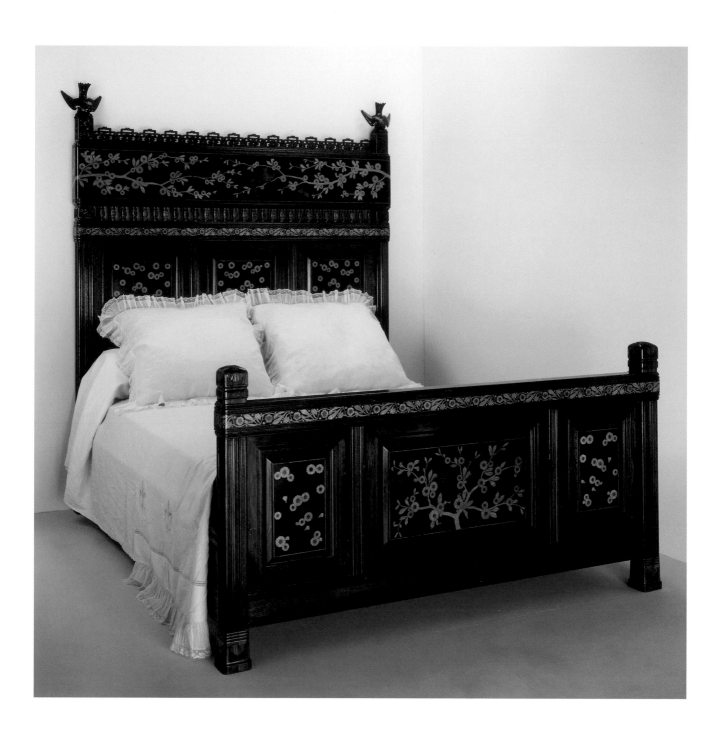

Designed by
Gustave Herter
American, born Germany, 1830–1898

Christian Herter
American, born Germany, 1835–1883

Manufactured by
Herter Brothers
New York, 1864–1907

Bedstead, ca. 1880
Ebonized cherry and marquetry of various
woods, 78 × 66 × 86 inches
Virginia Carroll Crawford Collection, 1983.199

THE LIST OF IMPORTANT PATRONS of the Herter Brothers included almost every captain of industry in America by the end of the 1880s. This bed was made for the home of Pierre Lorillard, an early tobacco magnate, who moved to New York to join the highest circles of society. In addition to Lorillard, the Herter Brothers executed major commissions for William H. Vanderbilt, J. P. Morgan, and the White House. —Stephen Harrison

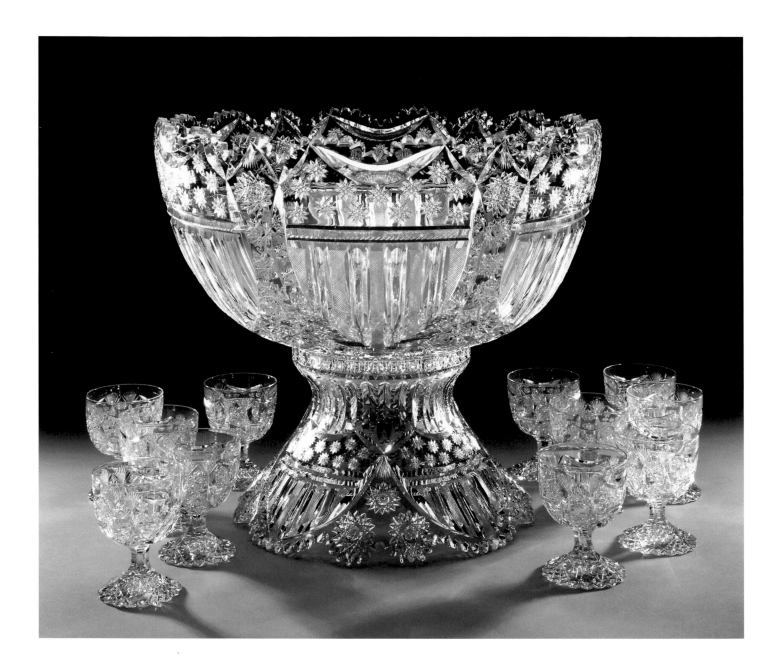

Engraved by
William Marrett
American, 1859–1921

Made by
Libbey Glass Company
Toledo, Ohio, 1888–1936

Punch Service, 1898
Lead glass with cut and engraved decoration,
17 × 18 × 18 inches
Purchase with funds from the Decorative Arts
Endowment, 1985.51.1–15

WHEN "RICH-CUT" GLASS was the height of fashion at the turn of the twentieth century, the celebrated Libbey Glass Company presented President William B. McKinley with a large punch set for use in the White House. At the time it was the largest cut glass punch bowl ever made. The High Museum's set was made as an identical spare for the one at the White House and descended in the Libbey family. —Stephen Harrison

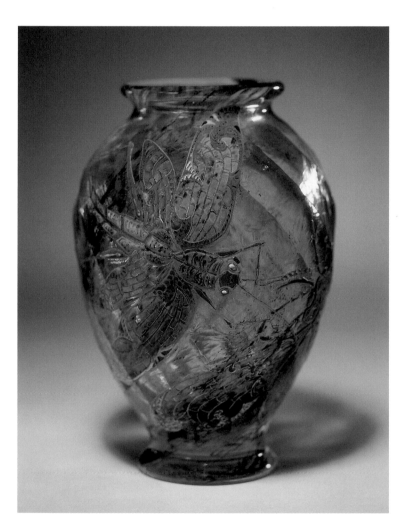

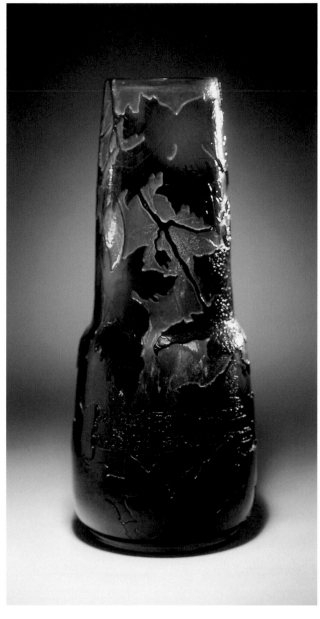

Emile Gallé
French, 1846–1904

Vase, ca. 1889
Enameled cased glass, 6½ inches high
Gift of Mr. and Mrs. Sergio S. Dolfi, 1984.358

Vase, ca. 1900
Cased glass, 13¾ inches high
Gift of Mr. and Mrs. Sergio S. Dolfi, 1984.348

ALTHOUGH EMILE GALLÉ WAS A PROLIFIC DESIGNER of furniture and other decorative arts, he is most remembered for his alluring work in glass at the turn of the twentieth century. The High Museum's collection of glass by Gallé spans his entire career. The earliest work features enameled decoration in the conventional Moorish taste of the 1880s. Later, like so many others, Gallé embraced the Japanese-inspired designs of the Aesthetic movement. His most celebrated works were vases made of colored glass encased by layers of differently colored glass. Their forms employ the naturalistic and symbolic motifs of Art Nouveau in rich, polished colors.
—Stephen Harrison

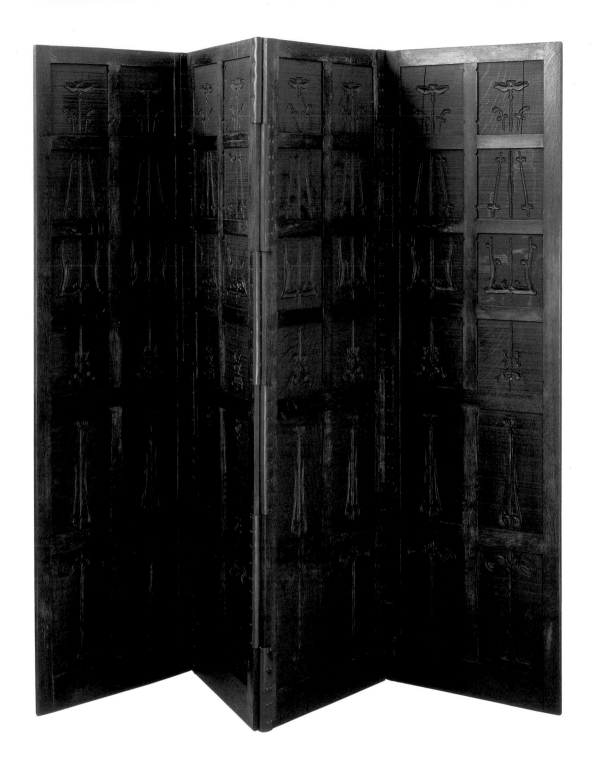

Made by
Charles Rohlfs
American, 1853–1936

Folding Screen, 1900
Oak, 72 × 22¼ × ½ inches
Virginia Carroll Crawford Collection,
1981.1000.53

CHARLES ROHLFS MADE THIS FOLDING SCREEN for his own home in Buffalo, New York. Although his furniture defies stylistic categorization, it owes much to the medieval influences of the English Arts and Crafts movement. Rohlfs also drew on the early currents of modernism found in Art Nouveau, particularly the use of sinewy, abstract plant forms in his carved decoration. —Stephen Harrison

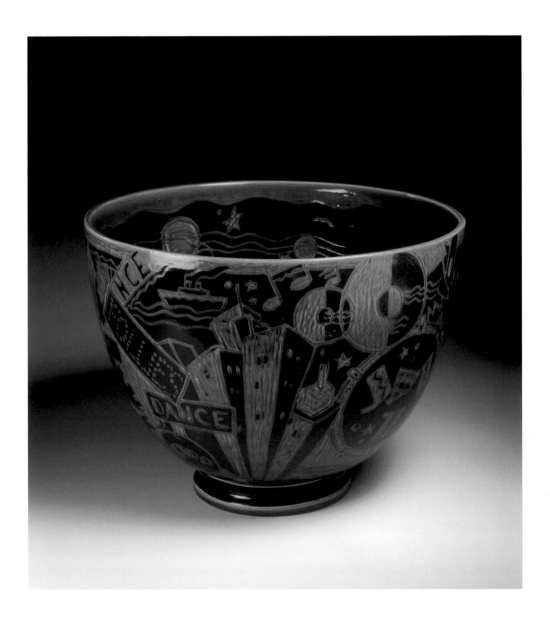

Designed by
Viktor Schreckengost
American, born 1906

Manufactured by
Cowan Pottery Studio
Rocky River, Ohio, 1913–1931

Jazz Bowl, ca. 1931
Porcelain with incised and slip decoration,
12 × 16½ × 16½ inches
Purchase in honor of Kathi Pierce Rhodes,
President of the Members Guild, 1993–
1994, with funds from the Decorative Arts
Endowment, 1993.13

THIS LARGE AND ELABORATELY DECORATED PUNCH BOWL was commissioned in 1931 by Eleanor Roosevelt while she was First Lady of New York State. She wanted a bowl for the governor's mansion that captured the vibrancy of New York City at night. The decoration reflected the bustling activity of America's largest metropolis with images of skyscrapers, ocean liners, neon signs, champagne glasses, and bubbles. This bowl became an important symbol of its time and was produced throughout the 1930s in various sizes and variations.
—Stephen Harrison

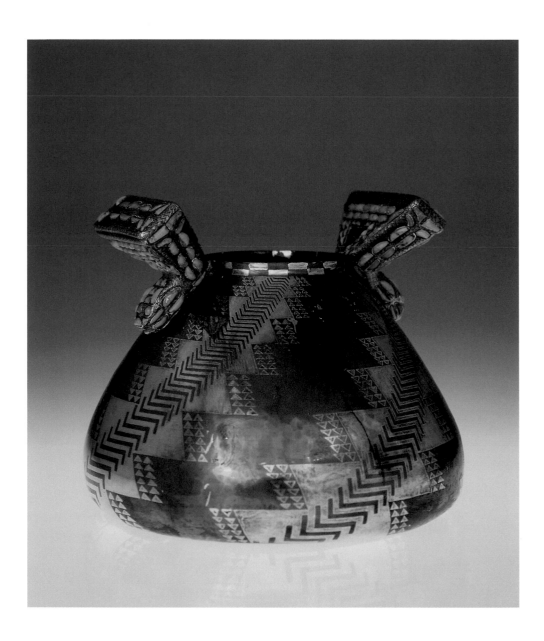

Designed by
Paulding Farnham
American, 1859–1927

Manufactured by
Tiffany & Co.
New York, established 1837

Bowl, 1900
Silver, copper, and turquoise, 7½ × 8¾ ×
8¾ inches
Virginia Carroll Crawford Collection, 1984.170

THIS BOWL WAS AMONG A SERIES Tiffany & Co. presented at the 1900 World's Fair in Paris as replicas of Native American objects. Designed to resemble a Hupa tribal basket with rattle-snake handles, this bowl adapted the geometric designs of authentic Native American artifacts also shown at the fair. —Stephen Harrison

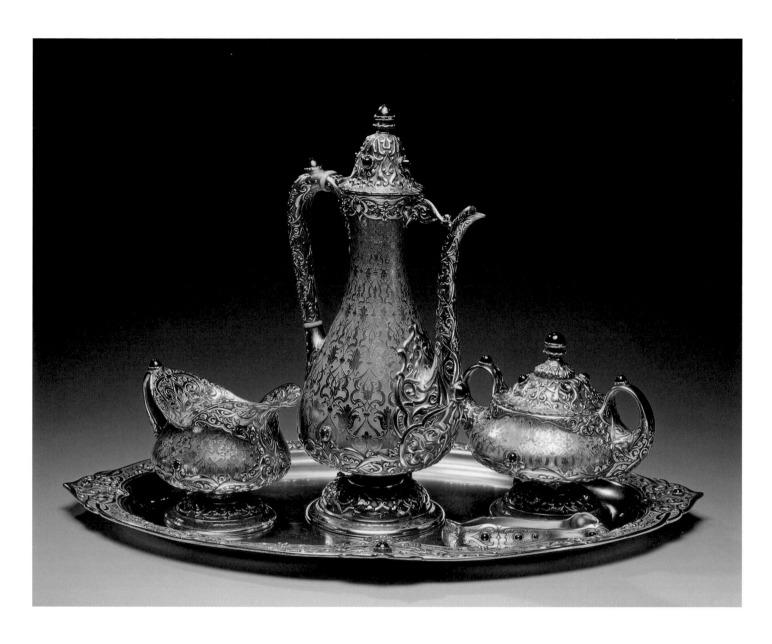

Designed by
Paulding Farnham
American, 1859–1927

Manufactured by
Tiffany & Co.
New York, established 1837

Coffee Set, 1902–1903
Gilded silver, enamel, amethysts, and ivory,
11 × 11⅝ × 16½ inches
Virginia Carroll Crawford Collection,
1984.168.1–5

ECLECTIC DESIGNS IN SILVER ABOUNDED at the turn of the century, when craftsmen and manufacturers worked in different modes to appeal to the diverse tastes of their customers. Tiffany & Co. was among the most successful at the highest end of the luxury market. An association with Turkish coffee inspired this coffee set in the so-called Islamic style, which mimicked the shapes and decoration of vessels from that region of the world. —Stephen Harrison

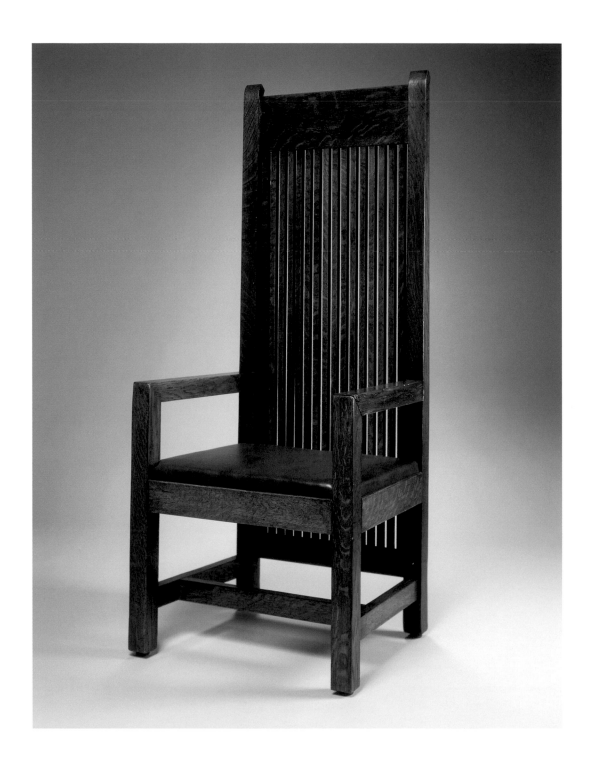

Designed by
Frank Lloyd Wright
American, 1867–1959

Manufactured by
John W. Ayers
American, 1850–1914

Armchair, ca. 1902
Oak, 56¼ × 23 × 20 inches
Virginia Carroll Crawford Collection,
1981.1000.49

THIS TALL, DISTINCTIVE ARMCHAIR was designed by Frank Lloyd Wright for the dining room of the 1902 Prairie-style house he built for Chicago businessman Ward M. Willits in Highland Park. The distinctive shape and strongly rectilinear form echoed the decoration and form of the room. When arranged at the table, the chairs' tall backs acted as a screen, providing the family with privacy while allowing light through the spindles. This innovative furniture motif was used in several of Wright's early houses and brought him international acclaim for his modern approach to architecture and design. —Stephen Harrison

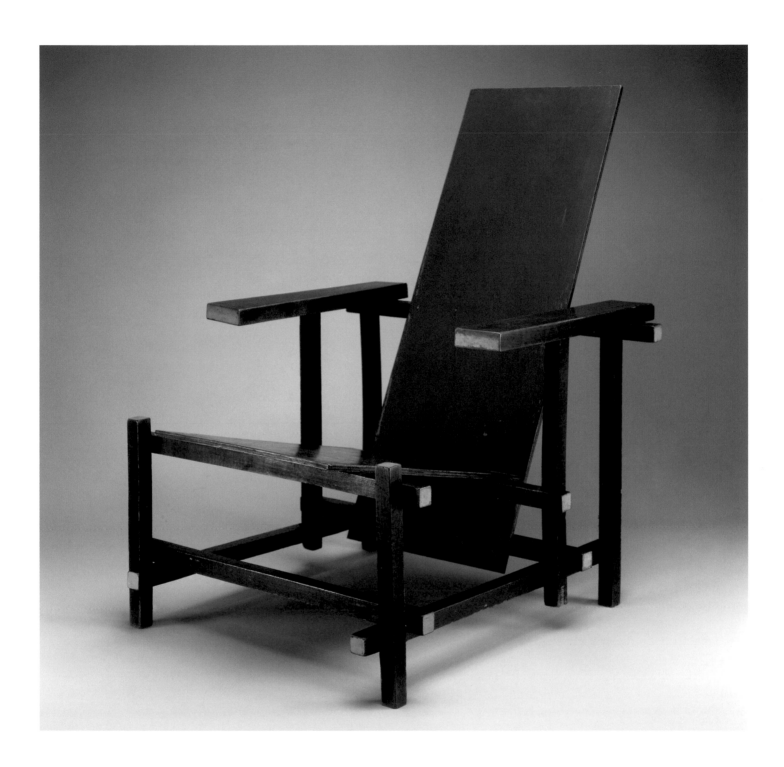

Made by
Gerrit Thomas Rietveld
Dutch, 1888–1964

Red/Blue Chair, 1922–1923, designed 1918
Laminated and painted beechwood,
34¼ × 26 × 25½ inches
Purchase with funds from the Decorative
Arts Acquisition Trust, the Decorative Arts
Endowment, the Friends of the Decorative
Arts, funds in honor of a friend and loyal
benefactor of the Museum, and the High
Museum of Art Enhancement Fund, 2002.256

THE *RED/BLUE CHAIR* is one of the most influential and recognizable furniture designs of the twentieth century because it redefined traditional notions of form and space within the confines of a practical household object. This design blurred the distinction between painting, sculpture, and architecture by reducing form to a series of planes and boundaries delineating space but not containing it. Rietveld's use of primary colors negated the natural form of the material and objectified the whole. This concept is often referred to as Neoplasticism and formed the major tenet of the De Stijl movement in Holland. This example was made by Rietveld as a gift to the Dutch artist Jacob Bendien. —Stephen Harrison

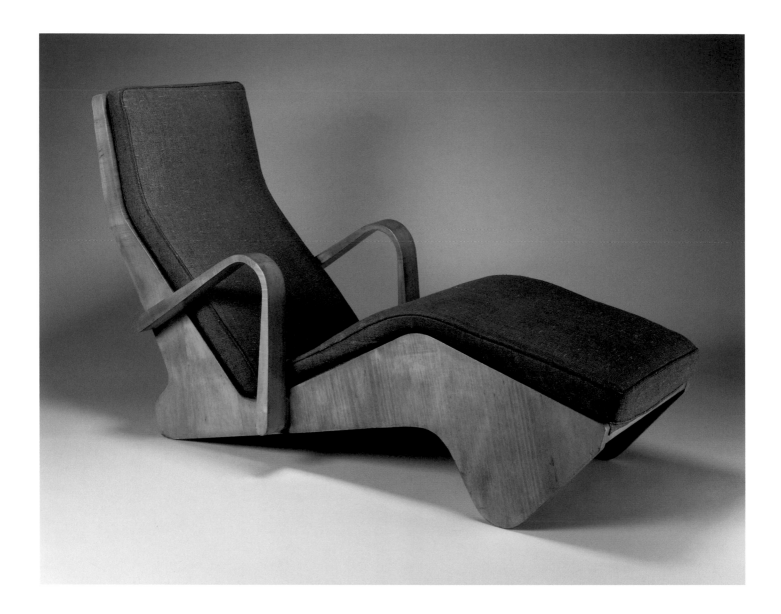

Marcel Breuer
American, born Hungary, 1902–1981

Lounge Chair, ca. 1936
Sycamore plywood, maple, and upholstery,
32¾ × 22 × 60 inches
Purchase with funds from the Friends of the
Decorative Arts and funds given in honor of
a friend and loyal benefactor of the Museum,
2003.2

MARCEL BREUER CONCEIVED of this significant lounge chair design when he was living and working in England from 1935 to 1937. During this time he collaborated with several influential architects, including Walter Gropius, as well as leading furniture manufacturers. This chair, designed for the 1936 *Seven Architects* exhibition at the London department store Heal & Sons, foreshadows his later American work, such as the furniture for Bryn Mawr College in Pennsylvania that employed plywood cutout forms. In this design, Breuer continues his exploration of spatial form, moving from outlined forms to paneled shapes that resonate in the work of later American designers, most notably Frank Lloyd Wright. —Stephen Harrison

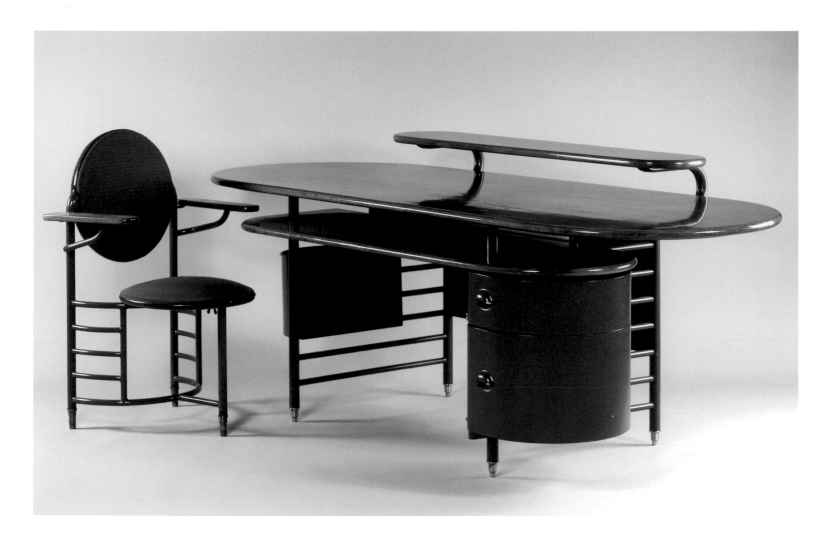

Designed by
Frank Lloyd Wright
American, 1867–1959

Manufactured by
Steelcase, Inc.
Grand Rapids, Michigan, established 1912

Desk and Armchair, ca. 1936–1939
Enameled steel, walnut, and brass-plating,
33½ × 84 × 35 inches; 34½ × 23½ ×
19½ inches
Purchase with funds from the Decorative
Arts Endowment, 1984.371.1–2

THE COMMISSION FOR THE ADMINISTRATION BUILDING for the S. C. Johnson Wax Co. in Racine, Wisconsin, was a turning point in the career of Frank Lloyd Wright. He had achieved fame earlier in the century, but by the mid-1930s his architectural practice had reached a plateau. This desk and chair, which he designed for the great workroom, reflect the overall geometrical form of the building. The international acclaim that the Administration Building and its furnishings received helped reestablish Wright's reputation as the greatest living American architect. —Stephen Harrison

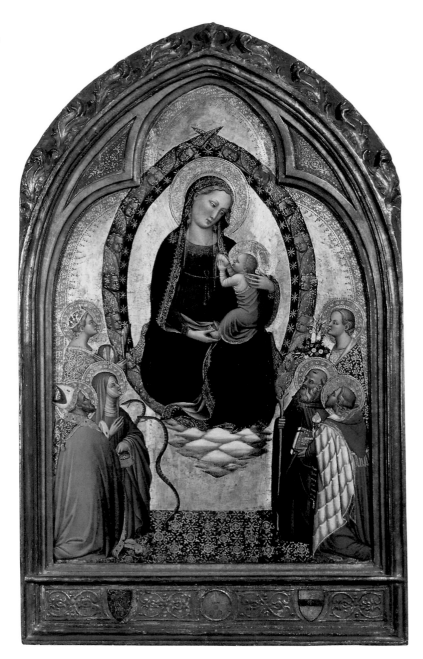

Tommaso del Mazza
Italian, active 1350–1415

Madonna and Child with Six Saints,
ca. 1390
Tempera on panel, 31¾ × 21⅜ inches
Gift of the Samuel H. Kress Foundation,
58.49

TOMMASO DEL MAZZA, A FLORENTINE ARTIST of the early Renaissance, was influenced by the works of such masters as Agnolo Gaddi and Jacopo di Cione. During his lifetime he produced altarpieces and small devotional paintings. Until recently, much of this artist's work was attributed to the Master of Saint Verdiana. However, research by the art historian Barbara Deimling tracing the influences, life, and works of Mazza and the unidentified Master revealed them to be the same person.

The Master of Saint Verdiana was given this name because of his depiction of St. Verdiana in this painting. This obscure thirteenth-century saint lived her life as a recluse, immured in a cell and tormented by serpents. She is shown on the left with two snakes at her side. The other saints are identified by their attributes: on the left, St. Catherine stands with a wheel and St. Nicholas has three gold spheres at his feet. On the right, St. Dorothy holds flowers, St. Anthony Abbott holds a T-shaped staff, and St. Julian clasps a sword in his hands. The Virgin and Child appear as a celestial vision to the group of saints. The work's gold background is typical of the medieval era, but the artist imbues the figures with a sense of plasticity that anticipates the Renaissance. —Emily E. Shingler

RIEMENSCHNEIDER'S WORK MARKS the high point of German Gothic sculpture. The artist spent many years in Würzburg, where he maintained a large workshop. This statue appears to have been made by skilled assistants in his workshop.

St. Andrew is depicted with the X-shaped cross of his martyrdom and is given a venerable yet gaunt appearance, with hollowed cheeks, deep creases in his forehead, and a look of intense concentration as he studies the book in his hand. The rich treatment of the draperies, the fine, visible sinews of the saint's hands, and the careful attention paid to each tendril in St. Andrew's hair and beard add to the power of the figure. —Emily E. Shingler

Giovanni Bellini

Italian, ca. 1426–1516

Madonna and Child, ca. 1510
Oil on panel, 37⅛ × 28¾ inches
Gift of the Samuel H. Kress Foundation, 58.33

GIOVANNI BELLINI CAME from a distinguished family of artists. His father Jacopo and his brother Gentile were important artists, and he was the brother-in-law of the painter Andrea Mantegna. Bellini became the official painter to the government of Venice in the early sixteenth century, and when Albrecht Dürer lived there from 1505 to 1507, he reported that Bellini was "the best painter." Bellini was the teacher of two of the greatest painters of the Renaissance, Giorgione and Titian.

One of Bellini's favorite subjects was the Madonna and Child before a landscape, the depiction of which he revolutionized through his naturalistic and poetic representations. Several years before painting this work, Bellini had switched from tempera, in which pigments were mixed with diluted egg yolk, to oil paint. The use of oil paint allowed Bellini to make subtle changes in color such as those seen in the fine shadows on the Madonna's face. In this painting, the figures appear before a symbolic green cloth of honor. The single bare tree in the upper right may allude to the Crucifixion as well as to the tree in the Garden of Eden. The balustrade with Bellini's name separates the mortal viewer from the sacred figures, emphasizing the devotional aspect of the image. —David A. Brenneman

Il Romanino
(Girolamo di Romano)
Italian, ca. 1484–1562

Madonna and Child with St. James Major and St. Jerome, ca. 1512
Oil on panel, 58⅜ × 54½ inches
Gift of the Samuel H. Kress Foundation, 58.45

ALTHOUGH SOME QUESTIONS REGARDING the attribution of this work persist, it is believed to have been painted by the northern Italian Renaissance artist Girolamo di Romano, known as Il Romanino. His career was spent working in the vicinity of his native Brescia, near Milan, and he was influenced by Venetian painting, especially the work of Titian and Giorgione. In this large altarpiece the stories of the saints' lives are told through their symbolic attributes. The staff and scallop shell on the left identify St. James (the patron saint of Spain, where he is known as Santiago), sometimes represented as a pilgrim in a cloak covered with shells. The Bible on the right refers to St. Jerome's translation of the Scriptures into Latin. —David A. Brenneman

Albrecht Dürer
German, 1471–1528

Knight, Death, and the Devil, 1513
Engraving, 9½ × 7⅜ inches
Gift of Professors Alice and George Benston,
2002.320

ALBRECHT DÜRER STROVE TO RAISE the quality and esteem of Northern European art to that of Italy during the Renaissance. *Knight, Death, and the Devil* is one of Dürer's master engravings, which, along with *Melancholia* and *St. Jerome in His Study,* represent the pinnacle of his achievement as a printmaker. The finely detailed and closely packed lines in this print make the horse's coat appear to shimmer and the knight's armor shine.

The meaning of the knight riding past Death (shown with hourglass in hand) and the Devil has puzzled generations of interpreters. Dürer's image has been associated with Erasmus's *Manual of the Christian Knight,* which urges every Christian to live as a soldier in the service of God and traverse the road to salvation fortified by weapons of faith. —Emily E. Shingler

Vittore Carpaccio
Italian, 1460–1526

Temperance, ca. 1525
Oil on panel, 42⅝ × 21⅝ inches
Gift of the Samuel H. Kress Foundation, 58.35

Prudence, ca. 1525
Oil on panel, 42⅝ × 21¾ inches
Gift of the Samuel H. Kress Foundation,
58.36

A STUDENT OF THE PROMINENT PAINTER Gentile Bellini, Vittore Carpaccio is best known for his detailed and colorful scenes of Venice. *Temperance* and *Prudence* may have been part of a set illustrating the Four Cardinal Virtues (the other two being Justice and Fortitude). The marble wall on which the figures stand would have established visual continuity among the panels. *Temperance,* or moderation, pours liquid from one vessel into another, presumably diluting wine with water. *Prudence,* or practical wisdom, is holding a mirror, a symbol of self-knowledge and foresight. The figures are identifiable but Carpaccio modified their defining attributes. *Temperance* pours liquid onto a plate rather than into a cup or vessel. *Prudence* stands before a grimacing dragon (instead of the usual sea snake) and a dove. The dragon can be seen as a symbol of either vigilance or evil, while the dove may be read as representing peace, gentleness, or the Holy Spirit. —Emily E. Shingler

Pieter Lastman
Dutch, 1583–1633

Paris and Oenone, 1610
Oil on panel, 25¾ × 43¾ inches
Purchase in honor of Thomas G. Cousins, President of the Board of Directors, 1987–1991, with funds from Alfred Austell Thornton in memory of Leila Austell Thornton and Albert Edward Thornton, Sr., and Sarah Miller Venable and William Hoyt Venable, 1990.57

THE LEADER OF THE SO-CALLED PRE-REMBRANDTIST GROUP, Pieter Lastman is credited with introducing historical subject matter into Dutch painting, which had focused almost exclusively on genre scenes and portraits. Lastman is best known for his influence on Rembrandt. Although Rembrandt was apprenticed to Lastman for only six months, it was in his master's studio that he first encountered paintings of historical and biblical narratives.

In this early painting Lastman illustrates the crucial moment in Ovid's *Metamorphoses* when the nymph Oenone implores her husband Paris not to leave. Paris rejects her entreaties, kidnaps Helen, and returns to Troy, where he is fatally wounded in the ensuing war with the Greeks. Lastman's treatment of the scene is unusual because he has transposed this classical story of tragic love into a contemporary Dutch landscape featuring a herd of goats and peasants milking a cow in the background. Lastman ensured that this painting's subject would not be misinterpreted by inscribing the words "Oenone" and "Paris," which are barely visible on the tree behind the two lovers. —Emily E. Shingler

Nicolas Tournier

French, 1590–1638

The Denial of Saint Peter, ca. 1630
Oil on canvas, 63 × 95 inches
Gift of the Members Guild in honor of its
twentieth anniversary and in memory of
Mr. Robert W. Woodruff on the occasion of
the 100th anniversary of Coca-Cola, 1986.52

IN 1619 THE FRENCH PAINTER Nicolas Tournier arrived in Rome, where he was influenced by the work of the Italian Baroque painter Caravaggio and Caravaggio's followers, especially Bartolomeo Manfredi. In this painting, Tournier captures the dramatic moment of Peter's spiritual crisis, when he denies to Roman soldiers that he is a disciple of Christ. The theatrical gestures and expressive poses of the figures, cast in sharp relief by a dramatic flash of light, are designed to make us feel like actual witnesses to the scene. Although Tournier's use of light and shade, which heightens the emotional intensity and pathos of the scene, is reminiscent of Caravaggio's style, the graceful figures and lyrical composition are derived from the seventeenth-century French school, especially the work of Valentin de Boulogne. Beginning in the 1620s, Tournier worked in France, primarily in and around the city of Toulouse. Paintings by Tournier are scarce, since many of them were lost or destroyed during the French Revolution.

—David A. Brenneman

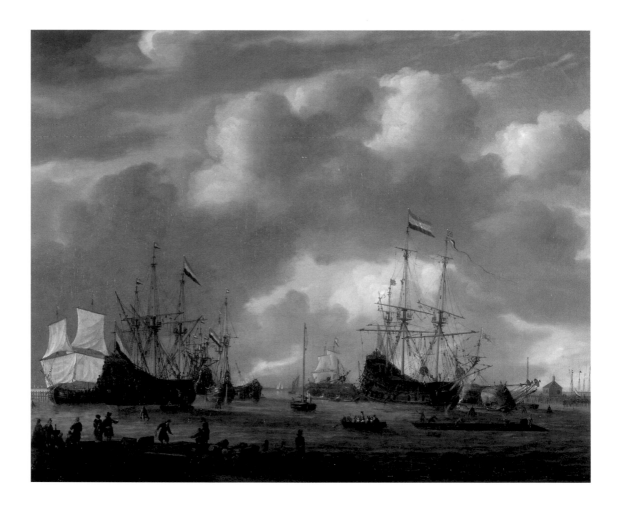

Zeeman (Reinier Nooms)
Dutch, 1623–1664

A View of the Amsterdam Harbor,
ca. 1643–1664
Oil on canvas, 24⅜ × 30⅜ inches
Gift of the Walter and Frances Bunzl
Foundation, 1991.300

REINIER NOOMS WAS A DUTCH PAINTER, draughtsman, and etcher who proudly identified himself throughout his career as "Zeeman" (Dutch for "Seaman"). He spent most of his early years as a sailor on Dutch merchant vessels and is likely to have been a self-taught artist. Widely traveled, Nooms painted views of ports in Venice, Paris, and the West Indies as well as his native Amsterdam. His maritime background enabled him to fill his paintings with accurate details of ships and convincing topographical views.

Zeeman's depictions are so accurate that these ships can be identified as actual mid-seventeenth-century Dutch cargo and naval vessels. The ships wait in the harbor for repair and maintenance. Onlookers, fascinated by the Dutch ships that dominated the sea at this time, gather to watch as the ships are debarnacled and retarred. Typical of the "monumental" phase of Dutch seventeenth-century seascape painting, the expansive sky is as prominent as the harbor.
—Emily E. Shingler

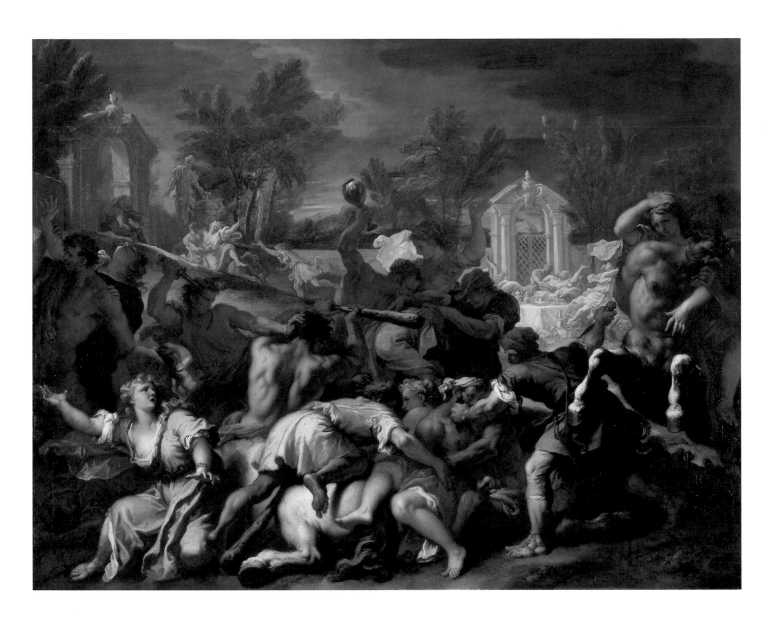

Sebastiano Ricci
Italian, 1659–1734

The Battle of the Lapiths and Centaurs,
ca. 1705
Oil on canvas, 54½ × 69⅝ inches
Gift of the Samuel H. Kress Foundation, 58.55

ONE OF THE MOST SIGNIFICANT ITALIAN ARTISTS of the late seventeenth and early eighteenth centuries, Sebastiano Ricci helped revitalize Venetian art. Trained under Alessandro Magnasco and greatly influenced by sixteenth-century Venetian master Paolo Veronese, Ricci developed a pre-Rococo style that paved the way for Giovanni Tiepolo. Throughout his career, Ricci enjoyed success with noble patrons in Italy and England, where he worked from 1712 to 1716.

The Battle of the Lapiths and Centaurs is a popular story from Ovid's *Metamorphoses.* The Lapiths were Greeks descended from giants. Pirithous, king of the Lapiths, invited the half-horse, half-man Centaurs to his wedding to Hippodamia. Ricci depicts the battle that ensued after Mars, the only god not invited to the celebration, spurred the drunken Centaurs to abduct the Lapith women. The artist's theatrical depiction emphasizes the intertwined muscular bodies of the brawling figures in the foreground. In the mid-ground, Ricci implies the vastness of the battle with a less defined, but similarly tangled mass of bodies to the right, and with a Centaur trying to escape with the bride to the left. Considered one of Ricci's masterpieces, this work displays his superb draftsmanship and flowing use of color. —Emily E. Shingler

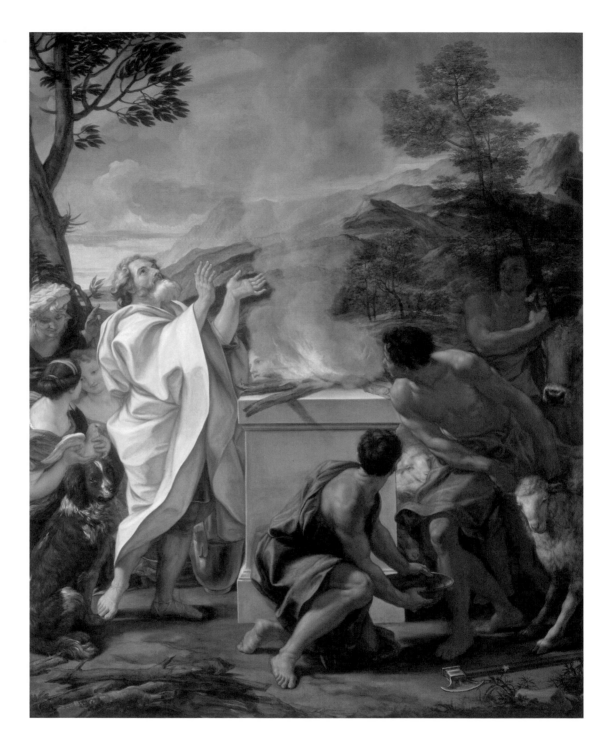

Il Baciccio
(Giovanni Battista Gaulli)
Italian, 1639–1709

The Thanksgiving of Noah, ca. 1700
Oil on canvas, 64½ × 51¼ inches
Gift of the Samuel H. Kress Foundation,
58.30

KNOWN FOR HIS PAINTED DECORATION of the ceiling of the nave of Il Gesù and other church domes in Rome, Giovanni Battista Gaulli, known as Il Baciccio, was trained by the sculptural and architectural genius of the Italian Baroque, Gianlorenzo Bernini. In these paintings, Il Baciccio's training reveals itself in the sculpted muscular features of the figures and the powerful sense that the drama takes place in a grand three-dimensional space.

These companion paintings, nearly identical in size, may have been intended as part of an altarpiece. Both illustrate Old Testament stories of sacrifice that foreshadow Christ's death and resurrection. *The Thanksgiving of Noah* depicts Noah and his family after the flood. Baciccio brings the narrative to life with details such as the ark visible in the right corner and the rainbow overhead. The dog in the left foreground turns away from the action and looks out of the painting, bringing the viewer into the action.

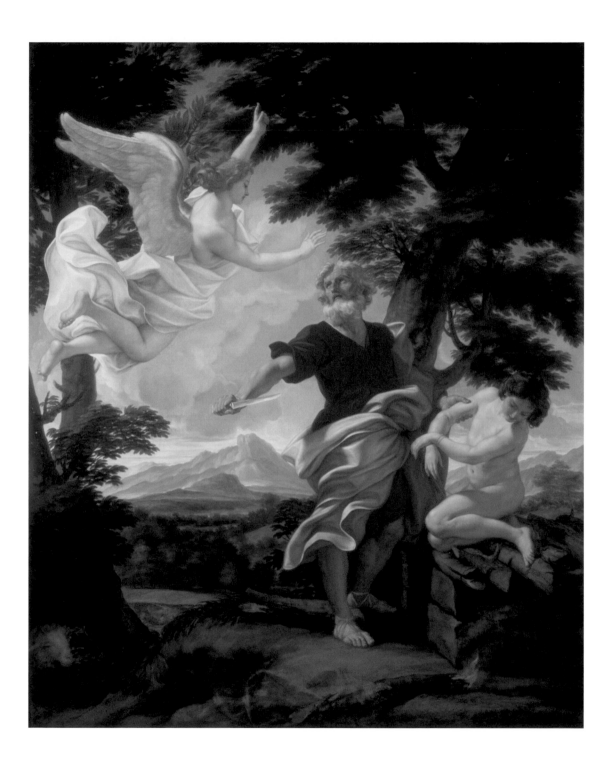

Abraham's Sacrifice of Isaac, ca. 1700
Oil on canvas, 63¼ × 51⅝ inches
Gift of the Samuel H. Kress Foundation, 58.31

Abraham's Sacrifice of Isaac illustrates a similar story. In a test of faith God orders Abraham to sacrifice his son, Isaac. At the moment that Abraham is about to prove his faith, an angel stops his hand. The work is made especially compelling by the artist's careful attention to detail: the lines of age and worry on Abraham's face, the cowering, innocent Isaac, and the sacrificial ram, just visible in the bushes in the lower left of the painting. —Emily E. Shingler

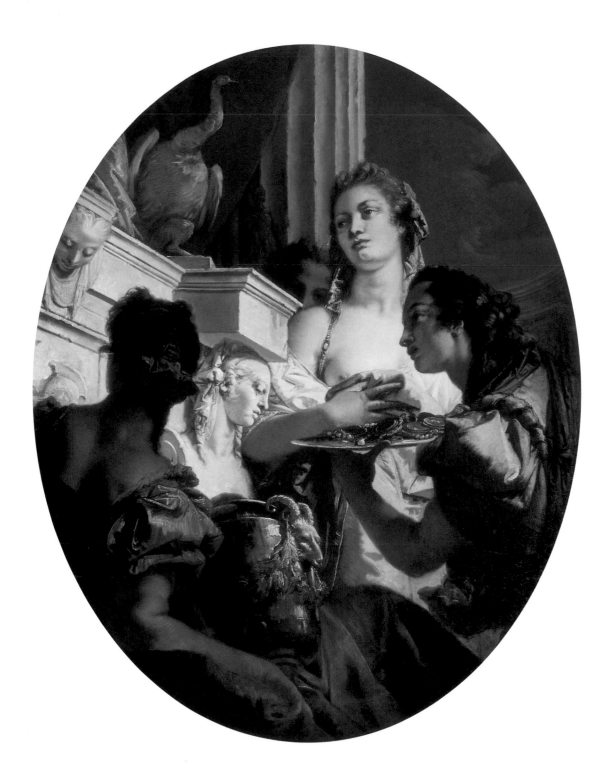

Giovanni Battista Tiepolo
Italian, 1696–1770

Roman Matrons Making Offerings to Juno,
ca. 1745–1759
Oil on canvas, 56⅞ × 44⅜ inches
Gift of the Samuel H. Kress Foundation, 32.6

VENETIAN ARTIST GIOVANNI BATTISTA TIEPOLO was the leading European decorative painter of the eighteenth century and the leading proponent of the Italian Rococo. Influenced by both Veronese and Ricci, Tiepolo achieved international fame with his illusionist ceiling decorations and brilliant decorative paintings in Italy, Würzburg, and Madrid.

This work is one of a set of four panels that originally hung over doors in the Palazzo Barbaro in Venice. Each of the paintings depicts a historical scene involving women. This work tells the story of the Roman matrons bringing offerings to the altar of Juno, wife of Jupiter. During the Second Punic War, the temple of Juno was struck by lightning. To appease the deity, the matrons of the city offered gifts from their dowries at Juno's altar. —Emily E. Shingler

Anne-Louis De Roussy
Girodet-Trioson
French, 1767–1824

The Funeral of Atala, ca. 1811
Oil on canvas, 35 × 46⅜ inches
Purchase with funds from the Forward Arts
Foundation, 1990.1

GIRODET, A STAR PUPIL of the Neoclassical painter Jacques-Louis David, won the Rome
Prize in 1789 and returned to Paris in 1795, thus avoiding the turmoil of the Revolution. He
was drawn to literary themes, and this painting is based on Chateaubriand's popular romantic
novel *Atala,* published in France in 1801. The novel recounts the tragic story of Atala, a half
Native American Christian maiden, and Chactas, a Natchez Indian. They fall in love after Atala
frees Chactas from captivity; the two flee and seek refuge in a cave. Fearing that she is on the
verge of breaking the vow of chastity she made to her dying mother, Atala poisons herself.
An early example of French Romanticism in painting, the entombment scene portrays the
profound grief of the anguished Chactas as he holds his dead beloved. A larger version of this
painting created a popular sensation when it was exhibited in Paris in 1811.

—David A. Brenneman

Jean-Baptiste Camille Corot
French, 1796–1875

Ravine in the Morvan, Near Lormes,
ca. 1840–1845
Oil on canvas, 18 × 18¾ inches
Gift of the Forward Arts Foundation, 72.39

COROT WAS ONE OF THE MOST INNOVATIVE landscape painters of the nineteenth century. His radical approach of painting *en plein air* produced landscapes of unprecedented freshness. The artist's work was a critical step between the classical tradition and the Impressionists.

This work is one of a group painted by Corot in the Morvan region of France between 1840 and 1845. The Morvan, an area renowned for its wooded hills and swift streams, is located in the western part of Burgundy. Corot's paintings from this period display his talent in working with light, his direct and engaging vision of nature, and his ability to craft original compositions that appear spontaneously conceived. In this view of a ravine the viewer's eye is first drawn to the river and the light playing on the crests of the turbulent water, then to the rocky banks, and finally the forest beyond. Corot must have been particularly pleased with this painting—he hung it in his living room at his home in Ville-d'Avray. —Emily E. Shingler

Antoine-Louis Barye
French, 1796–1875

Theseus Battling the Centaur, ca. 1855
Plaster with wax coating, 13¾ × 14⅛ inches
Purchase with funds from Irene and Howard
Stein, Mrs. Harold B. Friedman, and bequest
of Harry A. Pfiffner, 2000.2

THROUGHOUT THE 1830S AND 1840S, Barye produced romantic scenes of combat between wild animals. *Theseus Battling the Centaur* represents a departure for him in terms of subject matter and style. The simplified classical style of this work was influenced by Barye's study of reproductions of the Parthenon marbles, which had been relocated to London by Lord Elgin in the first decades of the nineteenth century. The literary source for Barye's sculpture is found in Ovid's *Metamorphoses:* a brawl erupted between the Lapiths and the Centaurs at the wedding of Hippodamia and Pirithous, and the Lapiths defeated the Centaurs with the help of Theseus and Hercules. By sculpting an exalted mythological subject in a historically informed style, Barye wanted to silence critics who labeled him a mere sculptor of animals. Nevertheless, the muscular equine body of the Centaur allowed him to display his abilities as a modeler of animal figures.

This cast of *Theseus Battling the Centaur* is a plaster "master model" that was used in the production of bronze replicas. It was Barye's usual practice to produce a preliminary sketch in wax or clay; a plaster cast was then taken from the less durable sketch. Barye applied a coating of wax to the plaster in order to more easily and intricately work the surface. The wax-covered plaster was then used to produce the sand mold from which a bronze cast could be made.

—David A. Brenneman

Frédéric Bazille
French, 1841–1870

The Beach at Sainte-Adresse, 1865
Oil on canvas, 23 × 55⅛ inches
Gift of the Forward Arts Foundation in honor
of Frances Floyd Cocke, 1980.62

ON A WINDY, OVERCAST DAY on the northern coast of France, fishing boats ply the choppy waters. In this unsentimental portrait of a beach near the city of Le Havre, whose skyline can be seen in the distance, Frédéric Bazille recorded the daily activities of people who worked hard on the shoreline. *The Beach at Sainte-Adresse* was one of a pair of paintings commissioned from the artist by his uncle. Its unusual horizontal format was dictated by its intended hanging over a door.

Bazille, one of the original group of Impressionist painters, was particularly close to Claude Monet during the 1860s. The artists traveled together and shared a studio in Paris. This painting may have been made as a response to Monet's artistic challenge, as it depicts the beach near Monet's home and is similar to a painting of the site executed by Monet in 1864. Bazille's promising career in the vanguard of Impressionism was cut short by his death in the Franco-Prussian War. —David A. Brenneman

Camille Pissarro
French, 1830–1903

Road to Louveciennes, ca. 1870
Oil on canvas, 15 × 18⅛ inches
Purchase with High Museum of Art
Enhancement Fund, funds from the
Livingston Foundation, Hambrick Bequest,
Alfred Austell Thornton in memory of
Leila Austell Thornton and Albert Edward
Thornton, Sr., and Sarah Miller Venable and
William Hoyt Venable, the Phoenix Society,
and Mr. and Mrs. Jerome Dobson, 2001.1

BORN IN THE DANISH WEST INDIES, Pissarro attended boarding school in France and returned to Paris in 1855 to study art. He entered the studio of Charles Gleyre, where he met Claude Monet and Pierre-Auguste Renoir. In 1869, Pissarro joined Monet, Renoir, and Alfred Sisley, who had relocated to the towns along the Seine River just northwest of Paris. Pissarro settled in the town of Louveciennes, where he stayed until September 1870, when he was forced to flee the advancing Prussian army. He escaped with his family to London. There he rejoined Monet and was introduced to the dealer Paul Durand-Ruel, who would become his ardent advocate.

The brief period of 1869–1870 was a crucial moment in the history of Impressionism, when the various influences of the Barbizon School and the Realist movement came together into a synthesis of shimmering color and bold, broken brushwork. Whereas Renoir's and Monet's breakthroughs came in painting the Seine near Bougival, Pissarro's occurred in painting the ancient road that ran through Louveciennes. This painting is one of these revolutionary works, characterized by a bulging perspective and painted in short, unblended brushstrokes. With unprecedented freshness and simplicity, Pissarro's picture captures the atmosphere of a lazy, rural afternoon in the winter or early spring. —David A. Brenneman

Claude Monet
French, 1840–1926

Autumn on the Seine, Argenteuil, 1873
Oil on canvas, 21⅜ × 28⅞ inches
Purchase with funds from the Forward
Arts Foundation, The Buisson Foundation,
Eleanor McDonald Storza Estate, Frances
Cheney Boggs Estate, Katherine John Murphy
Foundation, and High Museum of Art
Enhancement Fund, 2000.205

IN 1871 MONET MOVED HIS FAMILY to the town of Argenteuil, just northeast of Paris, along the Seine River. This river scene, painted in 1873, shows the banks of the Seine with some of the architectural landmarks of the town of Argenteuil in the distance, including the Château Michelet. Monet took his view from the vantage point of the Petit Bras, or Little Arm, of the Seine. In the foreground is the backwater of the Petit Bras, with several sailing boats and skiffs at their moorings. To the right, we see the near bank of the Seine, and to the left, the wooded Île Marante, a small island in the river.

Monet's views of the river from the early 1870s typically display a broad, sketchy technique that he employed to create a sense of spontaneity. The choice of colors and the manner in which they are applied in *Autumn on the Seine* are extraordinary. Giving up the characteristic short, choppy brushstrokes of the late 1860s and early 1870s, Monet painted the trees on the left with small touches of pastel oranges, yellows, and pinks. These brilliant colors are mirrored in the water below, resulting in a remarkable symmetry that makes it difficult to distinguish between the reflected colors and their sources. Counterbalancing the fiery colors on the left, the trees and shrubbery on the right are painted with muted greens and silvery grays, suggesting that they have not yet turned or that it is morning and the sunlight that illuminates the trees on the left has not reached those on the right. —David A. Brenneman

Claude Monet

French, 1840–1926

Houses of Parliament in the Fog, 1903
Oil on canvas, 32 × 36⅜ inches
Purchase with Great Painting Fund in honor
of Sarah Belle Broadnax Hansell, 60.5

BY THE END OF THE NINETEENTH CENTURY, Monet had achieved considerable critical and commercial success. Nevertheless, he continued to innovate. Beginning in the 1890s he simultaneously painted multiple versions of the same motif, lining up numerous canvases and moving from one to another as the light changed. The best known of these series were the Haystacks (1891) and the facade of the Rouen cathedral (1892). In the fall of 1899, Monet traveled to London, where he painted a series of views of the Houses of Parliament seen from a balcony of Saint Thomas's Hospital directly across the River Thames. He returned to London to paint in the winters of 1900 and 1901. Monet's choice of subject was undoubtedly influenced by the fact that J. M. W. Turner and James McNeill Whistler had also produced important paintings featuring the Thames.

In this view, the Thames is covered by thick fog and the Houses of Parliament loom in the distance. As is typical of Monet's late work, this composition, which has little suggestion of depth and features very free brushwork, verges on abstraction. Although begun in London sometime between 1899 and 1901, Monet continued to work on this painting in his studio in Giverny. This was one of thirty-seven views of London he exhibited in 1904 at the Durand-Ruel Gallery in Paris. —David A. Brenneman

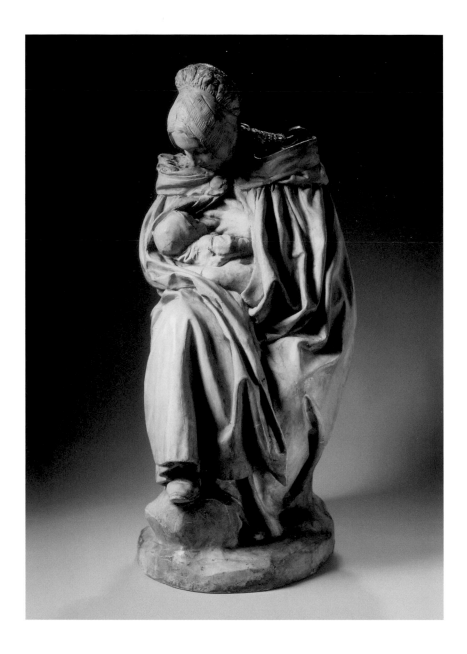

Aimé-Jules Dalou
French, 1838–1902

A Woman of Boulogne Nursing Her Child,
ca. 1890s
Plaster, 25¾ × 9½ × 13 inches
Purchase with funds from Irene and Howard
Stein, 2003.3

THIS PLASTER MODEL OF A YOUNG WOMAN nursing her infant belongs to a series of sculptures of this subject, which Dalou began in 1873 with a sculpture called *Maternal Joy.* In 1877 he exhibited a life-size terra-cotta of a nursing mother at the Royal Academy. That sculpture is related to the present work, which was probably produced for a private patron in the 1890s. This extremely rare plaster model may have been used in the production of a marble sculpture. There is also another plaster version of this subject in the collection of the Petit Palais Museum in Paris. The artist gave this plaster model to his trusted apprentice and marble carver, Auguste Becker.

Along with Auguste Rodin, Dalou was considered one of the leading avant-garde sculptors at the turn of the century. As a youth he was discovered by the sculptor Jean-Baptiste Carpeaux and received training at the École des Beaux-Arts. Like Rodin, Dalou apprenticed with the prolific sculptor Albert-Ernest Carrier-Belleuse. In 1871 Dalou was forced to flee France because of his support of the short-lived Paris Commune. He went into exile in London. His English patrons included many notable aristocrats as well as Queen Victoria, and during the 1870s he exhibited frequently at the Royal Academy in London. He later returned to France, where he enjoyed critical and public success. —David A. Brenneman

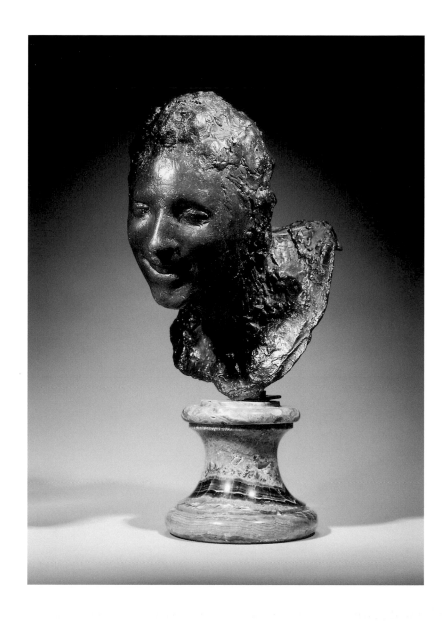

Medardo Rosso
Italian, 1858–1928

Little Laughing Woman (Petite Rieuse),
modeled ca. 1890, cast later
Bronze, 13⅝ × 9⅞ × 11 inches
Purchase in recognition of John W. Spiegel,
Chairman of the Board of Directors, 1997–
1998, through prior acquisitions from
Dr. Nancy Walls, a friend of the Museum,
Mr. and Mrs. Thomas K. Glenn, Richard and
Hamilton Smith, Mr. and Mrs. John W. Grant,
Jr., Elizabeth Berry Reid, Mrs. Inman Sanders,
The Children's Fund, Mrs. Harry E. Ward
and Harry E. Ward, Jr., Mrs. William R.
Hammond, and Mrs. Kate Sessions Marsh.
Acquired in memory of Reverend Wilbur Fisk
Glenn and Catherine Saunders Clay and in
honor of Mrs. Howard C. Smith and Florence
Davant Lawton, 1997.41

ROSSO IS ONE OF A SMALL GROUP of fin-de-siècle sculptors who attempted to find the sculptural equivalent of Impressionism. His sculpture sought to capture the fleeting qualities of light and movement and was highly influential for the Italian Futurists in the early twentieth century. Usually called the *Little Laughing Woman* to distinguish it from his *Large Laughing Woman (Grande Rieuse)* of 1891, this work is a portrait of the cabaret singer Bianca Garavaglia, known as Bianca di Toledo. Rosso made several versions, experimenting with the neck and collar, which he fragmented and in some versions eliminated entirely. He also experimented with different patinas. In this example the artist gave the work a brown coloration with splash of green on the forehead and just below the neck, perhaps to suggest rays of light striking the surface. In 1894 Rosso gave a version of the *Petite Rieuse* to Auguste Rodin and received in exchange a cast of Rodin's *Torso*. This version is similar to the one that Rosso gave to Rodin, which is in the collection of the Musée Rodin in Paris. —David A. Brenneman

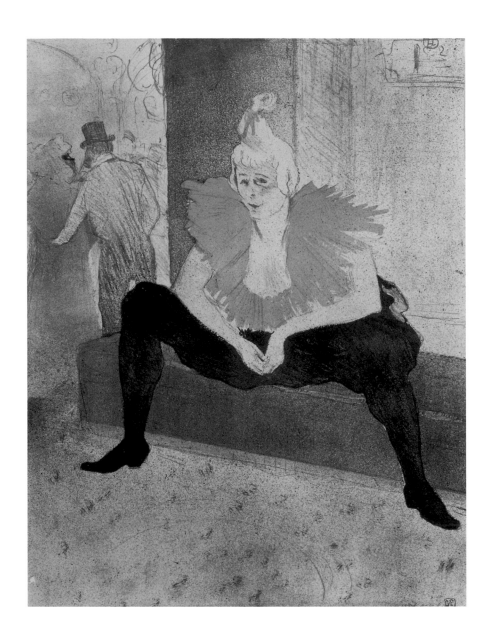

Henri de Toulouse-Lautrec
French, 1864–1901

Mademoiselle Cha-u-Kao, Female Clown, Seated, 1896
Crayon, brush, and spatter lithograph on laid Japanese paper, 21 × 16¼ inches
Gift of Irene and Howard Stein, 2001.13 c

THE SUBJECT OF THIS IMAGE is Mademoiselle Cha-u-Kao, a lesbian contortionist. It is part of a series of twelve color lithographs published in 1896 called *Elles (The Girls)*. In addition to this image, the High owns the complete set of lithographs. Now recognized as a masterpiece of printmaking, *Elles* was a financial failure when it appeared. The publisher, Gustave Pellet, had hoped that the subject of the album—prostitutes—would arouse the curiosity of male customers. However, Lautrec's sympathetic images of their mundane activities failed to find a market among Pellet's usual clientele, who expected something more sexually explicit.

Elles is a major acheivement in the history of printmaking. The brilliant yet subtle printing of the delicate veils of color required extreme sensitivity and precision. Lautrec is believed to have collaborated with the master printer Auguste Clot on these lithographs, which look like unique watercolors and pencil drawings rather than printed images. The images in the *Elles* series also demonstrate Lautrec's remarkable draftsmanship and powers of observation. In several of the images, the artist achieves his effect through an elegant and descriptive use of line. *Elles* demonstrates Lautrec's mastery of daring viewpoints, inspired by Japanese woodblock prints and made possible by his unrestricted access to his models. —David A. Brenneman

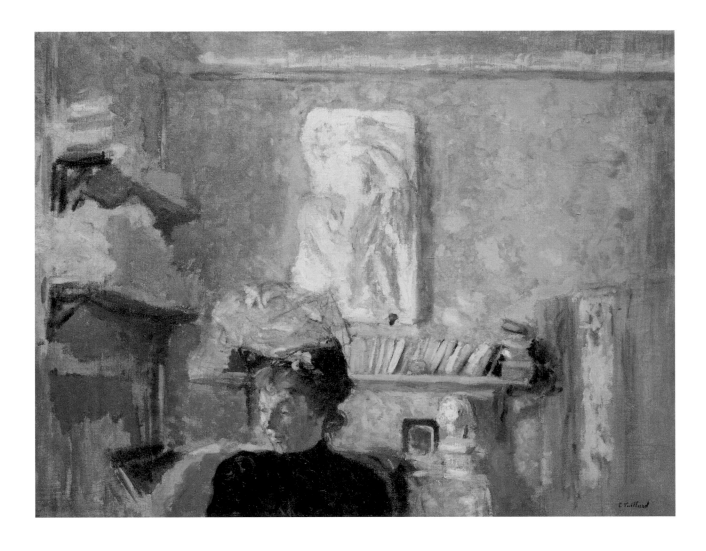

Edouard Vuillard
French, 1868–1940

Woman Before a Plaster Relief,
ca. 1900–1904
Oil on canvas, 21 × 27½ inches
Gift of the Forward Arts Foundation, 70.33

VUILLARD WAS ONE OF A GROUP OF ARTISTS who called themselves the Nabis, derived from the Hebrew word for prophet. Founded in the early 1890s and influenced by Paul Gauguin, these artists developed a style characterized by the use of heavy outlines and flat, patterned application of paint. Around 1900, Vuillard's style underwent a major change as his compositions opened and color palette brightened, but the artist continued to paint the domestic interiors that early in his career had earned him the title "Intimiste." The puzzling scene in this painting may be set in the artist's studio in the Rue Truffaut in Paris, which is lined with books and adorned with plaster casts of sculpture. The woman who seems to be the subject of the painting could be a model, a patron, or a visiting friend. Her figure is truncated just below the shoulders, as if she herself were a portrait bust, so we can only surmise what she is doing or why she is there. —David A. Brenneman

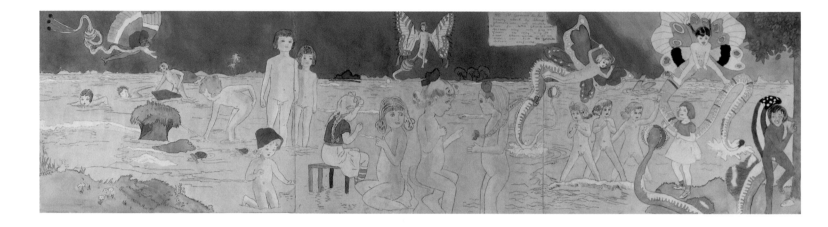

Henry Darger
American, 1892–1973

40 at Jenny Richee Facing attack by blengiglomeneans who mistake them for little Glandelinians because they wore gray [uniforms], the only way to save save themselves is to undress & hide the Glandelinian uniforms, early to mid-twentieth century
Watercolor, pencil, and ink on paper, 18¾ × 69¾ inches
T. Marshall Hahn Collection, 1997.52.1–4

IN A 15,145-PAGE TYPESCRIPT he began around 1909, Henry Darger invented a world of ineffable beauty and unspeakable horror, which he later illustrated with more than 250 double-sided watercolors. Overflowing with menace and violent detail, *The Story of the Vivian Girls, in what is Known as the Realms of the Unreal, of the Glandeco-Angelinian War Storm, Caused by the Child Slave Rebellion* is a tale of good versus evil. It recounts the wars among the citizens of various nations on a distant planet, including the malevolent Glandelinians, who enslave children, and their enemies, the Christian Abbieannians. The story's heroines are the seven blond Vivian sisters, Abbieannian princesses who ultimately lead their nation to triumph. Darger's narrative and drawings demonstrate a fascination with physical suffering.

The long horizontal sheet titled *40 at Jenny Richee...* features the Vivian sisters and Blengiglomeneans, enormous flying dragons who protect the Vivian girls. The children stand in the waters of an immense flood, one of the principal disasters in *The Realms of the Unreal,* in front of skies blackened by vast fires. —Susan Mitchell Crawley

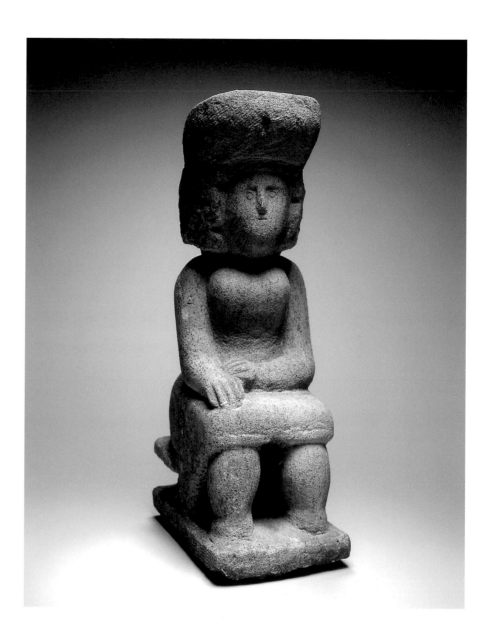

William Edmondson
American, 1874–1951

Nurse, late 1930s
Limestone, 22 × 7 × 11 inches
Purchase with Fay and Barrett Howell Fund,
1983.61

WILLIAM EDMONDSON BEGAN TO CARVE limestone blocks in his yard in Nashville, Tennessee, after the voice of God told him to do so. Using a homemade chisel, Edmondson first carved tombstones and later sculpted birdbaths, human figures, animals, and architectural forms, filling his yard with careful arrangements of his sculptures and monuments. Edmondson's subjects are often heroes of the African American community, such as teachers and preachers. Here he celebrates the nurses he admired during his long employment at a Nashville hospital.

Nurse demonstrates Edmondson's elegant economy of form. He rendered the basic shapes of the body as geometric volumes, concentrating details in the facial features and carefully coiffed hair. The hands, positioned gracefully in her lap, lend the figure a delicacy that belies its solidity. —Susan Mitchell Crawley

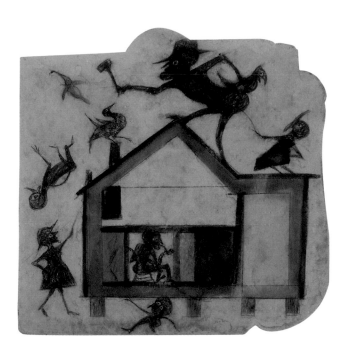

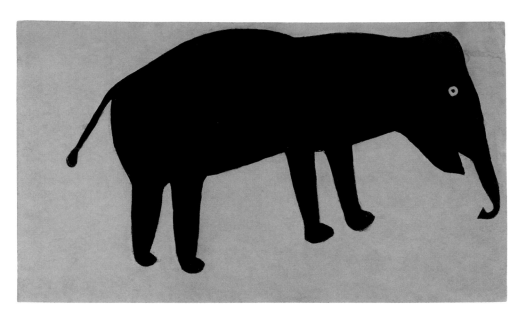

Bill Traylor
American, ca. 1853–1949

Untitled (Exciting Event: House with
Figures), ca. 1939–1947
Pencil and poster paint on cardboard,
13½ × 13⅞ inches
T. Marshall Hahn Collection, 1997.114

Untitled (Black Elephant with a Brown Ear),
ca. 1939–1947
Pencil and poster paint on paper,
14⅝ × 25¾ inches
T. Marshall Hahn Collection, 1997.113

DURING THE FINAL YEARS of the Great Depression in Montgomery, Alabama, a retired field hand in his eighties named Bill Traylor drew extraordinary images on pieces of discarded cardboard. The radically simplified forms of Traylor's drawings seem to echo the reductive tendencies of modernism and the witty vitality of his vision is striking.

Nowhere is the ebullience of Traylor's drawings more apparent than in his multifigure compositions, such as the drawing of a house with figures, which may have been inspired by an episode of poultry theft Traylor remembered. Traylor's negative space takes on a character of its own, intensifying the tension of the scene, which is drawn together by the relationship of curving lines. The artist often drew attention to important elements of his works through adjustments in scale—here, the man on the roof seems to provide the key to the action.

Traylor's dynamic line is seen in the subtle curve of the elephant's back, energizing this portrait of a calm but powerful beast. The repetition of ovals in the bulbous black tail and feet sets up a rhythm interrupted by the unexpected brownness of the dainty oval ear.
—Susan Mitchell Crawley

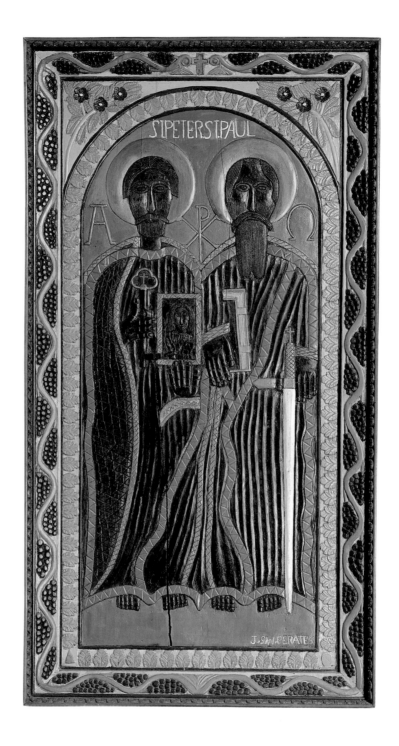

John S. W. Perates
American, born Greece, 1895–1970

St. Peter and St. Paul, ca. 1940s
Carved wood with paint, 73⅞ × 39 ×
5⅛ inches
Purchase with the T. Marshall Hahn Folk Art
Acquisition Fund for the T. Marshall Hahn
Collection, 1998.40

THREE RICH VEGETAL BORDERS SURROUND John Perates's representation of St. Peter and St. Paul. Subtle colors harmonize the complex patterning of the borders and prepare the eye for the tracery of low-relief ornamentation adorning the figures. Zigzags, cross-hatchings, and gold trim decorate the chitons of the two apostles, and striations bring texture and order to hair and beards and surround the eyes of the saints with radiant eyelashes.

Over three decades, Perates carved a series of panels depicting the life of Christ, the purported composers of the New Testament, and the earliest church fathers. Trained as a wood carver by his grandfather in Greece, he immigrated in 1912 to Maine, where he became a cabinetmaker. Perates derived his style from Byzantine icon painting that he had known since childhood. According to convention, St. Peter holds the key to the kingdom of God and an icon of Christ Pantocrator. St. Paul holds the sword of his martyrdom and his book of epistles.
—Susan Mitchell Crawley

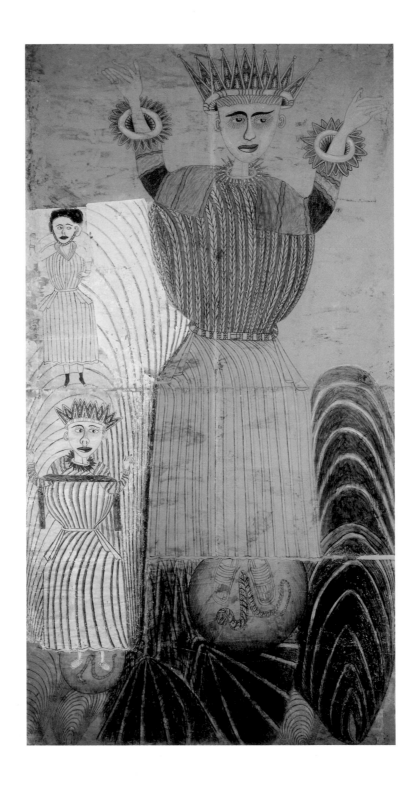

Martin Ramirez
American, born Mexico, 1895–1963

Untitled (Inmaculada), ca. 1950s
Crayon, pencil, watercolor, and collaged
papers, 92 × 45 inches
Purchase with T. Marshall Hahn Folk Art
Acquisition Fund for the T. Marshall Hahn
Collection, 1999.93

WHILE HOSPITALIZED FOR SCHIZOPHRENIA for more than thirty years, Martin Ramirez never spoke, but he created a body of powerful artworks built around a group of personal icons, including a Madonna figure he depicted many times. Ramirez spent his early years in the western Mexican state of Jalisco, where he would have seen Roman Catholic icons, locally carved figures, and regional interpretations of European religious symbols. One of the most popular of these figures is the Virgin of the Immaculate Conception, or Virgin Inmaculada, which presents the Madonna as the woman clothed with the sun, as described in the twelfth chapter of Revelation. She often appears crowned with stars, standing on the moon, with a serpent beneath her feet. Ramirez's large Inmaculada is dressed in Indian clothing and stands on a globe like the moon of the traditional Inmaculada. —Susan Mitchell Crawley

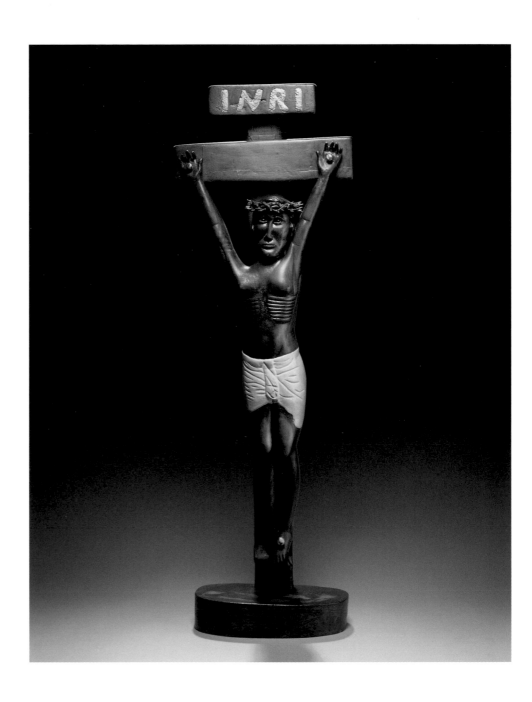

Ulysses Davis
American, 1914–1990

Jesus on the Cross, 1946
Carved cedar, mahogany crown of thorns with
toothpicks, and paint, 40½ × 14 × 6 inches
Purchase with general funds and funds from
friends of the Museum, 1995.64

ULYSSES DAVIS'S METICULOUSLY CARVED wooden sculptures are remarkable for their
wide range of subject matter and their expressive intensity. The Savannah artist whittled wood
between haircuts at Ulysses Barber Shop, the business he owned and operated for many years.
By the time of his death, Davis had created more than three hundred carvings inspired by
history, politics, fantasy, and religion.

Jesus on the Cross is one of many works that reflect Davis's deep religious convictions. To
prepare for this carving, Davis said, "I hunted around for the best piece of cedar I could find.
Nothing was too good for Jesus. I wanted this to be my masterpiece." Many aspects of Christ's
figure are exaggerated: the mask-like face is contorted, the ribs are reduced to a series of inden-
tations, and the stomach is a simplified semi-sphere. Davis's formal abstraction enabled him to
render sacred figures in an appropriate manner, for he believed that depicting them in human
form verged on sacrilege. The marks of Davis's tools are uncharacteristically evident on the
work's surface and reveal the vigor of his carving. Davis said, "As I worked on Jesus, I thought
of his being nailed to the cross, the strain on his body and the suffering he went through. How
he endured what was brought on him by mankind." —Beth Hancock

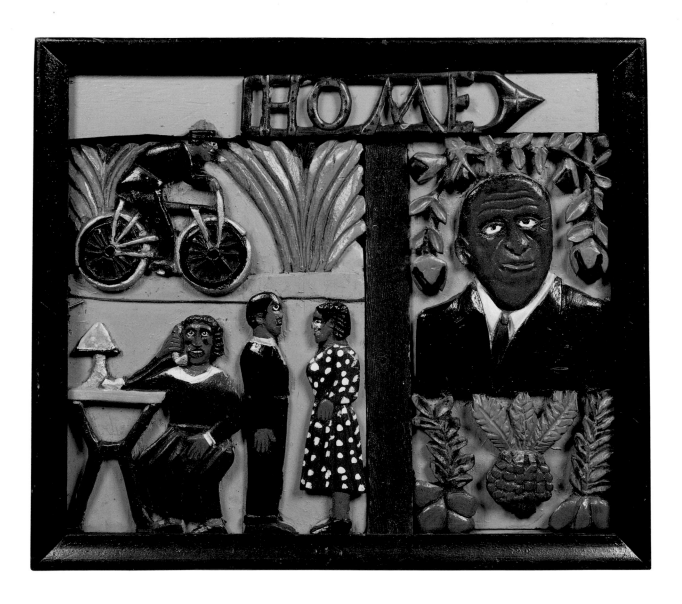

Elijah Pierce
American, 1892–1984

*Three Ways to Send a Message: Telephone,
Telegram, Tell-a-Woman*, ca. 1941
Carved wood with paint, 15½ × 18 ×
1½ inches
Purchase with T. Marshall Hahn Folk Art
Acquisition Fund for the T. Marshall Hahn
Collection, 1998.80

THIS WORK SHOWS THE SKILLED CARVING and assured design Elijah Pierce achieved at the height of his artistic powers. The relief is deeply cut, but the overall effect is of a flat pictorial space polychromed in soothing colors.

The left panel of the composition illustrates the old joke in the title. A telegraph delivery-man speeds down a road. Below him, a woman talks on the telephone and a couple talks in person. The right panel contains a portrait of the African American scientist and professor George Washington Carver, haloed by persimmon boughs and surmounting a display of sweet potatoes and peanuts. —Susan Mitchell Crawley

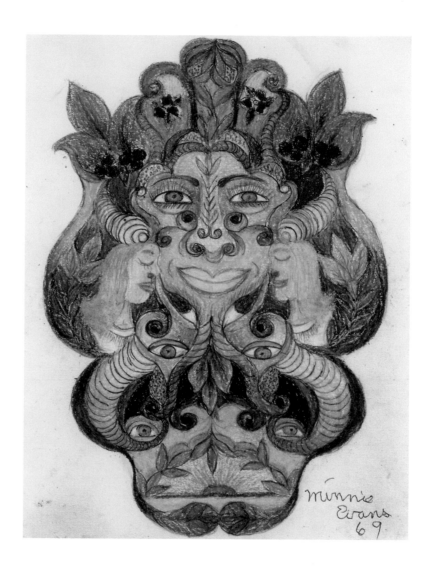

Minnie Evans

American, 1892–1987

Untitled (Three Faces Surmounting a
Landscape), 1969
Crayon and pencil on paper, 11⅞ × 9⅛ inches
T. Marshall Hahn Collection, 1997.68

MINNIE EVANS'S DRAWINGS WERE INSPIRED by her dreams and visions. The results seem
to have surprised even the artist. "Something told me to draw or die," she once said. "It was
shown to me what I should do. . . . When I get through with them I have to look at them
like everybody else. They are just as strange to me as they are to anybody else." In her brightly
colored, detailed drawings, Evans layered worlds of nature and spirit, plant and animal, human
and divine in symmetrical compositions of intricate swirling lines. Her spring of imagery was
steadily replenished by the flowers and foliage of Airlie Gardens on the Pembroke Estate near
Wilmington, North Carolina, where she was the gatekeeper for twenty-seven years.
—Susan Mitchell Crawley

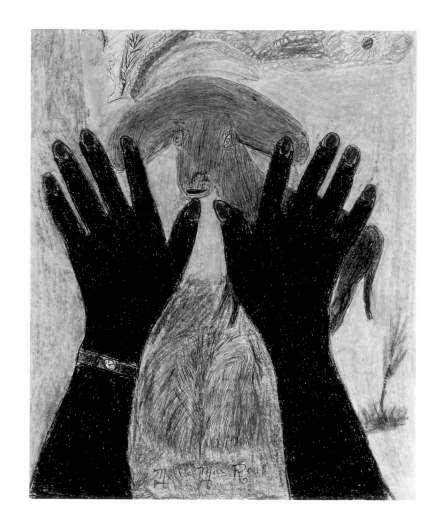

Nellie Mae Rowe
American, 1900–1982

Peace, 1978
Crayon and pen on paper, 17 × 14 inches
Gift of Judith Alexander, 2003.219

THROUGHOUT HER LIFE, Nellie Mae Rowe preferred making art to most other pursuits. When her parents insisted she leave school in the fourth grade to help out on the family farm in Fayette County, Georgia, she used art to escape the tedium of her chores. Upon the death of her husband many years later, Rowe's passion to create erupted in various media. Using found objects, gifts, and her own creations—including drawings, dolls, and chewing gum sculptures—Rowe elaborately decorated her home inside and out, calling it Nellie's Playhouse. Her art combined play and religious devotion into a distinctive celebration of God's gifts. "I try to draw because He is wonderful to me," she said. "I just have to keep drawing until He says, 'Well done, Nellie, you have been faithful.' Then I will know that I have finished my work." *Peace* is one of the best known of her gloriously colored drawings. —Susan Mitchell Crawley

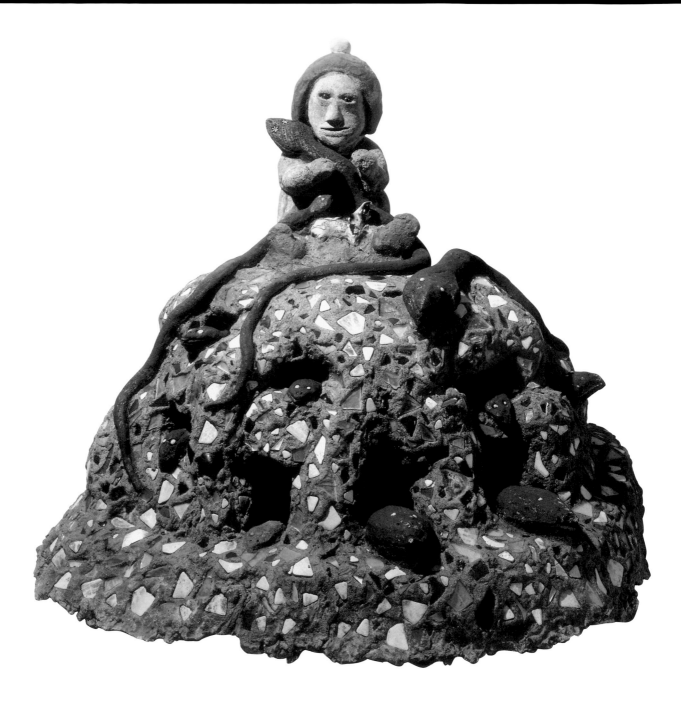

Howard Finster
American, 1916–2001

Weaned Child on the Cockatrice's Den,
ca. 1979
Paint on concrete, glass, mirrors, ceramic,
white marble stone, and brick, 38 × 41 ×
31 inches
Purchase with funds from the Cousins
Foundation, Inc., and donors to the Paradise
Project Campaign, 1994.216.2

And the sucking child shall play on the hole of the asp, and the weaned child shall put his hand on
the cockatrice' den. They shall not hurt nor destroy in all my holy mountain; for the earth shall be
full of the knowledge of the Lord, and the waters cover the sea. —Isaiah 11:8–9.

THE WEANED CHILD PLAYS SAFELY atop a nest of cockatrices (serpents). The child can even
nuzzle a snake crooked in his arm, because the enmity between living things has ended with
the return of Christ. The image, which appears in the book of Isaiah, inspired this sculpture
from Finster's visionary environment, Paradise Garden.

A perfect world was a theme of much of Finster's art. In the 1960s he began to construct
his masterpiece, Paradise Garden, on a piece of swampland he reclaimed in Pennville, Georgia.
He channeled the water into streams running around the four-acre plot and through fantastic,
mirror-bedecked wood and concrete constructions encrusted with found objects of every kind.
Like many Southern self-taught artists, Finster was fascinated by the power of the written word;
signs scattered throughout the Garden broadcast messages from Finster and the Bible, and paint-
ings, usually incorporating inscriptions, decorated the buildings. —Susan Mitchell Crawley

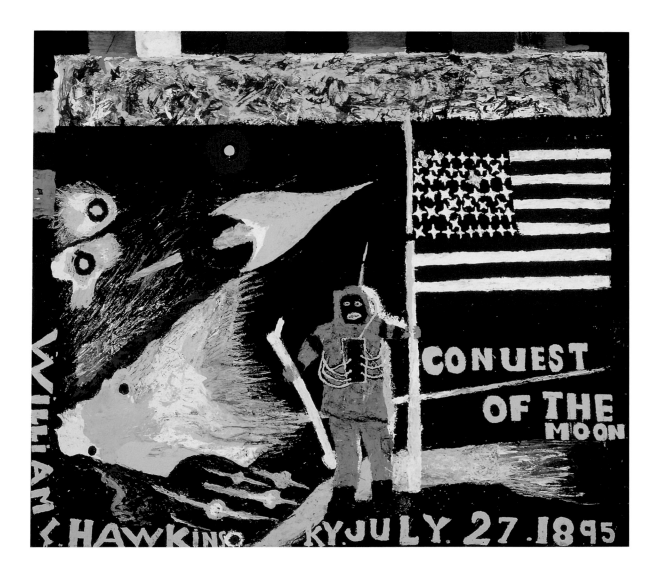

William L. Hawkins
American, 1895–1990

Con[q]uest of the Moon #1, 1984
Enamel paint on Masonite, 48 × 56⅛ inches
T. Marshall Hahn Collection, 1996.27

THE EARLIER OF AT LEAST TWO TREATMENTS of the subject, this painting of the first moon landing—with its sophisticated composition, fantastic colors, and virtuoso brushwork—is widely regarded as one of William Hawkins's greatest works. Behind the small astronaut in his audacious green spacesuit, the black infinity of the cosmos erupts in a riot of explosions and rockets, as if the universe itself were hailing—or protesting—this achievement. By painting the astronaut as a black man, Hawkins implicitly critiqued America's twentieth-century racial history as he reaffirmed this event as a "giant leap" for *all* mankind. His furious brushwork energizes the scene and dances near the top of this image in a decorative band that recalls stitchwork samplers.

Hawkins collected images from magazines and books to use as inspiration for his works. Although he often borrowed entire scenes for his paintings, in this case he probably combined several images of the moon landing he had gathered from popular periodicals.
—Susan Mitchell Crawley

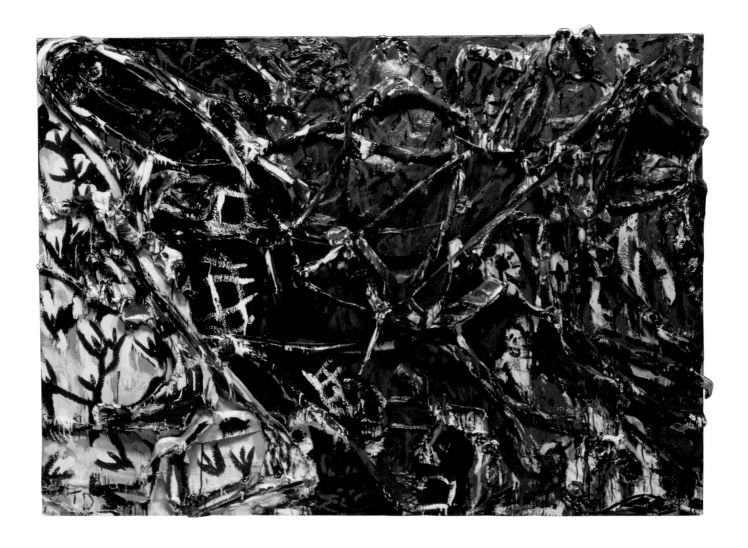

Thornton Dial
American, born 1928

Heading for the Higher Paying Jobs, 1992
Enamel and oil paints, cloth, tin, wood, and
industrial sealing compound on canvas,
mounted on wood, 64½ × 90 × 9 inches
T. Marshall Hahn Collection, 1997.55

DURING THE GREAT MIGRATION in the first part of the twentieth century, many African Americans left the rural South for the industrial North. Others stayed in the South but moved from farming communities to work in manufacturing towns like Bessemer, Alabama. This large mixed-media canvas portrays the migration of workers from the cotton fields of slavery and sharecropping to more remunerative industrial labor. On the left, the Southern sun bakes the ground where a brown field hand picks cotton. Above him, an open-mouthed mask struggles out of a dark coal vein; from the bottom an observant tiger peers. The broad, ruddy streak of an iron mine gives way to the blaze of a steel furnace that illuminates faces. Thornton Dial's painting also reveals the darker side of progress. The vine that constitutes the overseer's whip writhes from the cotton field through the mines to the steel mill, suggesting the powerlessness of the wage earner. The importance of struggle in annealing the spirit is evident here. As Dial says, "It takes fire to harden the material. It takes beating to harden the material. That's life."
—Susan Mitchell Crawley

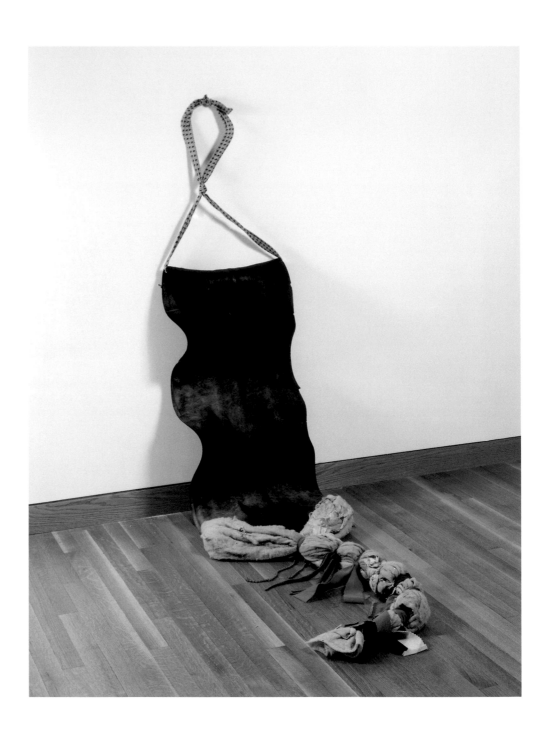

Lonnie Holley
American, born 1950

Blown Out Black Mama's Belly, 1994
Rubber inner tube, cloth, and wire coat
hanger, 84 × 22 × 4 inches
T. Marshall Hahn Collection, 1996.40

LONNIE HOLLEY'S ASSEMBLAGE of stretched inner tube and scraps of cloth is his tribute to his mother. According to the artist, Dorothy Mae Holley Crawford bore many children before her death in 1986. The ligatures on the lower portion of the piece represent the tied-off umbilical cords of this long series of children and by extension all the children of the world. Holley's amazement at the bodily stress of bearing and nurturing so many children pervades his homage.

The recycled materials in Holley's assemblages suggest their previous uses. A necktie supports the structure while recalling its human wearer. Years of hauling products across the continent left a patina of age and use on the dirty rubber inner tube. The umbilical of shredded stuffing spreads out on the ground like a chaise lounge left to weather, and the fabric strips recall discarded clothing. —Susan Mitchell Crawley

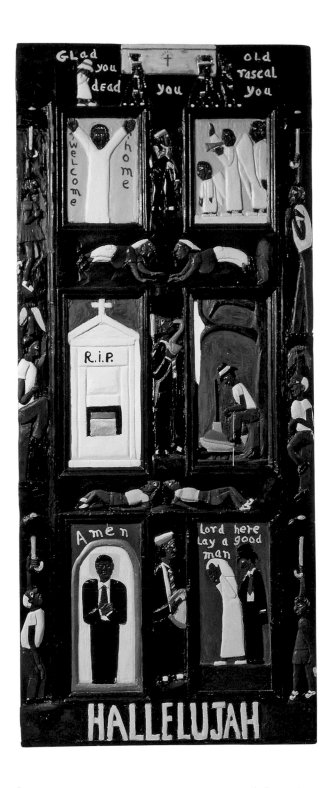

Herbert Singleton
American, born 1945

Hallelujah Door, 1993
Carved wooden door with enamel paint,
115¼ × 48¾ × 1¾ inches
T. Marshall Hahn Collection, 1996.185

SINGLETON TURNS CAST-OFF PLANKS and doors into records of life in his New Orleans neighborhood. His most common themes are street life, the oppression of blacks, biblical stories, and the jazz funeral. The artist has arranged his composition so that the events of burial and resurrection appear on the door panels while those of the funeral parade appear on the vertical and horizontal door elements. "Hallelujah" across the bottom rail signals the turning point between the sorrowful cortege and the celebratory return from the cemetery. Woven into the funeral procession at the top are words from a 1929 song by New Orleans jazzman Sam Theard. At the bottom right, a red dress indicates to Singleton the erosion of traditional values. —Susan Mitchell Crawley

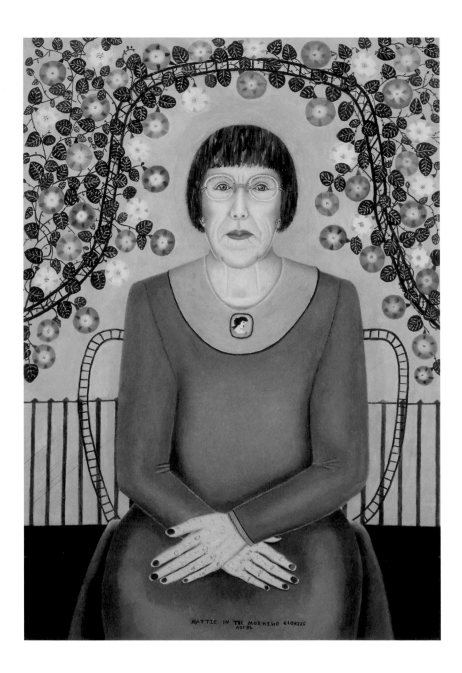

Mattie Lou O'Kelley
American, 1908–1997

Mattie in the Morning Glories, 1992
Oil on canvas, 39⅛ × 27⅜ inches
T. Marshall Hahn Collection, 1996.30

ALTHOUGH SHE IS BEST KNOWN for her memory paintings, Mattie Lou O'Kelley often painted subjects from life. This is the later of two self-portraits O'Kelley created for her friend and patron Marshall Hahn. The eighty-four-year-old artist paints herself wearing a cameo pin Hahn brought her from Italy, characteristically enriching its colors. In contrast to the bright, sweet tints in which she rendered the blossoms of the arbor, O'Kelley clothed herself in sour-apple green and its complement, pink, and set herself against a lemon yellow background. The astringent hues disrupt what might otherwise be a cloying scene.

The artist's hands bear the marks of a lifetime of hard work. Although O'Kelley complained that her hands looked ugly—in life and in the portrait—this artist, who regularly sweetened her childhood memories as she interpreted them on canvas, chose here to paint her hands as they were. Her one concession to vanity seems to have been adorning her nails with bright red polish to go with her rosy lipstick.

Morning glories had a special significance for O'Kelley. They grew wild around her tiny house in Maysville, Georgia ("just for me," she said). "Sometimes I wish I had all the morning glories I ever painted and gave a morning glory show in dead of winter," she wrote.
—Susan Mitchell Crawley

124

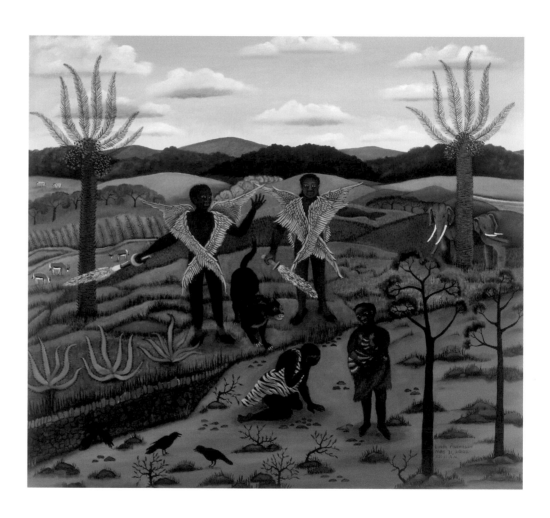

Linda Anderson

American, born 1941

The Banishment from the Garden of Eden,
2002
Oil on canvas, 22 × 24 inches
Purchase with funds from Mr. and
Mrs. Anthony Montag, Jane and Bert
Hunecke, and the Folk Art Acquisition
Fund, 2004.179

LINDA ANDERSON BEGAN PAINTING in the early 1980s, reproducing vignettes from her youth in the north Georgia mountains that would come to her as detailed visions she describes as "flashes of memory." During the past two decades her subject matter has expanded to other themes, including the Garden of Eden.

The Banishment depicts the expulsion of Adam and Eve from Eden after they have disobeyed God's command not to eat from the tree of the knowledge of good and evil. At the edge of the Garden two angels brandish swords of flame. Just outside of the Garden, Adam crouches on the bare ground, consumed by his immediate misery, while Eve stares down mournfully, as if foreseeing the long, bitter future to which their disobedience has doomed the human race. The linear division of the composition opposes lushness and desolation, while its strong diagonal produces a sense of vertigo, as if the ground has just dropped out from under the viewer.
—Susan Mitchell Crawley

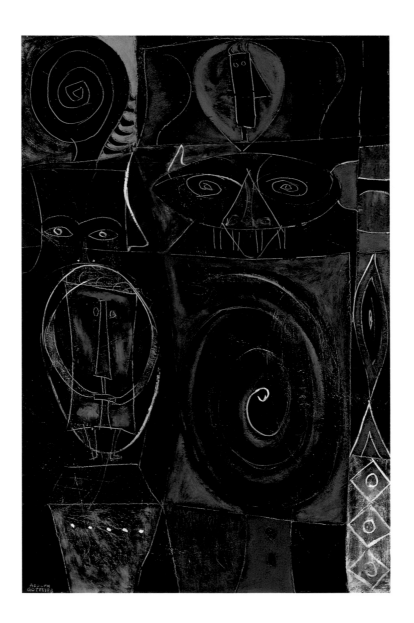

Adolph Gottlieb
American, 1903–1974

Masquerade, 1945
Oil and tempera on canvas, 36 × 24 inches
Purchase with High Museum of Art
Enhancement Fund and 20th Century Art
Acquisition Fund, 2000.201

BY 1935, WHEN HE HELPED CO-FOUND "THE TEN," Adolph Gottlieb had formed endur-ing friendships with several other young artists interested in expressionism, including Mark Rothko. They were particularly interested in Surrealism, which they came to know through the European expatriate artists who sought refuge in the United States during the Second World War. Gottlieb was particularly struck by the Surrealists' invention of automatic draw-ing based on the Freudian theory of the unconscious, and this played a key role in shaping his paintings. At the same time, he found inspiration in African and Native American masks that he began to collect in 1935.

In 1941 Gottlieb began his first mature body of work, which he called "pictographs." Each pictograph began with a rough grid, each square of which was filled with a shape or symbol that held psychological or mythological power. In *Masquerade,* mysterious faces emerge from the depth of the painting as if recalled from a dream. Gottlieb's title directs attention to the use of masks throughout history and across cultures, a reading he reinforced with earthy hues and textures. —Jeffrey D. Grove

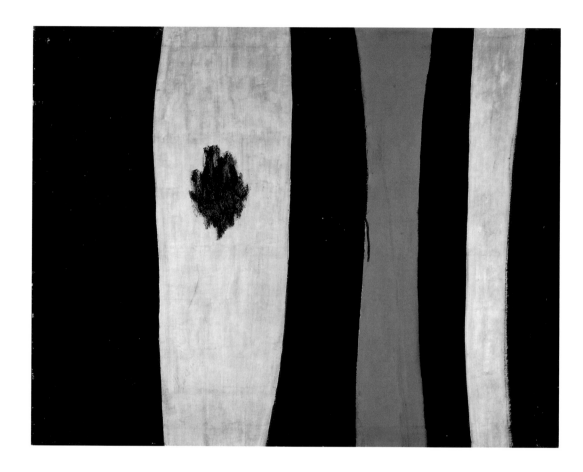

Robert Motherwell

American, 1915–1991

Barcelona, 1950
Oil on canvas, 30 × 38 inches
Purchase with funds from Alfred Austell
Thornton in memory of Leila Austell
Thornton and Albert Edward Thornton, Sr.,
and Sarah Miller Venable and William Hoyt
Venable and gift of the Dedalus Foundation,
2000.172

BORN AND RAISED ON THE WEST COAST, Robert Motherwell was educated in philosophy and aesthetics at Stanford and Harvard and did not fully devote himself to art until he settled in New York in 1939. He quickly became friends with the Surrealists who were then fleeing Europe and he embraced their theories of automatism, a means of using unconscious impulses to generate imagery. He became part of the community of Abstract Expressionist artists who were breaking with traditional conventions and pushing art into a more emotional and intellectual path. Well educated, well read, and articulate, Motherwell quickly became the unofficial spokesman for his peers, writing critical articles, giving speeches, and forming discussion groups around their new ideas.

Barcelona is a simple, frontal composition that encompasses several key motifs that Motherwell explored throughout his career. During the 1940s, he produced a series of stunning collages that he related to larger emotional, political, and philosophic struggles. Using torn paper on minimal backgrounds, he created work that was at once discordant and lyrical. In 1966, observing Motherwell's technique, the poet and curator Frank O'Hara wrote, "The family of forms is a relatively small one . . . whether passionate or subtle, whether buoyant or subdued; they are never used for narrative purposes." *Barcelona* develops this visual language through the use of emotionally charged brushwork within a severe, architectonic structure.

—Jeffrey D. Grove

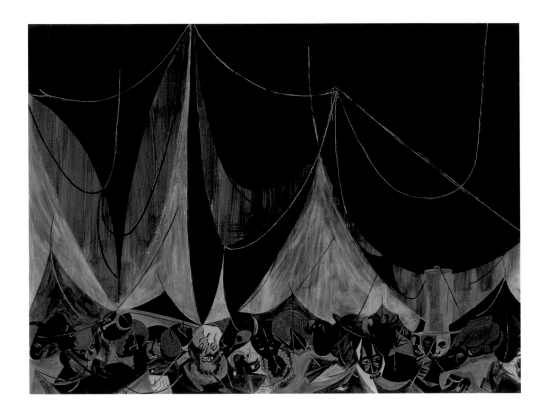

Jacob Lawrence
American, 1917–2000

Marionettes, 1952
Tempera on panel, 18¼ × 24½ inches
Purchase with funds from the National
Endowment for the Arts and Edith G. and
Philip A. Rhodes, 1980.224

JACOB LAWRENCE GAINED EARLY CRITICAL ATTENTION during the late 1930s with his narrative series on themes from black life and history. Throughout his career, his subject matter focused mainly on the struggle for freedom and social justice. *Marionettes* is one of the artist's more abstract works, reflecting the influence of Cubism's flat angularity. It also pays homage to traditional African art's geometric simplification in the mask-like faces of the tangled puppets.

Marionettes is inspired, according to Lawrence, by Harlem theaters, particularly the Apollo, where he often went in his youth. It is part of a series of works the artist made in 1952 that treat the subject of black theater. Rather than portraying the stars or landmark buildings, these paintings focus on performance and theatrical illusion—role-playing and the manipulation of individuals by others are the prevailing themes of the series. Here, for example, the stage curtain falls on lifeless puppets. Lawrence painted this work less than two years after his voluntary commitment to a psychiatric hospital. Thus, *Marionettes* may also be viewed as a commentary on certain kinds of relationships, an uncommonly personal subject for this artist. —Carrie Przybilla

Tony Smith
American, 1912–1981

Untitled (Louisenberg), 1953–1954/1968
Acrylic on canvas, 99¾ × 139¾ inches
Purchase with funds from Alfred Austell
Thornton in memory of Leila Austell
Thornton and Albert Edward Thornton, Sr.,
and Sarah Miller Venable and William Hoyt
Venable, 2003.66

KNOWN PRIMARILY FOR THE LARGE, ABSTRACT SCULPTURES made during the last twenty years of his life, Tony Smith was also an accomplished architect and painter. All of Smith's work explored the link between natural, biomorphic forms and the underlying universal structure that might be revealed through ideal geometry.

Born into a large, prosperous Irish Catholic family, Smith developed tuberculosis at age four and was intermittently confined to a separate, one-room house where he lived in virtual isolation until he recovered ten years later. In 1938 he became an apprentice to Frank Lloyd Wright, spending time as a carpenter's assistant and bricklayer on Wright's Ardmore project outside Philadelphia, studying briefly at Taliesin, and helping build Wright's Armstrong House in Ogden Dunes, Indiana. This experience provided Smith with the knowledge and contacts to open his own architectural firm in 1940.

Smith made the Louisenberg paintings—titled after a geological site near the Wagnerian city of Bayreuth—during a period spent in Germany in the early 1950s. Created far from New York and Smith's Abstract Expressionist friends, a variety of influences come to bear in the Louisenberg paintings: the ideals of the Bauhaus, Jean Arp's biomorphic forms, and Hans Hofmann's doctrine of chromatic tension. The series evolved from twenty-five thumbnail sketches, permutations of a single idea Smith drew on a sheet of lined writing paper. Smith's emergence as a sculptor in the 1960s caused him to be linked with the next generation of sculptors, including Carl Andre, Donald Judd, and Robert Morris. In 1968 Smith returned to his original Louisenberg sketches and with two assistants fabricated large paintings based on the most complex drawings. —Jeffrey D. Grove

Philip Guston
American, born Canada, 1913–1980

The Painter, 1959
Oil on canvas, 65 × 69 inches
Purchase with funds from the National
Endowment for the Arts, 74.118

PHILIP GUSTON WAS ONE OF A GROUP of artists in the 1950s associated with Abstract Expressionism. The actual painting process—the creative act itself—was highly valued by these artists, who tried to capture the energy of that process in their painting. In *The Painter,* an imposing, central black form seems to suggest both an easel and a figure in motion. The title implies that this animated form is the artist, involved in passionate, improvisational painting. This figure, composed of rapid brushstrokes, exemplifies the words of Harold Rosenberg, a critic close to the Abstract Expressionists, whose well-known 1952 essay "The American Action Painters" asserts: "A painting that is an act is inseparable from the biography of the artist. . . . The new painting has broken down every distinction between art and life." —Carrie Przybilla

Morris Louis
American, 1912–1962

Number 1-81, 1961
Acrylic resin on canvas, 82½ × 58 inches
Purchase with funds from Harriet and
Elliott Goldstein and High Museum of
Art Enhancement Fund, 2001.3

MORRIS LOUIS'S MATURE PAINTING STYLE developed in response to the work of the
Abstract Expressionists, particularly the paintings of Jackson Pollock and Helen Frankenthaler.
He embraced critic Clement Greenberg's assertion that painting must maintain its integrity as
a two-dimensional surface and avoid illusionistic representation. In particular, Louis recognized
the potential of Frankenthaler's technique of staining canvas to achieve the complete integra-
tion of paint with canvas. In 1953, at the age of forty-one, he began to paint without brushwork
or textured surfaces, pouring paint directly onto the canvas.

Number 1-81, painted in the last year of Louis's life, is from his last series of "Stripe" or
"Pillar" paintings. Ruthless in their simplicity, each is composed of parallel vertical bands of
brilliant color. In this work, the overlapping stripes of color seem to race toward the top of the
work, asymmetrically dissecting its rectangular plane but never quite reaching the upper edge.
This energizes the entire canvas, which appears to be in constant motion. —Carrie Przybilla

Frank Stella
American, born 1936

Manteneia I, 1968
Acrylic on canvas, 60 × 240 inches
Gift of Frances Floyd Cocke, 1978.46

ALTHOUGH OTHER ARTISTS HAD DEPARTED from the traditional rectangular support for their paintings, Frank Stella was among the first to explore the shaped canvas; his canvas's irregular format coincides with the pattern painted on it. *Manteneia I* is part of a long series of works based on semi-circular motifs, known as the Protractor series. Possibly inspired by patterns in medieval Irish manuscripts, the interwoven bands of fluorescent hues create spatial discontinuities since none of the arcs lies in consistent relationship with the others.

Stella strives for an immediate, purely visual effect, stating in a 1966 *Artnews* interview: "All I want anyone to get out of my paintings . . . is that you can see the whole idea without confusion. . . . What you see is what you see." —Carrie Przybilla

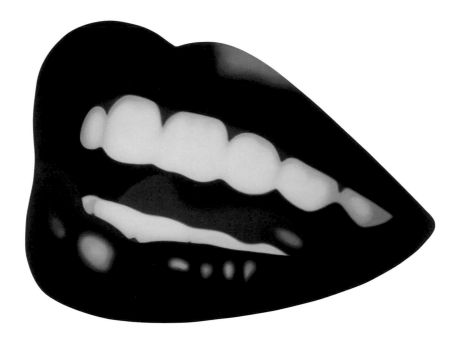

Tom Wesselmann
American, 1931–2004

Mouth #15, 1968
Oil on shaped canvas, 68 × 91 inches
Purchase in honor of Rawson Foreman,
Chairman of the Board of Directors,
1998–1999, with funds from Alfred Austell
Thornton in memory of Leila Austell
Thornton and Albert Edward Thornton, Sr.,
and Sarah Miller Venable and William Hoyt
Venable, 1999.47

FROM THE BEGINNING OF HIS CAREER in the late 1950s, Tom Wesselmann appropriated imagery from magazine photos and newspaper ads into his intimately scaled depictions of domestic interiors populated with female nudes. In a 1999 letter to the director of the High Museum, the artist explained that these works "were an attempt to go one step further from Matisse, to be more American and more bluntly erotic. Not erotic to be sexual, but erotic as an esthetic element of aggression."

In the mid-1960s, as Pop Art came to prominence, Wesselmann began to enlarge the scale of his works. Almost simultaneously, he began to focus on specific body parts—feet, mouths, breasts—but continued to situate them within a domestic environment. His first *Mouth* painting, begun late in 1965, was the first time the artist totally isolated a body part. Each work in the series, which he pursued into the early 1970s, depicts a single mouth that entirely fills a shaped canvas. They might belong to any one of his nudes from the same period. Although the artist has always preferred to work from live models, his *Mouth #14* and *Mouth #15* are based on photographs of Marilyn Monroe taken by Bert Stern, a friend of Wesselmann's. Simultaneously seductive, remote, and ominous, *Mouth #15* raises questions about the relationship of celebrity, sex, and aggression. —Carrie Przybilla

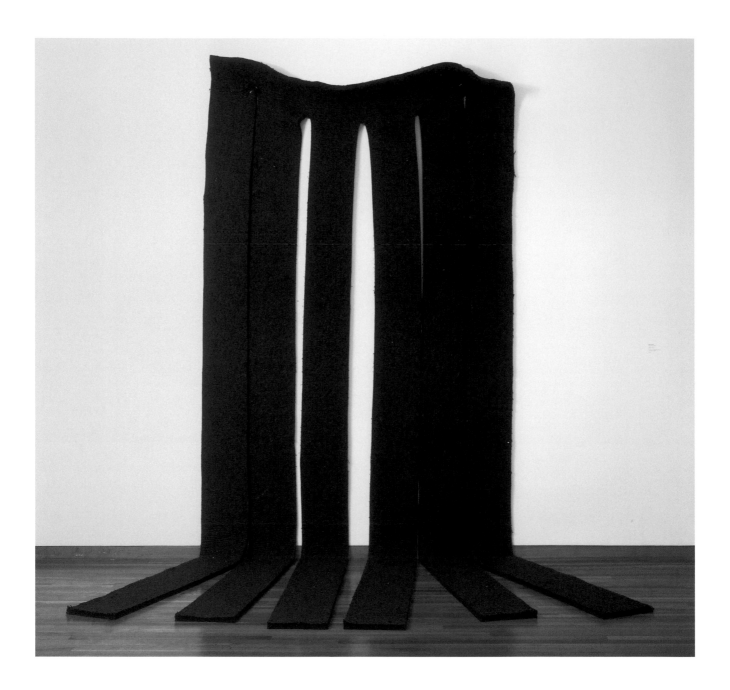

Robert Morris
American, born 1931

Untitled, 1969
Felt, 125 × 72 × 55 inches
Purchase with funds from Edith G.
and Philip A. Rhodes, 1987.35

AN ARTIST OF MANY TALENTS AND INTERESTS, Robert Morris played a central role as a sculptor and critic in defining three major artistic movements of the 1960s and 1970s: Minimalism, Process Art, and Earthworks. His first exhibited sculptures were props for dance performances he choreographed for New York's Judson Dance Theater in the early 1960s. These wooden, boxlike, geometric constructions emphasized form rather than expression and fit with the Minimalist aesthetic then on the rise. In the latter half of the 1960s, Morris explored more elaborate industrial processes for his sculpture, using materials such as aluminum and steel mesh.

Although Morris's felt sculptures appear to be radically different from the metal works, in many ways they represent a logical progression in his thinking about sculpture, while at the same time laying the groundwork for Process Art. In works such as this sculpture from 1969, Morris piled, stacked, and hung industrial-grade felt from walls and let the effects of gravity shape his work. In a 1968 essay published in *Artforum,* the artist explained that "random piling, loose stacking, hanging, give passing form to the material. . . . It is part of the work's refusal to continue estheticising form by dealing with it as a prescribed end." —Carrie Przybilla

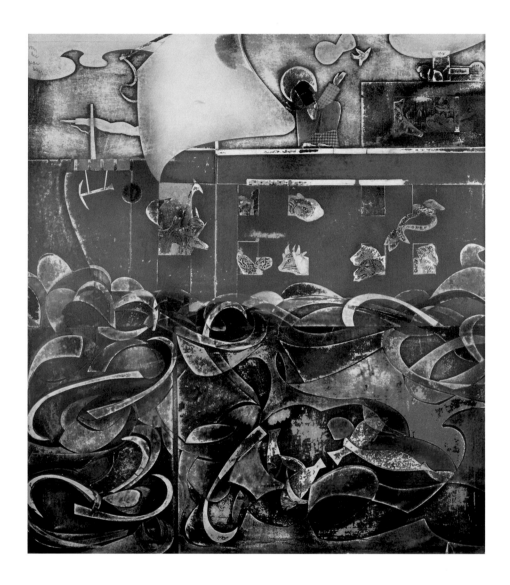

Romare Bearden
American, 1914–1988

Noah, Third Day, 1972
Collage and acrylic on board,
40½ × 35½ inches
Gift in memory of Peter Rindskopf
and purchase, 73.14

ROMARE BEARDEN DREW PRIMARILY upon personal experience, shaped by his African American heritage and his love of literature and music, to convey the universality of human experience. His studies at New York's Art Students League with the German immigrant painter George Grosz reinforced Bearden's confidence in art's power to express basic humanistic concerns. In *Noah, Third Day* Bearden imbues a well-known story from the Bible with a fresh energy through use of rhythmic patterning, flattened design, and juxtapositions of images: photographs of nature, Greco-Roman mosaics, Cubist forms, and references to African and early Christian art. In so doing, he implies a basic commonality among cultures.
—Carrie Przybilla

Ellsworth Kelly
American, born 1923

Red Curve VI, 1982
Oil on canvas, 74¼ × 140½ inches
Purchase with funds from Alfred Austell
Thornton in memory of Leila Austell
Thornton and Albert Edward Thornton, Sr.,
and Sarah Miller Venable and William Hoyt
Venable and High Museum of Art Enhance-
ment Fund, 2002.3

ELLSWORTH KELLY'S ART is about visual experience. Working with abstractions since 1949, when he lived in Paris and studied at the Ecole des Beaux-Arts, Kelly draws his forms from observation of the real world. Nonetheless, his paintings have no recognizable imagery and no illusion of depth.

The shape of *Red Curve VI* is its dominant feature. Asymmetrical yet balanced, the entire canvas functions like the "figure" in more traditional paintings; the surrounding wall reads as "background." Kelly wrote: "I have wanted to free shape from ground so that, with color and tonality, the shape finds its own space and always demands its freedom and separateness." Although completely abstract, Kelly's works typically are based on his observations of specific natural forms or elements in the urban environment, such as leaves, shadows, or reflections, all of which he repeatedly simplifies through line drawings. "My painting," he says, "is a fragment of the visual world with the third dimension removed." —Carrie Przybilla

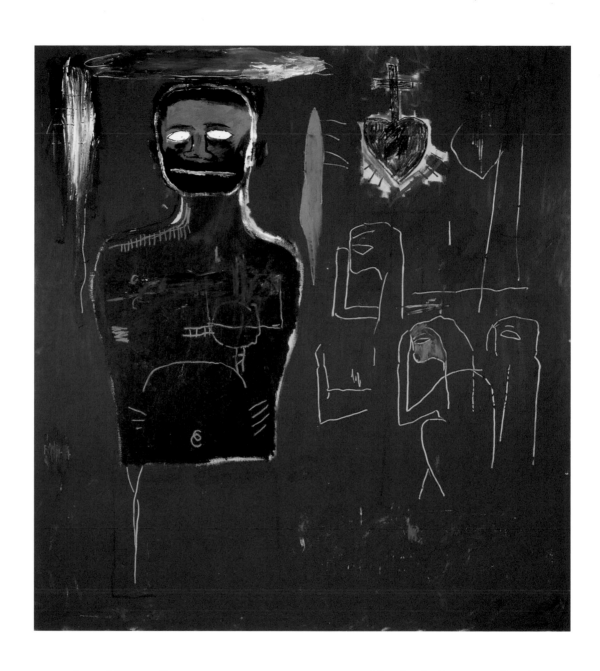

Jean-Michel Basquiat
American, 1960–1988

Untitled (Cadmium), 1984
Oil, oil stick, and acrylic on canvas,
66 × 60 inches
Purchase in honor of Lynne Browne,
President of the Members Guild, 1992–1993,
with funds from Alfred Austell Thornton in
memory of Leila Austell Thornton and Albert
Edward Thornton, Sr., and Sarah Miller
Venable and William Hoyt Venable, 1993.3

JEAN-MICHEL BASQUIAT INITIALLY GAINED recognition in the late 1970s for elaborate graffiti created on the streets of New York, a style he later transferred to painting on canvas. Raised in a middle-class home, Basquiat adopted an unschooled but street-smart persona to go with his painting. Despite its seemingly crude appearance, his art incorporates sophisticated references to contemporary culture, art history, and various pictographic codes, sometimes layered to the point of illegibility.

Untitled (Cadmium) incorporates many layers of meaning and its multiple references create a complex system of allusions that belie the unrefined appearance of Basquiat's work. Its vibrant red field recalls Henri Matisse's *Red Studio* (1911), a painting in the Museum of Modern Art that Basquiat admired and studied. The rudimentary figures he inscribed resemble mourning figures from ancient Egyptian art. The words "paper," "rock," and "scissors," painted over but still legible, recall the children's hand game. The limbless figure that dominates the canvas stares with hauntingly vacant eyes. It also bears physical wounds: a scar across the right shoulder and neck. These "track" marks recur frequently in Basquiat's work. The Sacred Heart (a wounded heart encircled by a crown of thorns and topped by a cross) above the mourning figures is a Roman Catholic symbol of Christ's suffering and unfailing love, and may refer to the artist's religious upbringing. —Carrie Przybilla

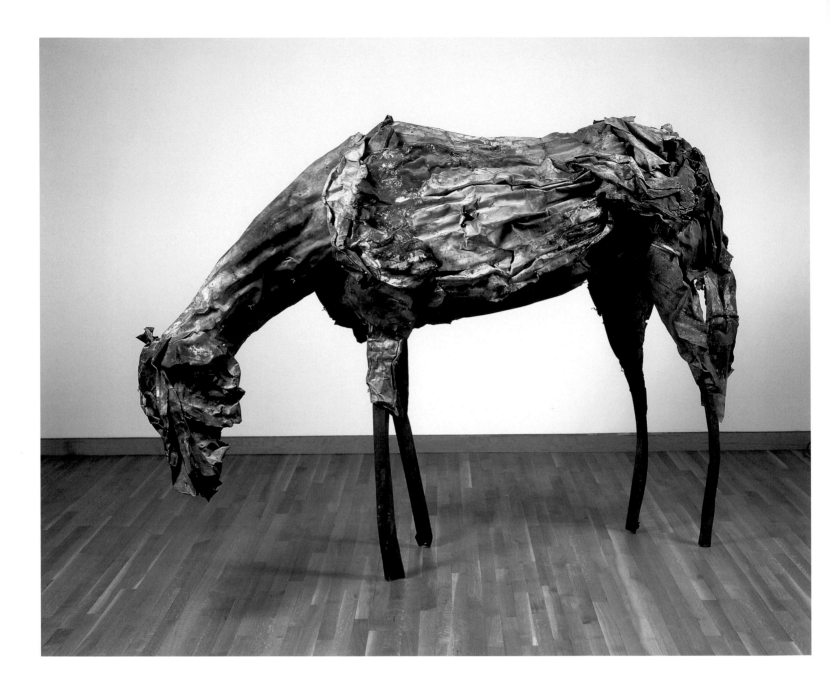

Deborah Butterfield
American, born 1949

Untitled (#3-85), 1985
Burned and crushed steel and barbed wire,
73 × 99 × 45 inches
The Lenore and Burton Gold Collection of
20th Century Art, 1999.110

ALTHOUGH DEBORAH BUTTERFIELD LOVES HORSES—she is a lifelong equestrienne—the artist is quick to note that in her sculptures horses are simply a means to an end. In various interviews she has pointed out that her work is ultimately based on "the empathy of shared gesture between horse and human. My work is about creating the empathy so that we can step into the form—if only for a split second—and have feeling for the 'other.' Most of the world is 'other,' and once we can step out of 'self,' we are more likely to be able to do so again." Life-size, created from found materials that show the effects of time, Butterfield's horses evoke a familiarity with which viewers can readily identify. This untitled work from 1985 is typical: the horse stands with neck extended, head lowered, and ears flattened in a posture that suggests submission and caution, even as it beseeches the viewer's attention. The crushed, rusting steel and barbed wire from which it is constructed reinforces the sense that this animal is bereft, decrepit, and world-weary. —Carrie Przybilla

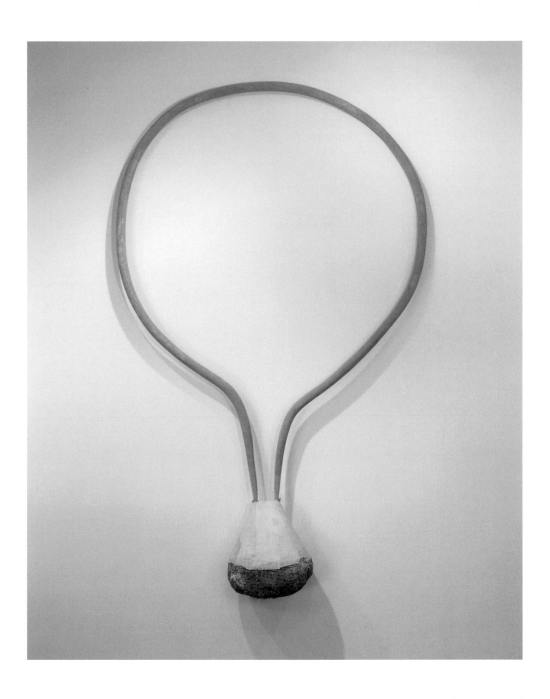

Martin Puryear
American, born 1941

Untitled, 1985
Acrylic on pine, kozo paper on steel mesh,
99 × 60 × 10 inches
Purchase with funds from Alfred Austell
Thornton in memory of Leila Austell
Thornton and Albert Edward Thornton, Sr.,
and Sarah Miller Venable and William Hoyt
Venable, 1994.50

WHILE SERVING IN THE PEACE CORPS in the 1960s, Martin Puryear learned carving and carpentry techniques from craftspeople near the remote African village where he was stationed. Later, while studying printmaking at the Swedish Royal Academy of Art, he also learned Scandinavian woodworking methods. These diverse, venerable craft techniques contribute to the sense of timeless serenity that pervades his art, while his slightly asymmetrical shapes and the evidence of the artist's hand impart a sense of vitality.

This work is one of the last of some forty "rings" Puryear made throughout the late 1970s and early 1980s. These roughly circular works are made primarily of laminated strips of wood. Some are open, with painted or carved ends; all have a dynamic feel of torque and of the quivering curve. Hanging on the wall, they maintain a ceremonial and symbolic presence, as if they were enlarged talismans, amulets, or trophies. —Carrie Przybilla

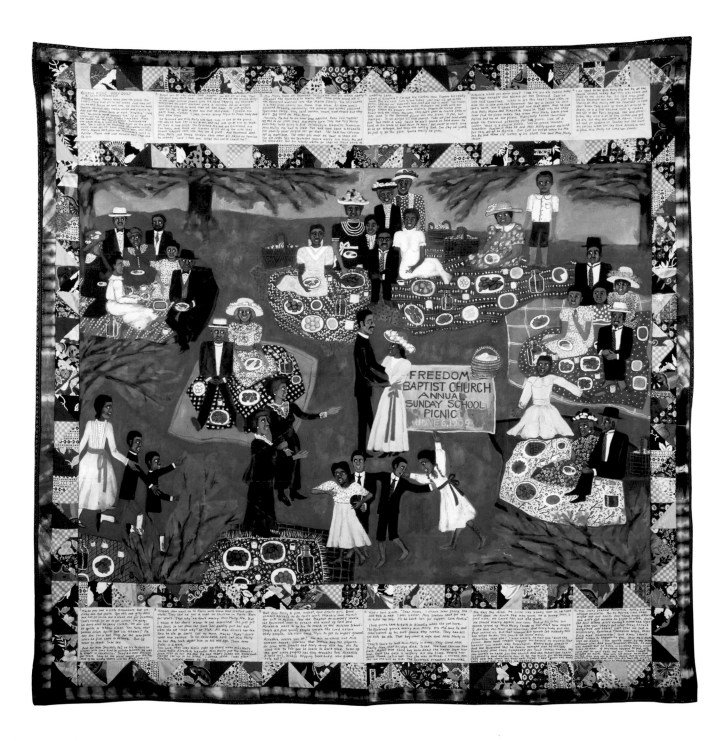

Faith Ringgold
American, born 1930

Church Picnic Story Quilt, 1988
Tie-dyed, printed fabrics and acrylic on cotton
canvas, 74½ × 75½ inches
Gift of Don and Jill Childress through the
20th Century Art Acquisition Fund, 1988.28

FAITH RINGGOLD BECAME AN ACTIVIST-ARTIST in the 1960s and has played a key role
in directing attention to the work of women and African Americans in the art world. She
has also made a pivotal contribution by using fabrics and other domestic materials (usually
seen as the province of "crafts") to make her art. Writing and performance are central to her
work, and since 1983 she has combined the traditions of storytelling and quilt-making in her
painted "story quilts," which began as collaborations with her mother, Willi Posy, a well-known
designer and seamstress.

This story is set in Atlanta's Piedmont Park in 1909. Ringgold's subject is the complex rela-
tionships within families and communities. In *Church Picnic Story Quilt*, small islands of people
form a larger circle. In the center, a young couple rivets the attention of all the others. Mama,
in the upper right-hand corner of the quilt, recounts details of the day's festivities. Mama's
account, told to her daughter Aleathia, reveals the web of relationships among characters.
—Jeffrey D. Grove

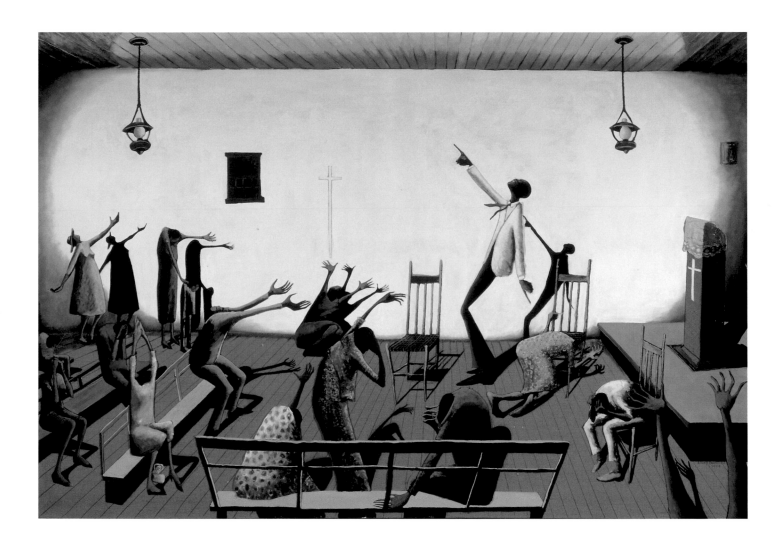

Benny Andrews
American, born 1930

Revival Meeting, 1994
Oil and collage on canvas, 50 × 72 inches
Purchase with funds from Alfred Austell
Thornton in memory of Leila Austell
Thornton and Albert Edward Thornton, Sr.,
and Sarah Miller Venable and William Hoyt
Venable, 1995.1

IN THIS WORK BENNY ANDREWS REVISITS childhood memories of revival services held each summer at the Plainview Baptist Church near Madison, Georgia. Encouraged by the congregation's singing and inspired by a dynamic preacher, people on the "mourners' bench" pray for a sign of forgiveness and salvation so they can be baptized. The rest of the congregation joins in their prayers for salvation. With bold colors, dramatic lighting, and theatrical gestures, Andrews conveys the anguish of the mourners and the ecstasy of the saved. The artist explained his interest in this childhood memory in an artist's statement for the Revival series (including this painting): "This poor community of African-Americans, oppressed through segregation and lack of many of the necessities needed for a decent life, could find relief in only one place, the church. Here in this small church you could let your mind open up, express yourself and feel that a higher being heard, understood and cared about you personally." —Carrie Przybilla

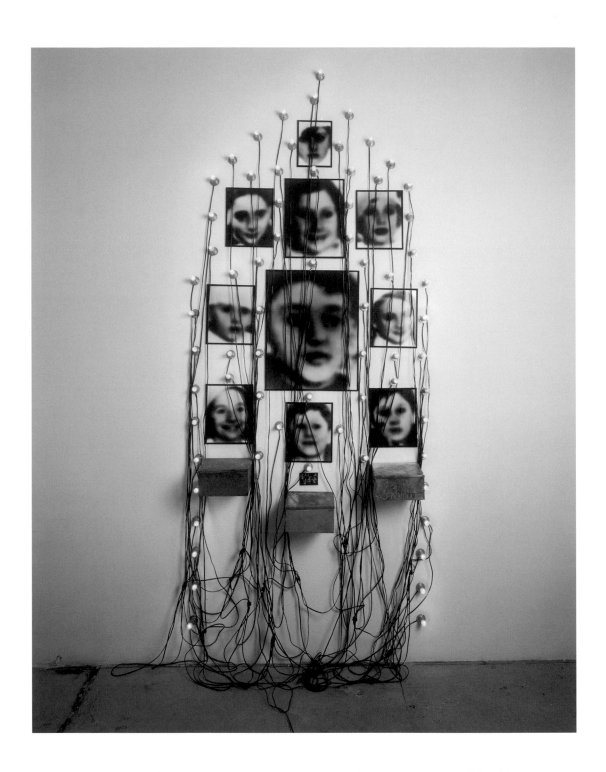

Christian Boltanski
French, born 1944

Monument/Odessa, 1990
11 photographs, 3 tin biscuit boxes,
68 light bulbs, glass, and electric cords,
122 × 48 × 8⅝ inches
The Lenore and Burton Gold Collection
of 20th Century Art, 1999.109

CHRISTIAN BOLTANSKI MATURED as an artist when art was being redefined by the emergence of Nouveau Realism in France, Fluxus in Europe and the United States, and Pop Art in the United States. These movements blended life and art, bringing images and objects from the real world into their art and their installations. A deliberate confusion of public and private, and collective and individual, identities is a principal strategy Boltanski uses to examine these themes.

Monument/Odessa comprises ten black-and-white portraits of unknown children (plus a small color photograph). Their identities are occluded by a tangle of electrical cords that drape around and in front of the photographs, supplying power to dozens of small electrical lights that surround the images. Rather than illuminate the pictures, the bare bulbs create a glare on the glass over the photographs, making them even more difficult to discern. The overall effect is that of a shrine or altar that memorializes an unspeakable loss. —Jeffrey D. Grove

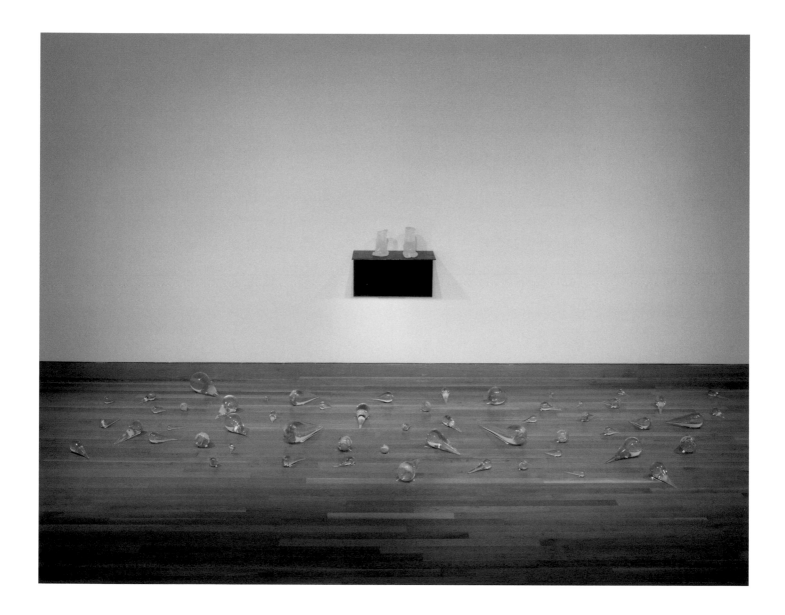

Kiki Smith
American, born Germany, 1954

Mother, 1992–1993
Glass and steel, installation size variable
Purchase for the Elson Collection of
Contemporary Glass, 1993.111

IN CONVERSATION KIKI SMITH HAS REFERRED to her sculpture as a means of "describing our relationship with other people's physicality." She uses the human body, presented in all its raw physicality and frailty, as a metaphor for emotion. Trained as an emergency medical technician, the artist finds a beauty and expressiveness in what many would term "blood and guts." She often uses fragile materials, such as wax, mud, and glass, to imply vulnerability and to evoke a visceral response in the viewer. In *Mother,* she examines the primal relationship between mother and child. The feet in this work are casts of Smith's mother's feet. The large drops of glass scattered around the feet recall tears shed because of the intimacy and conflicts inherent to mother-daughter relationships: attachment, rebellion, love, separation, and loss.
—Carrie Przybilla

Agnes Martin
American, born Canada, 1912–2004

Untitled #3, 1994
Acrylic and graphite on canvas, 60⅛ ×
60¼ inches
Purchase in honor of Pat D'Alba Sabatelle,
President of the Members Guild, 1995–1996,
with funds from Alfred Austell Thornton in
memory of Leila Austell Thornton and Albert
Edward Thornton, Sr., and Sarah Miller
Venable and William Hoyt Venable, 1995.86

FOR MORE THAN FIFTY YEARS, Agnes Martin sought to express a sublime reality that is perfect, eternal, and immaterial. For Martin, such beauty was the sole subject of art. She believed that beauty exists in our minds as an innate idea and that its existence is stable; our awareness of it, however, fluctuates. "We may be looking at the ocean when we are aware of beauty but it is not the ocean," she explained in interviews.

As a student in New York in the 1940s, during the advent of Abstract Expressionism, Martin developed an affinity for the work of Barnett Newman and Mark Rothko. Their interest in transcendental experience corresponded with her ambitions and preoccupations. She abandoned her representational style of painting and developed a form of biomorphic abstraction that grew increasingly concise during the 1950s. In 1957 Martin introduced geometry in her paintings as a vehicle for spiritual content. Points and lines—conceptual constructs that don't exist in the material world—would, she felt, depict the immaterial perfection she was seeking. She soon settled on the use of a grid. Martin's lines undulated with a sense of fragility and softened the strict uniformity of the grid. Her hand-drawn marks simultaneously suggested perfection and its unattainability.

Martin stopped painting in the late 1960s and early 1970s, but resumed following a retrospective of her work in 1973. Martin's work remained geometric, but—as the translucent bands of pale blue, yellow, and blue-gray in this work demonstrate—color took priority over line. —Carrie Pryzbilla

Gerhard Richter
German, born 1932

(799–1) Lesende, 1994
Oil on linen, 20¼ × 27¾ inches
Purchase in honor of John Wieland,
Chairman of the Board, 1994–1997, with
funds from Alfred Austell Thornton in
memory of Leila Austell Thornton and Albert
Edward Thornton, Sr., and Sarah Miller
Venable and William Hoyt Venable, 1996.136

GERHARD RICHTER IS ONE OF THE FOREMOST painters of his generation. A great deal has been written about the bewildering heterogeneity of his work over the past thirty years. His willful and defiant movement between abstraction and figuration, and his seemingly inconsistent methods of applying paint are consistent with Richter himself—the master of the paradoxical statement. Although he has emphasized that he is simply a painter and has never been a theorist, his paintings probe issues of representation and the effects of photography on painting.

His figurative paintings frequently seem "out of focus," although, as Richter has noted, paint on canvas cannot be unfocused. *Lesende* takes its title from the German word meaning "reader." This painting of the artist's wife reading demonstrates the unsettling way Richter's paintings fluctuate between the conventions of visual representation. The composition, subject matter, and blurred, momentary qualities in this work suggest photography, yet the rich application of paint reminds us that it is a painting. This collision between visual frames of reference results in an image that feels both nostalgic and impersonal at the same time. —Carrie Przybilla

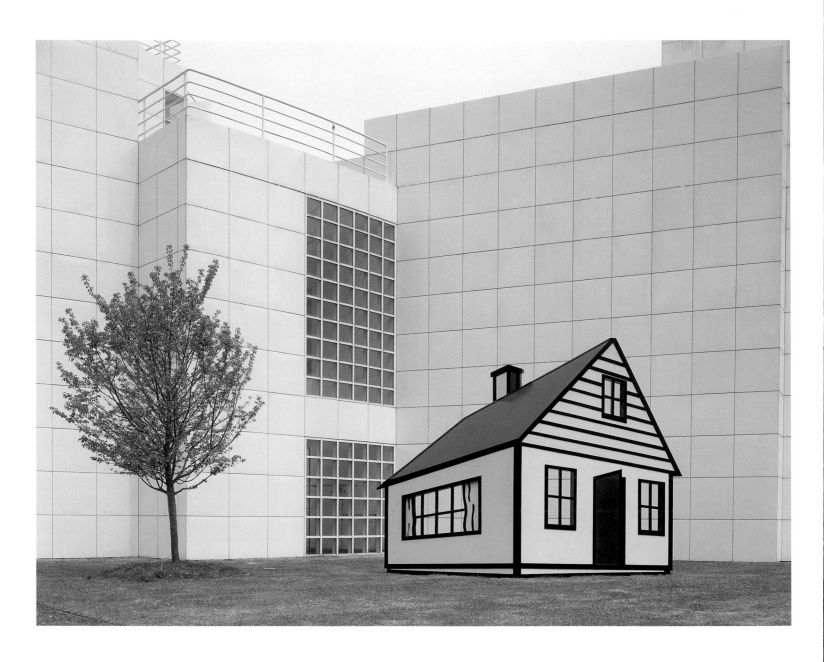

Roy Lichtenstein
American, 1923–1997

House III, 1997 (fabricated 2002)
Painted and fabricated aluminum,
157 × 210 × 60 inches
Purchase with funds from John Wieland
Homes and Neighborhoods in honor of
its company members, 2003.65

ROY LICHTENSTEIN WAS THE MASTER of the stereotype and the most sophisticated of the Pop artists in his analysis of the conventions of representation. He was part of a generation of artists that included Claes Oldenburg, Jim Dine, and George Segal, who returned to figuration and exalted ordinary objects in the wake of Abstract Expressionism. Lichtenstein's ability to distill commercial imagery, such as comic strips, to its most essential elements with a deadpan mixture of veneration and satire quickly won admirers around the world.

Lichtenstein's sculpture typically extended and played on his fascination with various illusionary techniques employed in commercial art and high art. Although substantial in height and width, most of his sculptures are only a few inches deep. Lichtenstein infused them with a sense of depth using the graphic conventions of painting and other two-dimensional media. From straight on, the corner of *House III* appears to project forward, toward the viewer. However, by walking around the work one sees that the corner actually recedes, that the eye has been fooled by the black outlines of the forms. —Carrie Przybilla

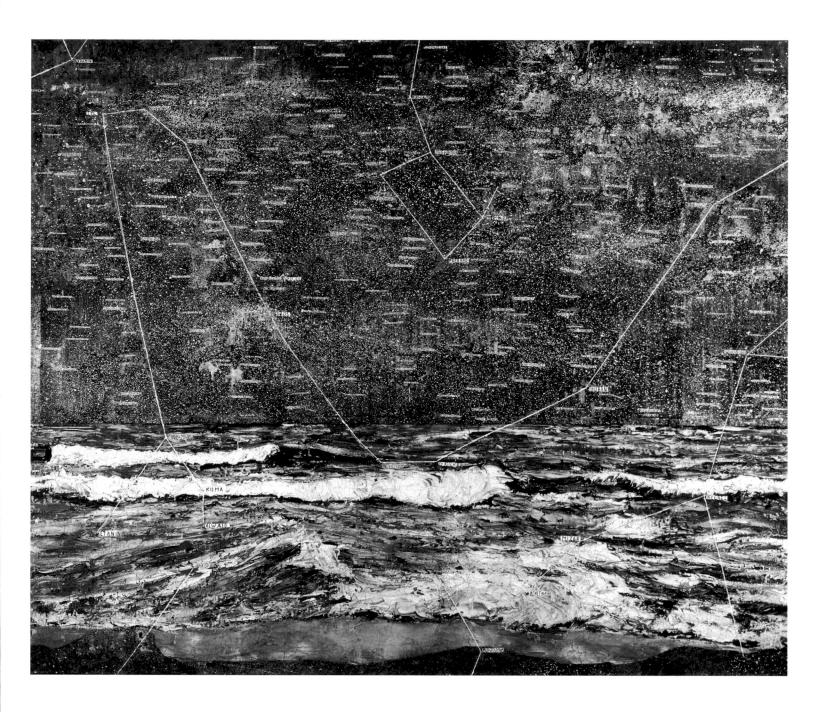

Anselm Kiefer
German, born 1945

Dragon (Drache), 2001
Oil emulsion on canvas, 185 × 220½ inches
Purchase with High Museum of Art
Enhancement Fund, 2003.5 a–b

ANSELM KIEFER LOVES ANCIENT MYTHS. In a 1984 interview, he described these stories as part of a collective unconscious. "As far as I am concerned the old sagas are not old at all, nor is the Bible. When you go to them, most things are already formulated."

The constellation diagrammed in this painting is Draco, the dragon. Perhaps the oldest named constellation, its terrible might figures in the myths of many civilizations. In Greek mythology, Athena's slaying of a dragon causes the division of heaven and earth—a reading reinforced by the horizon line in the seascape Kiefer depicts here. In numerous European legends, a young man must slay a dragon to make his fortune and win the hand of a maiden, as is the case in the medieval German saga of Siegfried and Brunhilde, as well as in the Greek myth of Andromeda and Perseus, both tales referred to in other Kiefer paintings. For the artist, the similarities among these stories across time and cultures point to a primal truth he hopes to discover and convey through his own work. —Carrie Przybilla

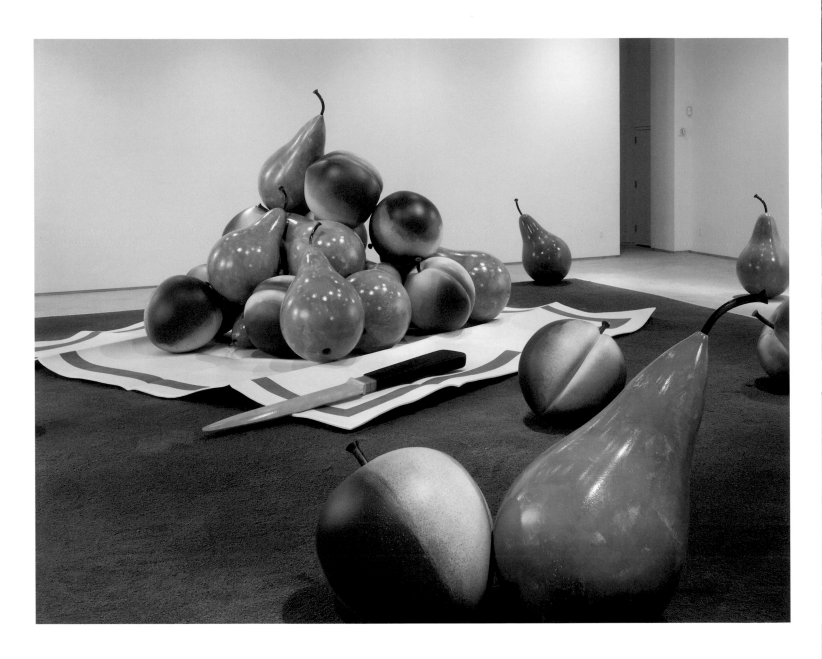

Claes Oldenburg
American, born Sweden, 1929

Coosje van Bruggen
American, born The Netherlands, 1942

Balzac Pétanque, 2002
Fiber-reinforced plastic, cast epoxy, and
stainless steel, painted with polyester gelcoat,
102 × 300 × 444 inches
Purchase with funds from Mr. and
Mrs. J. Mack Robinson and High Museum
of Art Enhancement Fund, 2002.259.1–39

CLAES OLDENBURG FIRST CAME to international prominence in the early 1960s as one of the leaders of the Pop Art movement. His transformations of common objects into droopy fabric sculptures or gargantuan monuments have captivated viewers for more than forty years. For the past twenty-five years he has worked collaboratively with his wife, Coosje van Bruggen.

The artists spend part of each year in France's Loire Valley. Fruit, the principal motif of this work, plays a major role in both the economy and the gastronomy of the region. Oldenburg and van Bruggen conceived *Balzac Pétanque* as a monument to the nineteenth-century novelist Honoré de Balzac to be sited in a square in Tours, the city of the writer's birth. Balzac's evocation of nature's bounty lies at the heart of this work. The composition of peaches and pears laid atop a napkin evokes the sensual experience of a summer picnic. This reading is underscored by the second part of the work's title. Pétanque is a French game similar to bocce ball. Played with metal balls on a grass field, it is a perfect sport to accompany a picnic on a lazy summer afternoon. —Carrie Przybilla

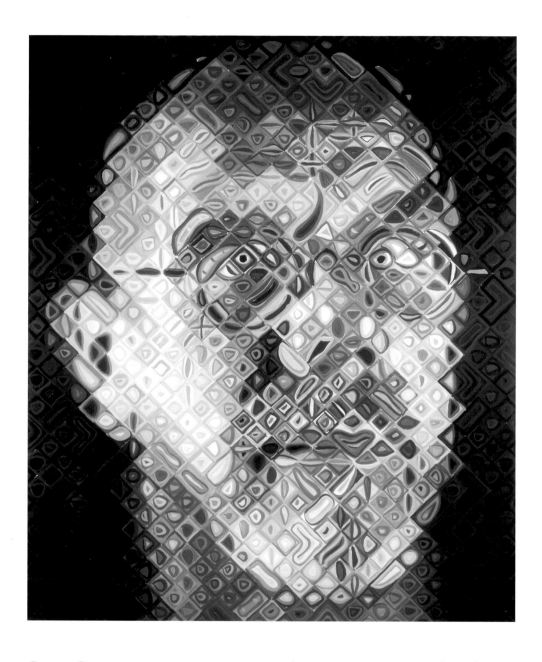

Chuck Close
American, born 1940

Self-Portrait, 2002–2003
Oil on canvas, 72 × 60 inches
Purchase with funds from Alfred Austell
Thornton in memory of Leila Austell
Thornton and Albert Edward Thornton, Sr.,
and Sarah Miller Venable and William Hoyt
Venable, and High Museum of Art Enhance-
ment Fund, 2004.1

CHUCK CLOSE HAS BEEN A LEADING FIGURE in contemporary art since the early 1970s. Focusing exclusively on the human face, which he has painted with thousands of tiny airbrush bursts, thumbprints, or looping multicolor brushstrokes, his detailed formal analysis of—and methodical approaches to—representation have redefined portraiture over the last four decades. Close's systematic approach and his use of a grid as an underlying basis for an image allies him with the Minimalists and Process artists who emerged in the late 1960s. Close has noted in interviews that this simple but surprisingly versatile structure of the grid has provided him the means for "a creative process that could be interrupted repeatedly without . . . damaging the final product, in which the segmented structure was never intended to be disguised."

In recent years, Close's hyper-realistic images have softened. While some might attribute this to the spinal aneurism he suffered in 1988, which left him paralyzed except for movement in his neck, shoulders, and upper arms, the artist says, "This was the path I had been on, this dissolution of the image. I realized that all I had done was catch up in my work with where I had been." *Self-Portrait* reflects how loose and painterly Close's work has become. It is only at a distance that the myriad individual small abstract paintings (contained in the gridded canvas) coalesce into Close's favorite and most readily available sitter . . . himself. —Carrie Przybilla

PHOTOGRAPHY

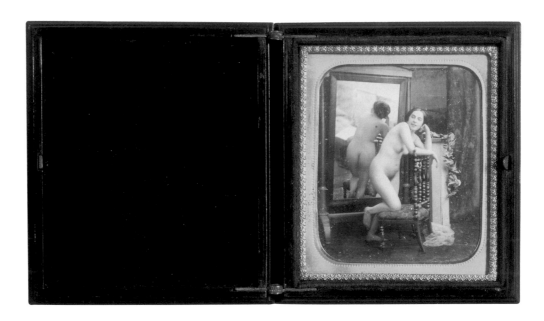

Unknown Photographer
French, nineteenth century

Nude, ca. 1855
Daguerreotype, 2¾ × 2¼ inches
Purchase with funds from a friend of
the Museum, 74.204

THE INVENTION OF THE DAGUERREOTYPE was first publicly announced at a meeting of the French Academy of Sciences in 1839. It quickly became popular, and continued to be the favored photographic medium until the ambrotype—a faster and less expensive photographic process—was introduced in the mid-1850s.

Daguerreotypes were designed for private consumption. Not only were they small, reflective, and delicate, they were unique objects, requiring the protection of a glass-cased, velvet-lined box. Many images like this one were produced in Paris, where pictures of nudes (made for artists and consumers of pornography alike) proliferated in the mid-nineteenth century, often in stereographic form, which heightened the illusion of three-dimensional space.

The realism of nude photography fueled Victorian debates about art and morality. Photography's emerging role as an expressive medium was also being called into question. In 1859 French poet and art critic Charles Baudelaire famously offered a sharp condemnation of the use of photography within the arts, warning of its potential corruptive effects. —Shelley Lawrence

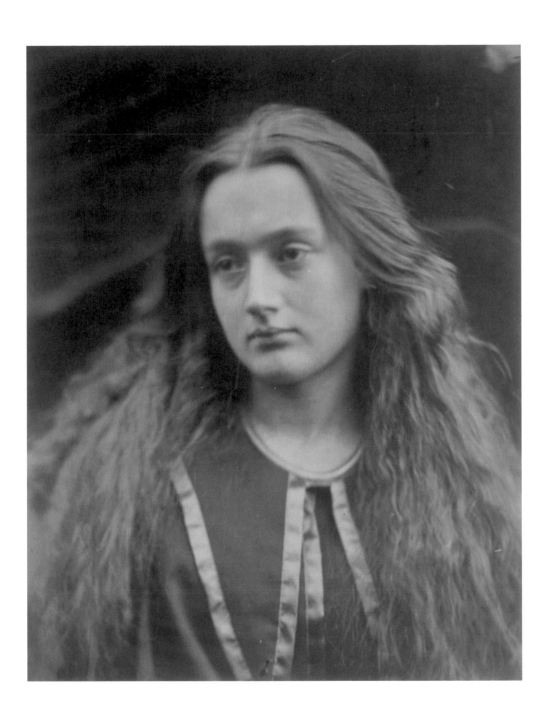

Julia Margaret Cameron
English, born India, 1815–1879

Mrs. Ewen Hay Cameron, 1870
Albumen silver print, 12¹⁵⁄₁₆ × 10¹⁄₁₆ inches
Purchase, 74.147

JULIA MARGARET CAMERON'S PHOTOGRAPH of her daughter-in-law, Mrs. Ewen Hay Cameron (née Annie Chinery), differs from the stiffly posed studio portraits of the time. Taking up photography at the age of forty-eight in 1863, Cameron was among a group of adventurous amateurs who experimented with the difficult photographic processes in the first decades of the medium.

Many of Cameron's portraits have a softened, diaphanous quality, as does this photograph. She was often criticized for this and other technical limitations, but Cameron ignored her detractors, saying that her goal was to reveal the inner person, not just the outer appearance.
—Thomas W. Southall

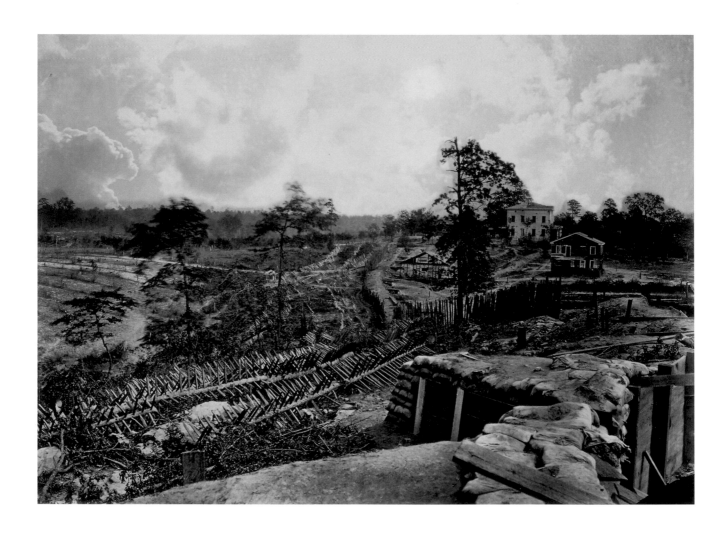

George N. Barnard
American, 1819–1902

Rebel Works in Front of Atlanta, Ga. No. 1,
1864, printed 1866
Albumen silver print, 10 × 14⅟₁₆ inches
Purchase, 1985.226.39

GEORGE N. BARNARD WAS ONE OF SEVERAL unacknowledged photographers who worked for Civil War photographer Matthew Brady before setting out on his own in 1863. Serving as official photographer for the Army of the Cumberland's topographical branch of the Department of Engineers, he documented notable battlefields, military works, bridges, and topographic views. His best-known works are his striking images documenting Sherman's march to the sea. Sixty-one albumen plates from this project were published by Barnard in 1866 as an album titled *Photographic Views of Sherman's Campaign*.

Like other war photographers of the period, Barnard did not have the technology to capture live combat; he often visited sites months after battles were over. As in this picture, Barnard frequently accentuates scenes of devastation with an imposed rendering of dramatic skies.
—Shelley Lawrence

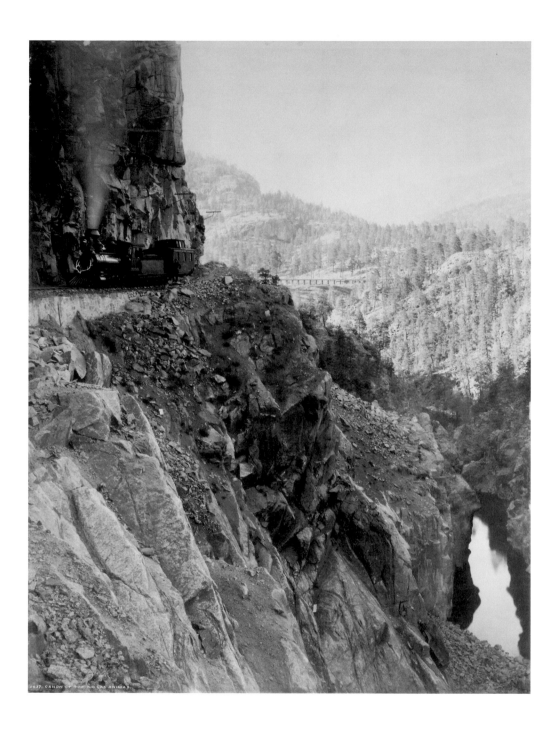

William Henry Jackson
American, 1843–1942

Cañon of the Rio Las Animas, ca. 1881
Albumen silver print, 20½ × 15¾ inches
Gift of Life Insurance Company of Georgia,
1980.117

BORN IN KEESEVILLE, NEW YORK, Jackson was an ambitious entrepreneur who had a profound influence on the development of commercial landscape photography. Both a photographer and painter, he was commissioned to photograph the Rocky Mountain countryside for Francis V. Hayden's Geological and Geographic Survey of the Territories in 1870. This project lasted eight summers, and allowed Jackson to photograph extensively throughout the American West. After establishing his Denver studio in 1880, he was offered commissions by Western railroad companies to record the great vistas and natural wonders along routes through the Rockies. Supplied with his own gear-toting locomotive by the Denver and Rio Grande Railroad, Jackson effectively juxtaposed the drama of the rugged Western landscape with the human ingenuity and technological progress represented by the railroad lines. Here, Jackson's train is pictured above the plunging canyon of the River of Lost Souls. —Shelley Lawrence

Alfred Stieglitz
American, 1864–1946

Equivalent, 1923
Gelatin silver print, 3½ × 4½ inches
Purchase with funds from the Georgia Pacific
Foundation, 1985.228

THROUGHOUT HIS CAREER, Stieglitz fought to establish photography as a fine art medium. A champion of the visual arts, his own work gradually transformed from the pictorialism espoused by his Photo-Secession group to the purist sensibility reflected in the work of photographers such as Paul Strand, whose photographs Stieglitz exhibited and published.

Stieglitz's Equivalent series was initiated in the early 1920s at his family home in upstate New York. Using photographs to convey a spiritual realm, he presented ethereal cloud formations as approximations of his states of consciousness. This striking photograph was made the year before his marriage to painter Georgia O'Keeffe, a productive and inspired time for both artists. —Shelley Lawrence

Edward Weston
American, 1886–1958

Palma Cuernavaca II, 1925
Platinum print, 9¼ × 6¼ inches
Gift of Lucinda W. Bunnen for the Bunnen
Collection to mark the retirement of
Gudmund Vigtel, 1991.54

THIS PHOTOGRAPH OF A PALM TRUNK was one of many creative breakthroughs Edward Weston made during an extended sojourn in Mexico from 1923 to 1927. A year earlier he had photographed another palm, showing the crown of leaves, but this photograph reduced his subject more radically to the simplest, most abstract elements. A viewer might easily mistake the subject for a factory smokestack—only the title or close examination reveals its true nature.

After Weston made this photograph, he wrote in his journal, "This picture is but a photograph of a palm, plus something—something—and I cannot quite say what that something is—and who is there to tell me? Why should a few yards of a white tree trunk, exactly centered, cutting across an empty sky, cause such real response? And why did I spend my hours doing it? One question simply answered—I had to." This photograph marked Weston's new understanding of how a straight photograph, manipulated only by choices of light and framing, could reveal extraordinary forms and surprises in even the most common subjects.
—Thomas W. Southall

Man Ray
American, born Germany, 1890–1976

Max Ernst, 1935
Gelatin silver print, 11 × 9 inches
Purchase with funds from Georgia Pacific
Corporation, 1984.228

BOTH MAN RAY AND MAX ERNST were leading figures in the Dada and Surrealist groups in Europe, early twentieth-century movements that challenged social and artistic conventions by introducing surprising juxtapositions and chance. Man Ray's photographic work often favored processes that involved an element of unpredictability.

Man Ray used the Sabattier effect—more commonly referred to as solarization—to make this distinctive photograph of Ernst. Discovered in 1862 by Armand Sabattier, the process involves exposing a partially developed image to a brief flash of light. The result is a partial reversal of tone that makes portions of the print appear negative. —Shelley Lawrence

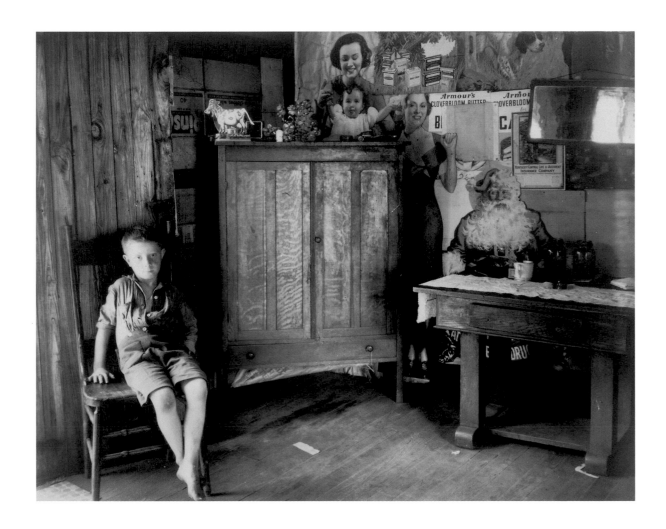

Walker Evans
American, 1903–1975

West Virginia Living Room, 1935
Gelatin silver print, 7½ × 9½ inches
Purchase with funds from the Atlanta
Foundation, 75.45

EVANS MADE THIS PHOTOGRAPH during the first year of the photography division of the Resettlement Administration (later renamed the Farm Security Administration). The mission of this newly formed government agency was to document the hardships of the Depression and the positive effects of New Deal policies.

The furnishings of this coal miner's home are spare and worn. The walls are decorated with commercial advertisements that reflect a prosperity this family was not likely to experience. But this photograph transcends its immediate mission as government propaganda. Rather than a condescending look at poverty, the image captures the dignity of the family. The barefoot boy sitting awkwardly in the chair looks straight into the camera and challenges the viewer. His direct stare shows no shame and asks for no pity. —Thomas W. Southall

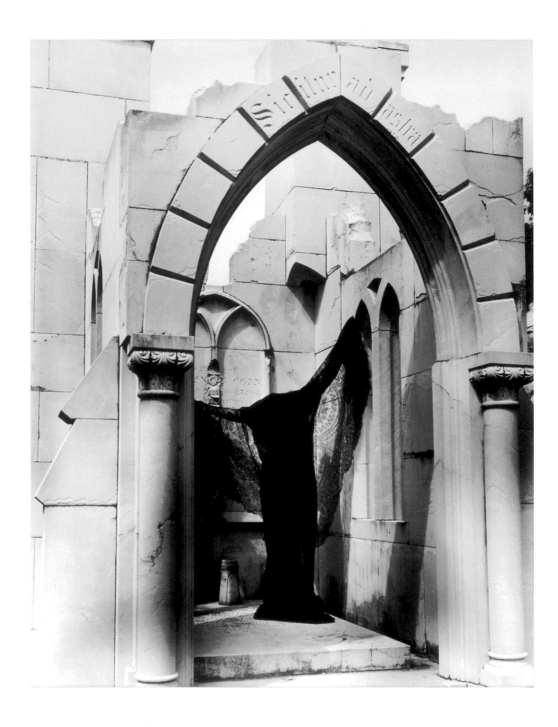

Clarence John Laughlin
American, 1905–1985

The Bat, 1940
Gelatin silver print, 19⅝ × 15⅜ inches
Gift of Lucinda W. Bunnen for the Bunnen
Collection, 1981.93

CLARENCE JOHN LAUGHLIN, A SELF-TAUGHT ARTIST based in New Orleans, began taking photographs in the 1930s. Influenced by the writings of Charles Baudelaire and Arthur Rimbaud, he used photography to express his ideas about the hypocrisy, amorality, and decadence of modern life. Laughlin was also a prolific writer, and his words sometimes illuminate his visual symbolism. He included the following explanation of *The Bat* to be exhibited with the image:

> In an imitation ruined abbey in a New Orleans cemetery—(even the cracks in the wall are faked!)—this image of hypocrisy appropriately appears. Batlike, hypocrisy flits everywhere, for it appears everywhere in church, state, big business—its head cunningly concealed (as with those who turn their heads, hypocritically, from all that gives the lie to their own untruths). And while they preach peace and humanity, the people of hypocrisy lead us, actually, into confusion, war and destruction.

—Thomas W. Southall

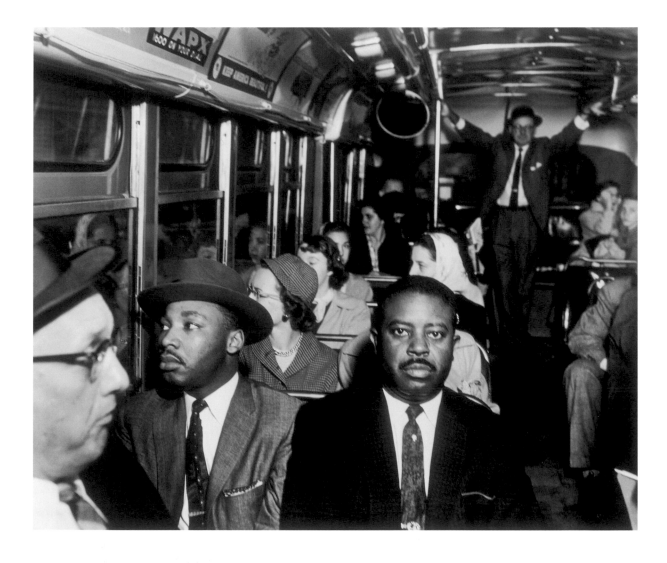

Ernest C. Withers
American, born 1922

First Desegregated Bus Ride, Montgomery, AL, Dec. 1956, 1956
Gelatin silver print, 14½ × 18½ inches
Purchase, 2002.24.2

WORKING AS A SELF-EMPLOYED PHOTOGRAPHER based in Memphis, Ernest Withers was well positioned to record a turbulent period in the American South. With photographic subjects ranging from the Civil Rights movement, to the baseball players of the Diamond League, to the blues and jazz performers in his hometown, he has always been close to his subject matter.

Withers could be called the original photographer for the Civil Rights movement, and his photographs constitute the most comprehensive documentation of that period in the South. Withers produced a book on the Emmett Till murder that contributed to the push towards equal rights. This photograph is included in a portfolio entitled *I Am A Man,* which features several iconic images, including this record of the first desegregated bus ride with Martin Luther King, Jr., and Ralph David Abernathy. —Thomas W. Southall

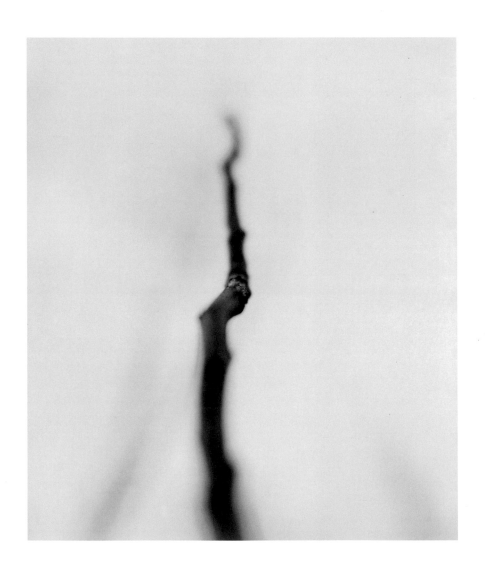

Ralph Eugene Meatyard
American, 1925–1972

Untitled, 1961
Gelatin silver print, 6⅛ × 5¼ inches
Gift of Lucinda W. Bunnen for the Bunnen
Collection, 1983.29

AN OPTICIAN BY TRAINING, Meatyard was mentored by Van Deren Coke (who headed Meatyard's local Lexington Camera Club) and attended workshops led by Aaron Siskind and Minor White. Meatyard used his knowledge of lenses and vision to produce a number of photographic experiments that feature simple and elegant observations of light, form, and motion. He is also known for his staged photographs of masked and costumed figures.

Untitled belongs to the photographer's Zen Twig series (the images resemble Zen calligraphy). The photograph's sharp focus on the small detail of a twig surrounded by an abstract "No-Focus" ground is typical of the series. After Minor White introduced him to the subject in the mid-1950s, Zen became an influence in Meatyard's life and work. He described it as a "philosophy more than a religion and a thing to do more than to talk about," in a letter written to Coke in the early 1960s. —Lori Cavagnaro

Roy DeCarava
American, born 1919

Coltrane on Soprano, 1963
Gelatin silver print, 13¹⁄₁₆ × 9¾ inches
Purchase with funds from the H. B. and
Doris Massey Charitable Trust, 1998.45

WHETHER PHOTOGRAPHING THE STREET LIFE of Harlem, the Civil Rights movement, or jazz musicians, DeCarava imbues his subjects with a subtle grace that is distinctly his own. Jazz musicians and performances were a focus of the Harlem-based photographer's work for many years. This portrait of John Coltrane typifies the discerning use of light and shadow that is the hallmark of DeCarava's work; Coltrane seems to burst from the shadow that nearly envelopes him. DeCarava's long exposure captures the great saxophone player within a kinetic moment, conveying the energy of the music he loves. His portraits of such luminaries as Billie Holiday, Lester Young, and Duke Ellington convey the sense of soulfulness and spontaneity that he believed came through "pure experience." —Shelley Lawrence

Diane Arbus
American, 1923–1971

*A Young Family in Brooklyn Going for
a Sunday Outing,* 1966, printed 1970
Gelatin silver print, 15¼ × 14¾ inches
Purchase with funds from a friend of the
Museum, 74.81 a

INSPIRED BY THE SUPPORT OF HER INSTRUCTOR Lisette Model in the mid-1950s, Arbus abandoned her career as a fashion photographer and began developing her oeuvre of direct, arresting portraits. Drawn to a wide range of subjects, she often photographed people who stood outside of societal norms: nudists, dwarfs, and the mentally handicapped were the focus of many of her most compelling images.

This image of a Brooklyn family on a Sunday outing—one of ten she chose in 1970 to represent her best work—exemplifies Arbus's uncanny ability to reveal something raw beneath the surface of the people she photographed. Taking the "ordinary" family outing as her subject, she wryly juxtaposes the notion of idyllic family togetherness with a sense of isolation that is conveyed through disconnected gazes of each subject, the odd appearance of the mother and the young boy, and the quiet haze of their urban environment. —Shelley Lawrence

William Christenberry
American, born 1936

Building, Hale County, Alabama,
1967–2000
Chromogenic development prints,
3½ × 5¼ inches and 4 × 5 inches
Purchase with funds from Photo Forum,
2001.20.1–16

FOR MORE THAN HALF A CENTURY, William Christenberry has been making paintings, drawings, photographs, and works in a variety of media inspired by his attachment to his west Alabama birthplace. These are the first and the seventh in a series of sixteen photographs of a single building facade made over a thirty-three-year period. *Building, Hale County, Alabama,* is one of Christenberry's first works to combine images made over an extended period.

Each of the individual photographs serves as a metaphoric portrait of the evolving building, and by extension a portrait of the people who built and used it over the years. The character of this building changes so completely through many different cycles over the years, it is initially difficult to recognize that the photographs document the same building. But as the building changed from general store to juke joint, its character evolved. With each change of name—from Soul Wheel, to the Shack, and then the Underground Nite Club—and each fresh coat of paint, the building reflected the changing economics, culture, and even politics of the community and the times. —Thomas W. Southall

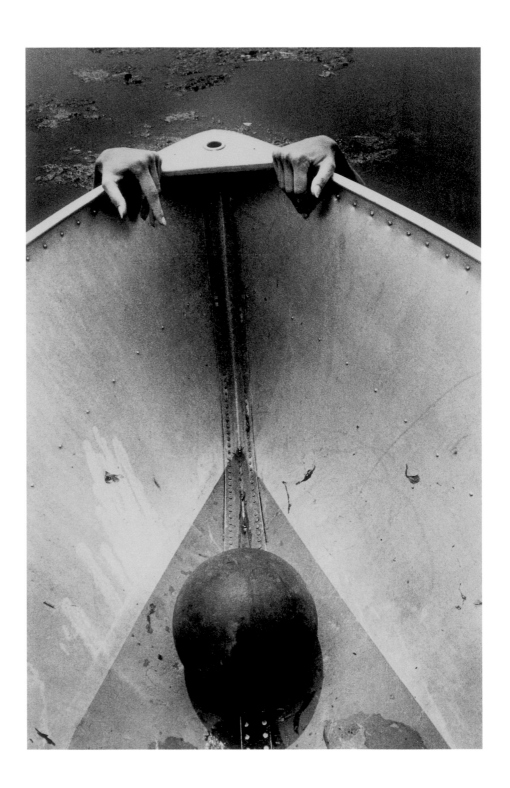

Ralph Gibson
American, born 1939

Untitled, from *The Somnambulist Series,*
1970, 1969
Gelatin silver print, 18 × 11 ¹³⁄₁₆ inches
Gift of the Kuniansky Family, 1997.137

GIBSON WAS AN APPRENTICE of Dorothea Lange and Robert Frank, though his work has never reflected the larger cultural sensibilities or agenda of either photographer. Rather, Gibson's work is concerned with a private sense of perception that he expresses through his focus on singular objects, gestures, and moments. In *The Somnambulist Series* Gibson created images that have a fragmented, hallucinatory quality that suggests the disjointed, disorientating experience of sleepwalking.

Gibson's work is primarily known through the books he publishes at Lustrum Press, a business he founded to publish his own work. *The Somnambulist Series* includes a trilogy of books featuring dramatic but simple compositions that suggest incomplete narratives drawn from the periphery of consciousness. —Shelley Lawrence

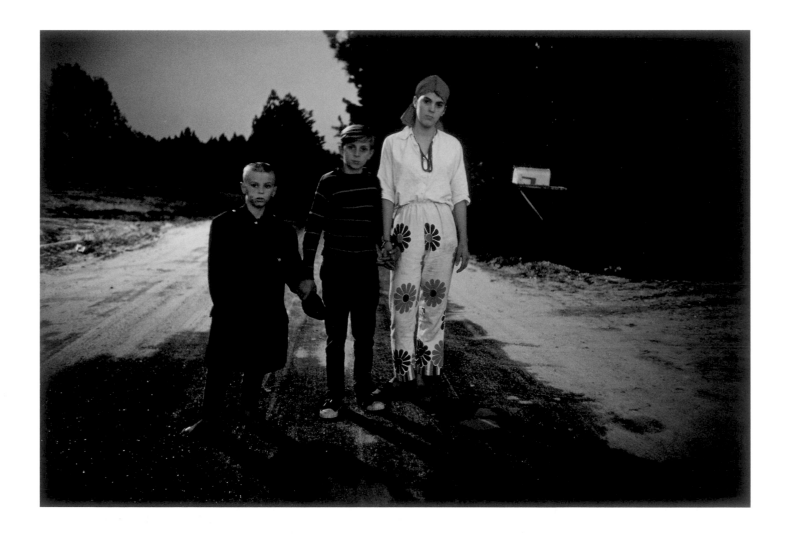

William Eggleston
American, born 1939

Halloween, Outskirts of Morton, Mississippi, 1971
Dye transfer print, 11¹⁵⁄₁₆ × 17¾ inches
Gift of Lucinda W. Bunnen for the Bunnen
Collection, 1982.56

WHEN EGGLESTON TOOK THIS PICTURE of three trick-or-treaters in 1971, color photography was rarely exhibited in art museums. Credited with helping to usher in the age of color art photography, Eggleston's photographs brought a new focus and form of description to familiar subjects. He is known for his photographs of everyday life in his native surroundings. Eggleston's use of the dye-transfer print jarred expectations of art photography. "I am at war with the Obvious," he proclaimed in the afterword of his 1986 monograph *The Democratic Forest*—a sentiment resonating in this image's symbiosis of subject and its curious sources of illumination. —Shelley Lawrence

Chuck Close
American, born 1940

Self-Portrait (3 Parts), 1980
Three dye diffusion prints,
each 77 × 43½ inches
Gift of Lucinda W. Bunnen for the Bunnen
Collection, 1981.162.1–3

THE ARTIST CHUCK CLOSE IS MOST WELL KNOWN for his large-scale paintings of heads, all of which are based on photographs. Although photographs have been essential to Close's art since the late 1960s, he viewed them as tools for his paintings rather than independent works of art. This enormous, three-panel photograph depicting the lower half of Close's bearded face was a point of departure for the artist. It is one of a series of multipanel self-portraits produced while experimenting with a large-format Polaroid camera in 1979–1980. In the mid-1980s, Close recalled that working with the Polaroid camera was the "first time that I considered myself a photographer. . . . From that point on, I began to make photographs that deal with the kind of issues I deal with in my paintings." —Lori Cavagnaro

Richard Misrach
American, born 1949

Desert Fire #1 (Burning Palms), 1983
Chromogenic development print,
18¼ × 23 inches
Gift of Patricia Patrick, 1984.100

IN 1979 CALIFORNIA-BORN Misrach began *Desert Cantos,* a series of eighteen discrete groups of images that explore the deserts of the American West. The *Cantos* comprise thousands of photographs spanning twenty years, and include prints that are lyrical, joyous, horrific, and ironic. They often record moments of human violence and indifference, set against a landscape of exquisite natural beauty. From photographs of natural and human-made disasters, to nuclear test sites, space shuttle launchings, and tourist meccas, Misrach raises probing questions about the complex relationship between man and the environment.

Desert Fire #1 (Burning Palms) exemplifies the paradoxical quality of the *Cantos.* Misrach lets the viewer wonder about the cause of fire and smoke in this seductive composition.

—Thomas. W. Southall

Harry Callahan
American, 1912–1999

Eleanor and Barbara, Chicago, 1953,
printed later
Gelatin silver print, 8 × 9¹⁵⁄₁₆ inches
Purchase with funds from the H. B. and
Doris Massey Charitable Trust, Dr. Robert L.
and Lucinda W. Bunnen, Collections Council
Acquisition Fund, Jackson Fine Art, Powell,
Goldstein, Frazer and Murphy, Jane and Clay
Jackson, Beverly and John Baker, Roni and
Sid Funk, Gloria and Paul Sternberg, and
Jeffery L. Wigbels, 1997.13

Untitled, ca. 1981
Chromogenic development print, 4⅜ ×
6¹¹⁄₁₆ inches
Gift of Jeff and Tiffany Wigbels for the
Wigbels Collection, 2000.136

FROM HIS FIRST PHOTOGRAPHS, Callahan became known for his uncommon vision of common subjects—people on the street, buildings near his home, the beach, grasses, and his wife Eleanor. Callahan photographed Eleanor over many years within the various homes and cities where they lived. In the eloquent portrait *Eleanor and Barbara, Chicago,* Callahan makes lyrical use of a shaft of light piercing the imposing shadows of Chicago buildings. This thoughtful use of light and scale is one of the hallmarks of Callahan's photographic vision.

In the late 1970s Callahan began concentrating on color photography. The simplicity of his color beach photographs echoes his earlier (primarily black-and-white) images of the beach and water. His photograph of footprints along the beach in *Untitled* is almost monochromatic, but the rich deep blue of the shadows defining the footprints emphasizes Callahan's revelation of the color found in seemingly neutral subjects. —Thomas W. Southall and Shelley Lawrence

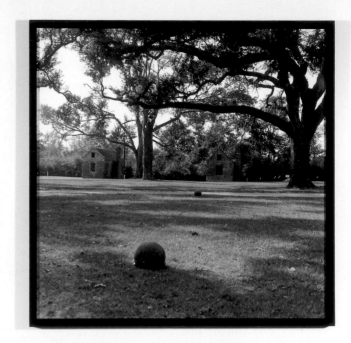

Carrie Mae Weems
American, born 1953

Untitled (Boone Plantation), 1992
Gelatin silver print and text panel,
photograph: 31 × 31 inches;
text panel: 20 × 20 inches
Purchase, 1999.57 a–b

CARRIE MAE WEEMS'S AFRICAN AMERICAN HERITAGE and her interest in history, culture, and folklore inform her photography. *Untitled (Boone Plantation)* belongs to her *Sea Island Series* (1991–1992), a group of more than twenty image-and-text works that were inspired by the Sea Islands off the coast of Georgia and South Carolina. According to the ceramic plates that are another component of the series, Weems was "looking for Africa" in this project. The Gullah culture of the Sea Islands, with its strong ties to West African culture, provided an especially rich site for her investigation.

Although this photograph appears to depict an idyllic pastoral landscape, it represents a site with a tragic history. The abandoned buildings at the edge of the tree-canopied field were a plantation's slave quarters. Weems reveals the history of a place and a culture by pairing this ambiguous image with a text panel recounting a folktale about slaves who could fly home to Africa. The combination of image and text establishes a dialogue that challenges viewers to think about the racially charged history of the United States and what Weems has described as "our humanity, our plight as human beings." —Shelley Lawrence

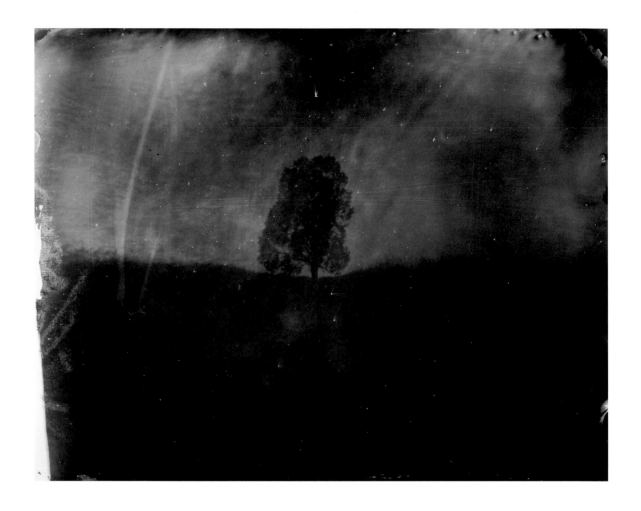

Sally Mann

American, born 1951

Untitled (Antietam #1), 2000
Gelatin silver print, 40 × 50 inches
Purchase, 2003.58

MANN'S ANTIETAM SERIES IS CENTRAL to her exploration of death and loss, especially as it is understood in the South. Although no figures are present in this or any of her Antietam landscapes, the photograph's brooding darkness and richly textured surface suggest the tragic legacy of this Civil War battlefield. On a single day in September 1862, some 23,000 men were killed, wounded, or declared missing here, one of the greatest one-day losses in American history.

Mann's use of the collodion wet-plate process produces the painterly quality of this image. Prevalent from 1851 to 1855, collodion requires the photographer to quickly flow a thick chemical mixture onto a glass plate that is then light-sensitized through submersion in a silver nitrate bath. Mann takes advantage of chance marks that occur in the process of making plates—scratches, dust, and other surface variations scar the surface and suggest a turbulent atmosphere that underscores the history of the place. —Thomas W. Southall

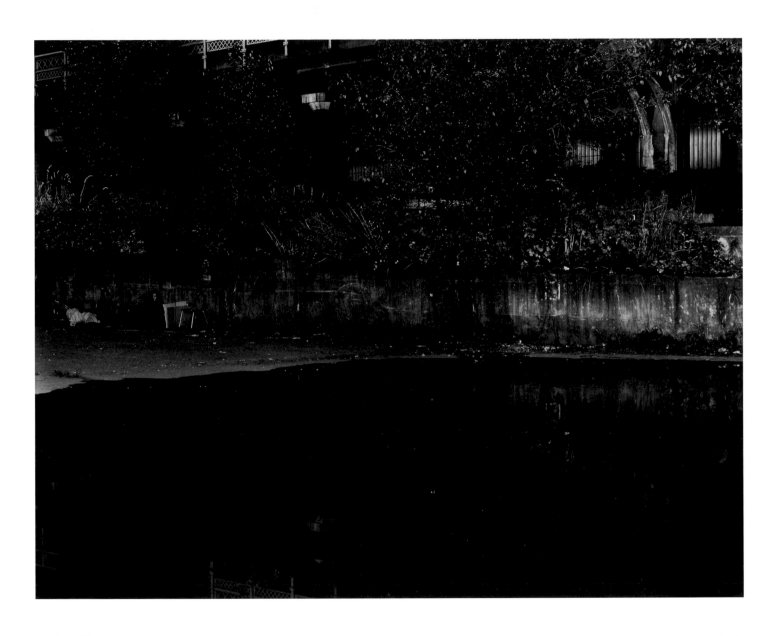

Jeff Wall
Canadian, born 1946

Night, 2001
Gelatin silver print, 99 × 123⅜ × 3 inches
Purchase with funds from High Museum
of Art Enhancement Fund, 2003.67

THIS EIGHT-BY-TEN-FOOT BLACK-AND-WHITE PHOTOGRAPH is subtler and darker—both visually and emotionally—than Wall's usual color transparencies. *Night* is so dark that viewers have to adjust their vision, as if suddenly going from daylight into deep shadow. At first this scene of a homeless camp in the harsh urban landscape of a concrete drainage ditch is difficult to read; the figures are not very legible and the dark pool of water in the foreground resembles a starry sky. Its diminutive figures at the edge of a body of water suggest the elements of a classical romantic landscape painting, but this depiction of homelessness is a tragic update of the pastoral theme.

Night owes much of its mystery and power to its implied photographic realism. The enormous scale of the work, literally enveloping and overwhelming the viewer, creates an almost cinematic effect, causing viewers to suspend disbelief, resulting in a tension between what they experience viscerally and what they know to be a carefully constructed scene.
—Thomas W. Southall

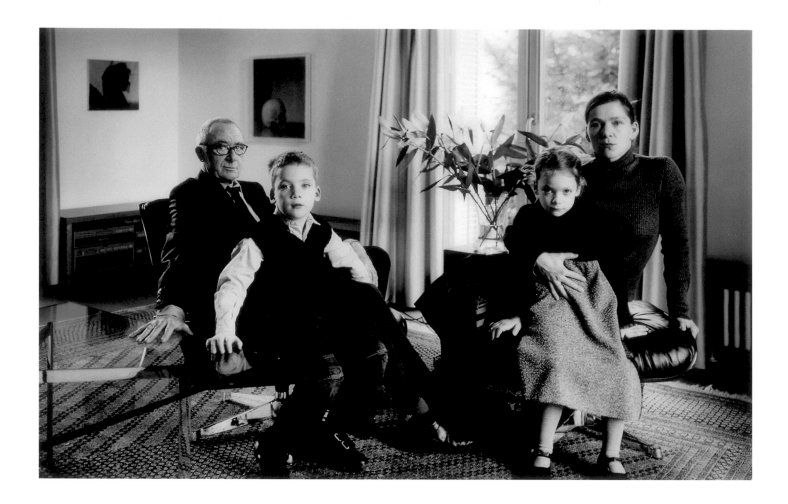

Thomas Struth

German, born 1954

The Richter Family 1, Koln, 2002
Chromogenic development print,
40³⁄₁₆ × 63⁹⁄₁₆ inches
Purchased with funds from the H. B. and
Doris Massey Charitable Trust, 2002.261

THOMAS STRUTH IS RENOWNED for his understated head-on portraits, landscapes, and views of museum galleries and famous public places. Although his style is subtle, his portrait of the contemporary painter Gerhard Richter and his family demonstrates a level of control and interpretation that is less evident in Struth's portraits of less famous subjects. The centrally placed family stares into the camera in a seemingly detached manner that recalls the photographic typologies of industrial buildings by Struth's teachers Bernd and Hilla Becher, or even August Sander's posed, almost scientific portrait survey of German citizens in the 1920s and 1930s.

Although the painter himself is the smallest, most distant figure in the group, everything around him seems to reflect his significance. Two of Richter's small paintings—a still life with a skull and a view of the back of his wife's head—frame the artist's head. The children's body language and the way they mimic the postures and gestures of their parents is especially compelling, almost chilling. —Thomas W. Southall

Notes on Contributors

DAVID A. BRENNEMAN is the Chief Curator and Frances B. Bunzl Family Curator of European Art. He has organized numerous exhibitions, including shows on Toulouse-Lautrec, Monet, Bazille, Degas, and Impressionism.

LORI CAVAGNARO holds a PhD in art history from the University of Texas at Austin. She is an editor in the publications department.

SUSAN MITCHELL CRAWLEY is the Associate Curator of Folk Art. She has curated exhibitions of self-taught art and the works of Jimmy Lee Sudduth.

JEFFREY D. GROVE is the Wieland Family Curator of Modern and Contemporary Art. He has written and lectured extensively on Abstract Expressionism and contemporary art and criticism.

BETH HANCOCK is the Curatorial Assistant of Folk Art. She received her Master of Arts degree with a specialization in modernism and subjectivity from University College London.

STEPHEN HARRISON is the Curator of Decorative Arts. He is a widely recognized scholar of nineteenth- and twentieth-century decorative arts and the co-author of the book *China and Glass in America, 1880–1980: From Tabletop to TV Tray.*

SHELLEY LAWRENCE is the Interim Associate Curator of Photography. She holds an MFA in photography from the University of Arizona, and has organized exhibitions for the Center for Creative Photography and the High Museum of Art.

LINDA MERRILL has served as the Curator of American Art at the High Museum of Art and the Freer Gallery of Art, Smithsonian Institution. She is now an independent scholar, living and working in Atlanta.

CARRIE PRZYBILLA was Curator of Modern and Contemporary Art at the High Museum of Art from 1988 to 2004. Before joining the High staff, she held curatorships at the Museum of Contemporary Art, Chicago, and at Illinois State University. She is currently pursuing a PhD in contemporary art history at Emory University.

AKELA REASON received a PhD in art history from the University of Maryland at College Park. She has worked for several museums, including the Smithsonian Institution and the Philadelphia Museum of Art.

EMILY E. SHINGLER is the Assistant to the Chief Curator and Curatorial Assistant for European Art. She holds an MA in art history from Richmond University in London.

THOMAS W. SOUTHALL is Curator of Photography at the Harn Museum of Art, University of Florida, Gainesville. He has served as Curator of Photography at the High Museum of Art, Amon Carter Museum, and Spencer Museum, University of Kansas.

CAROL A. THOMPSON is the Richman Family Foundation Curator of African Art. A doctoral candidate in performance studies at New York University, she was formerly with the Museum for African Art and taught at Vassar College.

SYLVIA YOUNT is the Margaret and Terry Stent Curator of American Art. She has organized numerous exhibitions and has published widely on late nineteenth- and twentieth-century American art and culture as well as on issues of curatorial responsibility and current museum practice.

Index of Artists, Designers, and Makers

Photo Credits

Peter Harholdt, photography: pp. 10, 16, 17, 18, 19, 20, 21, 22, 23, 24, 25, 26, 27, 28, 29, 30, 31, 32, 33, 36, 39, 41, 42, 43, 45, 46, 48, 50, 52, 53, 55, 58, 59, 62 (bottom), 63, 64, 65, 66, 67, 69, 72, 74, 76, 77, 78, 79, 80, 81, 82, 83, 84, 86, 87, 88, 91, 99, 101, 102, 103, 104, 105, 106, 108, 109, 110, 111, 112, 113, 114, 115, 117, 118, 121, 122, 123, 124, 127, 128, 131, 140, 141, 147, 152, 154, 156, 157, 158, 159, 160, 161, 162, 163, 164, 168 (bottom), 169, 170, 171, 172.

Michael McKelvey, photography: pp. 34, 35, 37, 44, 47, 56, 57, 60, 68, 70, 73, 75, 89, 90, 92, 94, 95, 96, 97, 98, 100, 107, 116, 119, 132, 134, 137, 155, 165, 166, 167, 168 (top).

Jerome Drown, photography: pp. 38, 51, 130, 135, 150, 151.

J. Mike Jensen, photography: pp. 40, 125, 146.

© 2005 The Georgia O'Keeffe Foundation/Artists Rights Society (ARS), New York: pp. 45, 154.

Photo courtesy of Spanierman Gallery, New York: p. 47.

Courtesy of Frelinghuysen House and Studio, Lenox, MA: p. 50.

© 2005 Artists Rights Society (ARS), New York: p. 51.

© Estate of Ben Shahn/Licensed by VAGA, New York, NY: p. 52.

© Estate of Hale Woodruff/Elnora, Inc., courtesy of Michael Rosenfeld Gallery, LLC, New York, NY: p. 53.

© Estate of Theodore Roszak/Licensed by VAGA, New York, NY; photo courtesy of Martha Parrish & James Reinish, Inc., New York: p. 54.

Tom Meyer, photography: pp. 61, 145.

Photo courtesy of Helga Photo Studio, New Jersey: p. 62 (top).

David Zeiger, photography: p. 71.

John D. Schiff, photography: p. 85.

Photo courtesy of Bullaty-Lomeo Photographers, New York: p. 93.

© Family of Minnie Evans, courtesy of Luise Ross Gallery, New York: p. 115.

Courtesy of Barrister's Gallery: p. 123.

Courtesy of Linda Anderson: p. 125.

© Adolph and Esther Gottlieb Foundation/Licensed by VAGA, New York, NY: p. 126.

Beth Phillips, photography: p. 126.

© 2005 Estate of Tony Smith/Artists Rights Society (ARS), New York; photo courtesy of Matthew Marks Gallery, New York: p. 129.

Courtesy of McKee Gallery, New York: p. 130.

© 1961 Morris Louis: p. 131.

© 2005 Frank Stella/Artists Rights Society (ARS), New York: p. 132.

© Estate of Tom Wesselmann/Licensed by VAGA, New York, NY; photo courtesy of George Adams Gallery, New York: p. 133.

© 2005 Robert Morris/Artists Rights Society (ARS), New York: p. 134.

© Romare Bearden Foundation/Licensed by VAGA, New York, NY: p. 135.

© Ellsworth Kelly, photography courtesy of Matthew Marks Gallery: p. 136.

Mary Caroline Pindar, photography: pp. 139, 143, 144, 153.

© Faith Ringgold, 1988: p. 140.

© 2005 Artists Rights Society (ARS), New York/ADAGP, Paris; photo by Michael Goodman, courtesy of Marian Goodman Gallery, New York: p. 142.

© Agnes Martin, courtesy of PaceWildenstein, New York, p. 144.

© Gerhard Richter, courtesy of Marian Goodman Gallery, New York: p. 145.

© Estate of Roy Lichtenstein: p. 146.

© Anselm Kiefer, courtesy of Gagosian Gallery, New York: p. 147.

Ellen Page Wilson, photography, courtesy of PaceWildenstein, New York: p. 148.

© Chuck Close, courtesy of PaceWildenstein, New York p. 149.

Courtesy of Center for Creative Photography, The University of Arizona © 1981 Arizona Board of Regents: p. 155.

© 2005 Man Ray Trust/Artists Rights Society (ARS), NY/ADAGP, Paris: p. 156.

Library of Congress, Prints & Photographs Division, FSA/OWI Collection, [reproduction number, e.g., LC-USF342-000894-A]: p. 157.

Courtesy of the Clarence John Laughlin Estate and the New Orleans Historical Society: p. 158.

© Ernest C. Withers, courtesy of Panopticon Gallery, Boston, MA: p. 159.

Photograph © Roy DeCarava, 1996: p. 161.

Courtesy of the Diane Arbus Estate: p. 162.

© William Christenberry, courtesy of Pace/MacGill Gallery, p. 163.

© Chuck Close, courtesy of Pace/MacGill Gallery: p. 166.

© Richard Misrach, courtesy of Fraenkel Gallery: p. 167.

© Sally Mann, courtesy of Edwynn Houk Gallery, New York: p. 170.

© Jeff Wall, courtesy of Marian Goodman Gallery, New York: p. 171.

© Thomas Struth, courtesy of Marian Goodman Gallery, New York: p. 172.